the loverly
wedding planner

PASADENA

san francisco

CEREMONY

reception →

← COCKTAILS

the lo♥erly™
wedding planner

THE MODERN COUPLE'S GUIDE TO
simplified wedding planning

Kellee Khalil

and the editors of lover.ly

**TEMESCAL
PRESS**

For general information on our other products and services or to obtain technical support, please contact our Customer Care Department within the United States at (866) 744-2665, or outside the United States at (510) 253-0500.

Temescal Press publishes its books in a variety of electronic and print formats. Some content that appears in print may not be available in electronic books, and vice versa.

TRADEMARKS: Temescal Press and the Temescal Press logo are trademarks or registered trademarks of Callisto Media, Inc., and/or its affiliates, in the United States and other countries, and may not be used without written permission. Loverly and the Heart logo are trademarks and service marks of Dubblee Media, Inc. in the USA and other countries. All other trademarks are the property of their respective owners. Temescal Press is not associated with any product or vendor mentioned in this book.

Photography © Jose Villa Photography; Christina Lilly Photography; Caroline Tran; Rachel Solomon; Troy Grover Photographers; Braedon Photography; Megan Clouse; Theo Milo Photography; Landon Jacob; Abby Jiu Photography; Valorie Darling; Love, The Nelsons; Jacqueline Pilar Photography; Brklyn View Photography. Additional credits appear on page 276–277.

Illustrations © 2015 Sharon McMullen

ISBN: Print 978-1-62315-590-2
eBook: 978-1-62315-591-9

The March to the Altar

ENVISION YOUR IDEAL WEDDING
boho chic? • glam and formal? • rustic and relaxed?

SET YOUR DATE
and your budget

CHOOSE A VENUE
indoor or outdoor? • ceremony and reception in the same location?

BOOK YOUR VENDORS
photography • flowers and décor • entertainment

FIND YOUR ATTIRE
and get your gown or suit! • outfit your wedding party • find your accessories

SELECT YOUR MENU
and your cake

CHOOSE AN OFFICIANT
and plan your ceremony

SEND OUT THOSE INVITATIONS
don't forget postage!

FINALIZE YOUR GUEST COUNT
call up those stragglers, as needed

GET MARRIED
and have some champagne!

Contents

preface

*P*lanning a wedding is no easy feat. I should know. I've helped plan so many that I'm pretty much a professional bridesmaid . . .

But it was the first wedding I helped plan that changed everything. It was 2010, and my sister Leila asked me to be her maid of honor. We were already working together at Be Inspired, the L.A.-based wedding PR agency she had founded, so between our understanding of the industry and her connections, we expected the planning process to be a cinch.

We were *so* wrong.

I spent hours and hours in front of my laptop, searching for creative shower themes and bachelorette ideas, hunting for bridesmaid dresses everyone might actually like, wondering how on earth to DIY vintage vineyard details on a budget. As I clicked through Google search pages and copied and pasted links to my running list, I thought: If it's this hard for Leila and me, how much more are other brides and grooms struggling?

So, one month after my sister said "I do," I packed my bags and headed to New York City, where I poured my heart (and post-college savings) into building a platform for modern couples that would make wedding planning easier and more fun. On Valentine's Day of 2012, Loverly was launched.

What's Loverly? I like to think of it as your new wedding BFF, helping you get inspired, plan, and shop for the big day. On our website, you'll find ideas and inspiration from the wedding industry's most stylish and skilled bloggers and photographers, which can be saved, organized, and shared. You can shop original wedding-worthy products at every price point, from gowns and décor to gifts and more. Use our handy

want more from loverly?
head to loverlybook.com to unlock
exclusive tips and advice from kellee

tools to create a custom wedding website, or plan away with our easy-peasy checklists and budget calculator. And of course, read up on the latest and greatest planning advice, tips, and etiquette, straight from the Loverly Editorial Team.

We believe the planning process should be inspiring and exciting and that your big day should be perfectly you—whether you want to get hitched on the beach or in a barn, whether you're all about black tie or totally into cowboy boots, and whether you want to embrace tradition or break all the rules. This book—our first!—will walk you through everything you need to know about getting married today, because a lot has changed over the years and we've been keeping up.

So, why not let us be your professional bridesmaid? From our website, to our app, to this helpful new guide, we've got you totally covered from "yes" straight through to happily ever after.

Are you ready? Create an account on Lover.ly so we can pretty up your inbox with weekly news and tips, and start reading. You got this!

xo, Kellee

Jose Villa Photography (top); Christina Lilly Photography (bottom)

introduction

Congratulations—you're engaged! You're one step closer to spending the rest of your life with your other half, and that is an amazing step for you and your partner. Pop some bubbly or kick back with some friends. This is a moment worth savoring.

Once you're done sharing the news and posting about it online, it's time to start planning your wedding, which will surely be an exciting, celebratory, and, yes, sometimes stressful task. Orchestrating a huge event for your nearest and dearest might seem overwhelming, but with this book to guide you, you'll be able to enjoy the process and focus on what's really important: creating a day that will truly reflect you as a couple.

No matter what you've seen in wedding magazines or assumed from checking out blogs, your day can be as traditional or as offbeat as *you* want it to be. By maintaining your own vision and shaking off the social pressure to include details that simply don't speak to you, you'll create a wedding that's as unique as you are. That's the point after all—to celebrate *you* two!

In this book, you'll find

- step-by-step assistance with the logistics, from start to finish.

- must-know information about each phase of the planning process.

- practical month-by-month timelines to make planning easier.

- insightful, encouraging, non-judgmental advice to assist you along the way.

The Big Picture

Clockwise from top center: Caroline Tran, Megan Clouse, Braedon Photography, Caroline Tran, Troy Grover Photographers

chapter one

first things first

The next few months are going to be some of the most exciting of your relationship thus far. Not only are you getting married, but you're also planning an awesome party to celebrate with everyone you love.

If you've never planned an event this large before, you might find this process a tiny bit nerve-racking. There's going to be some pressure to make this *one* day the most memorable and beautiful of your life. There's also the realization that you have to make a billion decisions, down to what stemware to rent for the champagne toast.

Take a deep breath and remember: Your wedding is about you and your partner's promise to love and cherish each other for the rest of your lives. It's about a life-changing commitment, not the decisions and worries that come during wedding planning. Your day would be awesome even if it were just the two of you and someone to officiate. And really, all stemware clinks the same, so whichever style you choose will be perfect.

a blissful engagement

Being engaged is a happy, celebratory time, a calm before the storm of wedding planning, if you will. Take this time to enjoy each other, show off your new bling (if that's your style), and start talking about the next stage of your life. Giving yourselves this breathing room will set you up for less intense—and more unified—months of planning.

One aspect to being engaged that you might have already encountered is that people (friends, family members, even randoms you don't know) will be so excited by your news that you'll find yourself fielding a lot of unsolicited advice and questions. (As in, *Please tell me you're not having a destination wedding* and *OMG when are you going to set a date already?!*) The best way to handle them? Smile—it keeps you from biting the person's head off—and simply say that you have it covered.

On the bright side, you may also choose to have an engagement party soon after the question is popped. Usually a parent hosts this party, but don't be afraid to let any member of your family or close friends volunteer. Anyone can throw a soiree in your honor, and the party is often held where the couple lives. The event doesn't need to be an over-the-top celebration: It's really just a chance for your nearest and dearest to congratulate you in person and show their support.

find out more on lover.ly
To find inspiration for every element of your wedding, check out our inspiration section at lover.ly/wedding-inspiration.

ENGAGEMENT ANNOUNCEMENTS

After the question is popped, you'll want to share your happy news with, well, everyone! But before you change your relationship status on Facebook or post a selfie flashing your new bling, take a peek at these tips.

- **Be sure to tell VIPs first—offline.** Before making any sweeping announcements online, first tell your parents, siblings, and BFFs the news. Then, call or text any other super-close family and friends to let them know you're engaged, depending on your level of closeness or preferred method of communicating with them.

- **Decide how you want to share the news.** Some couples simply change their Facebook relationship statuses from "In a relationship" to "Engaged" for a subtler announcement, while others post a photo (or video) of the big moment itself on their social media accounts. Still others might go the traditional route with an announcement in the local newspaper. Do what you feel most comfortable with—it's *your* big news!

- **Get creative.** Yes, you can simply post a photo of your new bling on your social media accounts, but if you want to share the news in a fun way, play to your personalities. You might consider snapping a post-engagement selfie of both of you (using a popular hashtag like #SoLoverly, #HeSaidYes, or #SheSaidYes). You could even take a cute photo of, say, your dog with a sign displaying your news, create a photo collage, or even draw a comic strip. Wedding blogs and websites—including our own—have tons of fun ideas to inspire you.

advance notice necessary

While it's great to postpone planning a bit to enjoy being engaged, there are a few elements that will need your attention at least nine months in advance—even longer if you live in a busy city or plan to purchase items that cannot be rushed at the last minute, such as a designer wedding gown. Jot a few of these deadlines into your calendar, if only so you can stay as worry-free as possible once you get into the thick of planning. Tackle the following to-dos right away if you're tying the knot in less than a year:

Venue: Depending on the city you're planning to get married in, some venues book up over a year in advance. (Unbelievable, right?!) If there's a particular location in which you're hoping to wed, call the place ASAP to find out how soon you will need to reserve a date. Some venues even have online calendars that show their availability for events.

Budget: Deciding who's paying for what—and how much you have to spend—may be easy for some couples, but it's typically a bit tricky for most. Before booking anything (or settling on your wedding vision), it's important to get a sense of the money situation.

Dress: Many designer gowns are made-to-order, and this process can take months. While you'll wind up with a truly one-of-a-kind dress, it may also be a bit unnerving if you find your dream gown but realize it won't be ready in time for you to actually wear it. If you have your eye on a particular dress, call or email the store or designer and ask for a timeline. And don't forget that alterations can take a couple of months, too.

Photographer: Having professional wedding photos is usually a must for couples. Make sure the pros in your area aren't all booked up—and ensure that you find someone with a style you love—by securing photography early on.

Religious requirements: Depending on your faith, you may need to attend marriage classes before you make things official (you or your partner may even want to convert). Therefore, it's best to do a little research to see how long this preparation might take. If you already know that you'd like a particular person to officiate (for instance, a favorite rabbi or minister), check with them as soon as you can to confirm availability.

Travel: These days, people fly in from all over the country (and world) to attend nuptials. If you know that many of your closest friends and family members will likely need to book travel (flights, hotels, and so on) and arrange for time off from work to attend your wedding, try to set a date and share the information with these special people as soon as possible so they can start researching their options.

Honeymoon: For couples who want to take large-scale vacations post-wedding, getting a jump on planning is important. Around-the-world plane tickets and African safaris, for example, will need to be booked well in advance of your actual travel dates.

ETIQUETTE PRIMER

As you can imagine, there are quite a few traditions associated with weddings. At this stage, it's important to be in the know about a few key etiquette points before you jump into planning.

- When you're planning (or having others plan) your pre-wedding events, like the engagement party or bridal shower, be sure that everyone on those guest lists are people you plan to invite to the wedding.

- For destination weddings or weddings with many out-of-town guests, provide at least two lodging options (a high rate and a low one) to be mindful of people's varying budgets.

- Speaking of budgets: Those who pay usually have more say—if your parents are paying for most or all of your wedding, be aware that they may feel that they've "earned" the right to dictate certain details or can veto ideas they don't like.

the well-organized planner

Staying organized is a must while wedding planning—if only for your own sanity. First of all, you'll have tons of paperwork like contracts, proposals, menus, timelines, and other documents you'll want to have in order. Plus, as you start buying décor items (as well as things like stationery, bridal party gifts, and favors, if you so choose), you'll need to organize those items as well.

REAL COUPLES SPEAK "Our entire office in our home was filled floor to ceiling for nearly a year with perfectly labeled boxes full of our wedding décor. Everything was labeled by table and by 'zone.' It definitely looked a little crazy, but Natasha was super organized and executed everything perfectly." –Natasha and Greg

The following tips will help you keep everything streamlined, yet accessible, during your planning process:

1. Keep all of your important info organized in one physical place. You don't necessarily need to buy an actual wedding-themed planning binder (unless you want to), but it's nice to have hard copies of all of your contracts and proposals in one place. Print everything out, hole-punch them, and separate the documents by vendor using tabbed dividers. This way, if your parents are paying—or just want to be involved—it's easy to show them all documentation. Plus, for some people, it's simply easier to flip through printed-out docs rather than searching for files on a computer. A helpful tool for staying organized is Google Docs, which will allow you to collect all of your information in one place online, accessible from any computer.

2. Take advantage of programs and apps that make it easy to stay organized when you're on-the-go or sharing

information with others. Online file management tools like Google Docs and Dropbox allow you to share and edit important files, whether you're finalizing your menu with the caterer or inputting items into the budget with your parents. Mobile apps like Trello and Evernote make it easy to schedule (and remember) appointments and keep track of to-do lists with your wedding planning crew. The helpful thing about all of these tools is that they allow you to store and update different information in digital workspaces that are accessible from any computer or smartphone. So if you're traveling before the wedding, live in a different city from your parents, or are having a destination wedding, you can easily stay organized and connected throughout your planning.

3. If you're planning to start a fitness or healthy eating program before the wedding, an app like MyFitnessPal can track your progress. And of course, if you want one tool that organizes all of your wedding-related plans, then

sites like Loverly and WeddingWire offer a few different app options, from one that helps you find your wedding gown to another that assists you with venue searching. The WeddingWire website is great for reading vendor reviews, too.

4. Organize your physical space early on by compiling décor and other wedding items in their boxes. To keep them organized, label them by area or type (e.g., "Welcome Table" or "Favors"). This way, nothing will get lost and you will have an easy time transporting the items to the venue (and setting them up) when the day comes. Also, because these boxes are easy to stack, you won't have a random pile of wedding stuff overwhelming your home—and stressing you out!

find out more on lover.ly
To start saving your favorite ideas and inspiration on Loverly, head over to lover.ly/wedding-inspiration and download our mobile app for your iOS or Android device.

THE PROCRASTINATOR'S FAQ

What if I still need a venue—and most are either unavailable or over-budget?

Think outside the box: Look into getting married at your parents' house or at a private home that can be rented out, a restaurant or bar, art galleries or museums that can be used after-hours, or public parks (although you might need a permit) where guests can gather. Also, don't forget that you can always get hitched at city hall. Remember: There's going to be so much love in the room, wherever you are will feel special.

What happens if I can't find a caterer?

Many restaurants offer catering services with menus that are more expansive than what they typically serve at their establishments.

What if I haven't found a dress and there's no time to go through a designer? And what if I need bridesmaids' dresses, too?

You can look into purchasing a gown from a sample store or trunk show, or buy an off-the-rack white gown at a department store. Major retailers like J.Crew and Ann Taylor now sell bridal and bridesmaids' dresses. Or you can simply ask bridesmaids to wear the same color, but have them choose their own dresses.

What do we do if we didn't order wedding bands in time for the big day?

Buy "travel" wedding rings you can use for your ceremony and honeymoon—and wear for years to come whenever you go on vacation. (You can find gold-plated and sterling silver bands online for around $10.) That way, the ones you use for your ceremony will still be special and you won't lose the real thing when you're abroad.

What if we can't find a live musician to play at the ceremony?

Contact local colleges or music schools to find a stellar student or instructor to lend their talents for your ceremony.

5. Keep tabs on your inspiration and decorating ideas using pin boards or online tools. On Loverly, we have a bundling feature that makes it easy to select and save your favorite wedding planning ideas as you figure out your vision for the big day. Once you've created a Loverly bundle of your favorite ideas and inspiration, you can share it with the people you're collaborating with, like your vendors or your planner. Amazon also offers a plug-in where you can save any item you find online to a Wish List. It's a great tool when you're researching everything from registry items to favor ideas and want to keep it all in one place. Once you install the plug-in for your browser, all you have to do is click a button and that particular item will save to your list. Then, when you want to purchase, the link is right there.

wedding inspiration

If you haven't already, you'll likely get the urge to check out wedding magazines, blogs, Loverly, Pinterest, Instagram,

and other sources of inspiration so you can figure out your vision for your own celebration.

While many magazines feature mainly conventional nuptials, you'll find ideas online that suit whatever kind of wedding you have in mind. Wedding blogs showcase anything from high-end affairs to indie celebrations or even eco-friendly fetes. As you look around, you'll find sites and blogs that reflect your personalities and styles—stick to the ones that speak to you and you'll find a wealth of ideas to jump-start your planning.

The amazing thing is that there really are no rules when it comes to getting married—and what a wedding "should" look like. For example, pretty much any space qualities as a venue nowadays. Sure, many couples take the traditional route of getting married in places of worship, hotel ballrooms, or even at their homes. But many others take nonconventional routes by saying their vows in industrial warehouses, botanical gardens, and rustic barns, or at the top of ski slopes, on hiking trails, and even underwater. The logistics might be tricky in some cases, but the setting is completely up to you.

LETTING GO OF "PERFECT"

Blogs, magazines, and other forms of visual inspiration can be a great source of ideas when wedding planning, but they can also cause some unexpected stress for some couples. After all, those (gorgeous!) images can sometimes spark a desire for perfection, which seems completely unattainable.

Remember that your wedding will be so much more than how it looks. When you feel like you might be getting sucked into the mentality that everything needs to be "just so," keep in mind that while beautiful details are awesome—and may be extremely important to you while planning—you'll most likely have limited time, energy, or resources to focus on all of them. To spare yourself some stress, consider focusing your attention on certain key details that matter the most to you. That way, you'll still be able to have the wedding you love without feeling overwhelmed. Let go of self-imposed expectations and realize that your wedding will be wonderful no matter what!

While the location is the driving factor for many of the other big decisions, from the dress to the décor, much of the wedding inspiration you'll see featured in magazine spreads and blogs focuses on all of the small details that can set your event apart from others. Once upon a time, all you had to do was choose your colors and get some flowers to jazz up your event, but now there's no shortage of choices for element like favors, table settings, and escort cards. Not to mention all of the new trends, like dessert bars, signature drinks, monogrammed cocktail napkins—the list goes on and on and on!

Of course, you don't have to have all—or any—of these at your wedding. Factors like budget and personal preference really come into play here. Before deciding what kinds of favors you want, ask yourself if you even need (or want) them. There might be some other detail (like a dessert bar) that you'd prefer and would be just as appreciated by your guests.

Remember, the only thing that *must* happen at your wedding is that two of you get married. Basically, everything else is fair

game! Let blogs, magazines, and pictures inspire you, but keep in mind that it's your personal style that should dictate what elements and details you have—or don't—on your wedding day.

So, where to start? Use the images you come across to discover what style most appeals to you: Are you two more of a glam city couple or a down-home duo? And it's okay if you're not quite sure, or if you're a combination of different styles—you'll figure it out! The vibe you want for your celebration will guide your choice of location, as well as how to choose and orchestrate the details.

REAL COUPLES SPEAK "Plan as much as you can in advance, and then try to let go of everything as soon as the wedding festivities begin. The overwhelming love, camaraderie, and eagerness to help that permeates wedding events is like nothing else—and they show that the details (yes, those ones you planned so carefully) aren't what matters most in the end. Steph got lipstick on the front of her ivory-colored dress when putting it on before our ceremony. The music we'd planned to walk to after the ceremony didn't start. Our site tried to shut the party down an hour before our negotiated closing time. And yet we absolutely had the best day of our lives. All of the mishaps make for hilarious stories after the fact." –Stacy and Stephanie

note space YOUR DREAM WEDDING

Take a moment to write down 5 to 10 must-haves for your wedding
(e.g., a certain venue, a custom gown, a dessert bar, peonies in an array
of colors, etc.). Come back to this list throughout your planning process to
help you stay on track with your vision.

chapter two

a vision in white . . .

OR BLUE . . . OR BLUSH . . .

*B*efore you can start to tackle specific planning tasks, you'll need to make some important decisions about what kind of wedding you really want—from where you'll hold the celebration to how small or large you'd like the guest list to be. These decisions, of course, are big ones, so it's okay to take your time before moving forward.

Naturally, you two might have differing views on what kind of wedding you envision, which is completely normal! Yes, you're committing to spending your lives together as a unit, but you're still two distinct individuals. So, if your ideal "I dos" don't completely match up, don't worry. Instead, think of wedding planning as a wonderful chance to practice some necessary skills—compromise and communication—which you'll surely use for the rest of your marriage.

managing expectations

The best place to start planning is to listen to your gut about what you really want—and don't.

By now, you've probably attended some weddings, or at least seen photos online or in wedding magazines. Each event usually has a clear vibe (or even a clear-cut theme), and while there's a traditional order of events, many couples switch things up to suit their tastes. You may decide to forgo a bridal party. Or you may have your heart set on walking down the aisle together, rather than being escorted by a parent or other family member. Whether you follow tradition or decide to make your own rules, the important thing is that your decisions are your own.

Of course, if your parents are paying (and even if they are not), they may have distinct ideas about how the wedding should look and feel. After all, they most likely have been anticipating this day for a long time, just like you. So, part of managing expectations isn't just about figuring things out with your future spouse, but explaining your vision to your parents as well.

Other family members, and even your friends, may offer their input as well. These are merely suggestions and you should take them as such: Remember, your wedding is about the two of you.

In the end, you want to show up to your wedding feeling excited and comfortable. If you plan a day that's just not your style, you may end up dreading it, rather than looking forward to it. Let the planning process become an opportunity to show the world (okay, your friends and family) who you are as a couple with a celebration that reflects your relationship. Do this, and no matter what type of wedding you plan, you will look back feeling satisfied with the result.

To help figure out what matters most to both of you, ask each other these questions to help you prioritize:

1. How important is the time of year to you? (For example, are you set on an outdoor wedding?)

2. How big is too big for your wedding—and how small is too small? (Try to decide on a guest range of what would work for both of you.)

3. Would you prefer a sit-down dinner or a casual BBQ event? (This choice helps dictate the vibe, as well as the types of venues you should consider.)

4. Do you want to travel somewhere for the wedding and plan remotely, or marry where you live? (A big consideration: You may not want to hop on a plane or drive a long distance right before the big day.)

5. Looking at the notes you made in "Your Dream Wedding" at the end of chapter 1, what on that list could you not live without? (Try to each choose three things that *really* matter to you.)

zen in the face of conflict and drama

You're probably familiar with the idea that wedding planning can cause people to go a little crazy. When you combine an expensive high-pressure event, two people with presumably little planning experience, a major life step, plus both of your families and all of your friends, there's a lot riding on this whole wedding thing. Here's how to stay sane:

1. Don't talk about wedding planning when you're hungry, tired, or stressed about something else (like a looming work deadline, for example).

2. When you have conflicting tastes or opinions, take turns being the "decider"—and then stick with the decision you or your partner makes.

3. If you find yourself getting crazed over a minor detail (for instance, obsessing over what kind of ribbon to tie around your favors), recognize what's happening, pause, and force yourself to breathe deeply and relax for a few

SPECIAL CIRCUMSTANCES: HONORING PARENTS

Many people are part of blended families where parents are divorced or remarried. If this includes you, you may be wondering who will walk you down the aisle if you're, say, close to your dad *and* your stepdad, or if your mom raised you on her own.

There are no rules for these or any other parental scenarios—for instance, if you have two mothers, or if your grandmother raised you. You could consider having two people walk you down the aisle, rather than choose one over the other. Or you might have one parent handle one important task, like the walk down the aisle, and ask another to give a speech at the reception. Involve as many parents and parental figures as you'd like in whatever way seems fitting to you.

In other cases, you may have lost one or both of your parents before your big day. To honor their memory and to allow yourself to participate in customary wedding rituals, a groom, for instance, may choose to do the usual mother-son dance with his aunt or grandmother instead, and a bride, for instance, might have her brother, grandfather, or other family member walk her down the aisle. There's

no right or wrong way to go about this: You may even decide to skip certain traditions if that makes more sense to you.

In recent years, some couples have honored a deceased parent by leaving a small flower and note on their empty chair at the ceremony, or by setting up a little table with a framed photo and a lit candle. If you'd like to honor their memory a little more privately, you can incorporate a memento, such as a special piece of jewelry, into your attire by attaching it to your bouquet, pinning it to your lapel, or sewing it into your clothing.

Start thinking early on about what you might want to do so you have plenty of time to make a final decision. You may have new ideas about how to incorporate or honor parents, or even change your mind during the planning process.

seconds. Try to remember that most people probably won't focus on this detail the way you might—and that's okay. On the big day, it's likely that you won't be as focused on it either.

4. To minimize family drama, remain united: If your parents question something that's important to both of you, stick to your guns together. When you show solidarity, your choices are more likely to be respected.

5. When it comes to the budget, be mindful of the person who is paying. If you want to go beyond the budget, offer to cover the added costs—or choose something less expensive.

6. Designate wedding planning to one day each week, during which you can tackle your to-dos. This will help keep planning fatigue at bay.

7. Listen to each other: If your partner tells you it's fine for a certain decision to be up to you, believe it, make the choice, and move on.

your wedding style

Finding your wedding style is a combination of your personal taste and how you've imagined your ideal nuptials to play out in your mind. Maybe you've always envisioned getting married in your parents' backyard with as many guests as you can cram into the space. Or perhaps you've dreamed of an intimate sit-down dinner at a swanky hotel—and you'd prefer live music over a DJ dance party.

Of course, your wedding day desires may have changed once you got engaged. So, the best way to discover your style is to use your personalities and your day-to-day life to guide you. For example, if you're not fancy or extravagant, by all means, don't feel pressure to host a formal fete—after all, a wedding doesn't need to be black-tie to be meaningful. Likewise, you don't need to DIY every last detail in order for your wedding to be special—maybe you'd rather enlist a pro to design your day so all you have to do is show up.

10 QUESTIONS COUPLES CAN ASK EACH OTHER TO ESTABLISH STYLE

1. What vibe do you want your wedding to have? (A huge party or an intimate affair? Black tie optional, or cool and casual?)

2. How would you describe your personal styles? (Laid-back? Trendy? Hipster? Preppy?)

3. What do you love to do together?

4. What's unique about you as a couple and as individuals?

5. Are there certain colors you absolutely love . . . or hate?

6. Are there any traditional elements you think your wedding must have?

7. What are some places you've been (either traveled to or even favorite restaurants) that have a style or vibe you really like?

8. What's the décor style of your home?

9. How do you define yourselves? (Are you adventurous world travelers? Are you passionate about a certain cause or activity? Do you have a distinctive hobby?)

10. If you could use only one word to describe the type of wedding you want, what would it be?

You might also consider using your relationship as inspiration. This way, you're bound to find common ground to establish your wedding style. Maybe you two met at a comic book convention and want to incorporate bold colors with black and white accents into your décor. Or, if you've bonded over a shared love for English literature, you might consider a ceremony in a venue resembling a traditional English garden.

If trying to decide on a style sounds intimidating, don't worry. You don't need established "colors" or a set "theme" if the concept doesn't agree with you. However, having a loose idea of what you want will make the planning process much easier for you when it's time to make decisions about décor items (flowers, linens, and so on), as well as give you some inspiration for all the fun extras (favors and other details) so you don't feel like you're just throwing a bunch of random stuff together.

By at least brainstorming style early on, you'll both have a road map of what the day might look and feel like for you and your guests. From there, you can determine the direction that's most true to you—and fits in best—with your wedding wants.

DESTINATION WEDDING

The pros: Your guests get to travel to an exciting locale (more than likely, some would have to travel to your wedding anyway), and you get to wed somewhere special. Many couples choosing destination weddings pick a favorite vacation spot or place that's meaningful to them in some way, adding a layer of significance to the soiree.

The cons: Some guests will be unable to make the trip due to expense or not being able to get time off needed for travel. Plus, planning from afar can be a challenge, depending on the location and the wedding vendor community there.

If you choose to go the destination route, there are some pointers:

- Tell guests your date and location as soon as possible so they can plan to attend.

- Be prepared to relinquish some control: You may not have a chance to visit the venue or meet with vendors before the big day. If that's the

case, then seriously consider hiring a local wedding planner who can do all of these important tasks for you.

- Make sure you know the rules for marriage licenses, especially if you're getting hitched out of the country (you may need to make things official at home first). Also, don't forget to make sure your passports aren't expired!

- Give extra care to your guests: Providing welcome bags, hosting a welcome dinner, or at least sharing information on key sights to see are all appreciated.

- Pack your bag and check it twice: There's no running home to grab your veil if you leave it at home. Designate family members and friends to transport items you'll need for the big day (if you can't take everything yourself), and make sure you have a detailed list of who's bringing what.

worksheet SETTING OUR PARAMETERS

Use this space to sketch out an overview of your wedding:

BUDGET RANGE
...
...

TOP 3 PRIORITIES
...

 1.
...

 2.
...

 3.
...

IDEAL LOCATION(S)
...
...

TIME(S) OF YEAR
...
...

NUMBER OF GUESTS
...
...

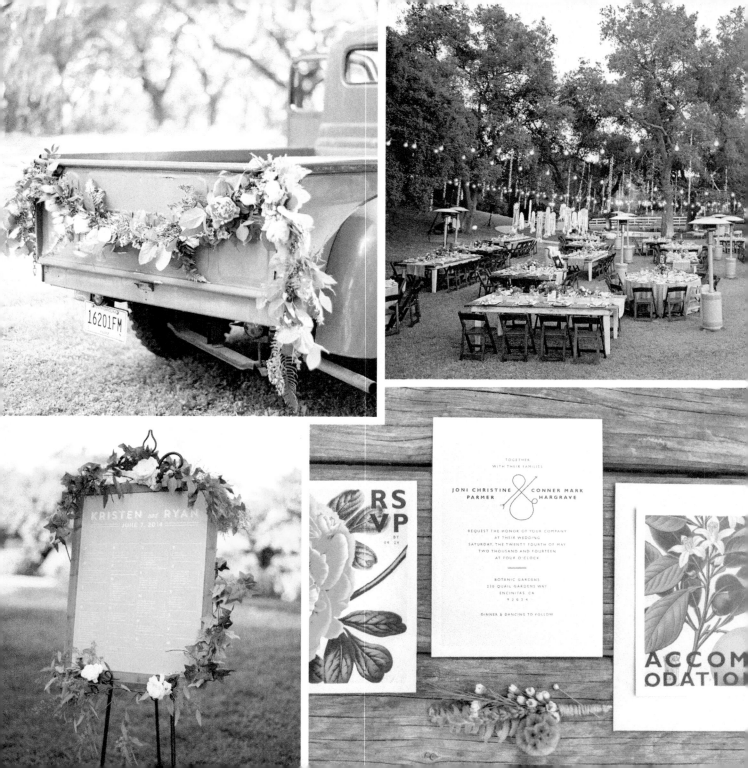

KRISTEN and RYAN
JUNE 7, 2014

RS
VP
BY
06/24

TOGETHER
WITH THEIR FAMILIES

JONI CHRISTINE CONNER MARK
PARMER & HARGRAVE

REQUEST THE HONOR OF YOUR COMPANY
AT THEIR WEDDING
SATURDAY, THE TWENTY FOURTH OF MAY
TWO THOUSAND AND FOURTEEN
AT FOUR O'CLOCK

BOTANIC GARDENS
230 QUAIL GARDENS WAY
ENCINITAS, CA
92024

DINNER & DANCING TO FOLLOW

ACCOM
ODATIO

Planning and Logistics

Clockwise from top center: Braedon Photography, Rachel Solomon, Braedon Photography, Troy Grover Photographers, Abby Jiu Photography, Landon Jacob Photography

chapter three
laying the groundwork

12+ MONTHS OUT

With your big day still a year away, you have plenty of time to get some major components in place without the pressure to make every single wedding decision ASAP. Setting the foundation of when and where you'll host your wedding, as well as who you want to be there, can feel huge. However, making these decisions early leaves you free to focus on the fun details well in advance—not to mention things other than wedding planning.

In this chapter, you'll be guided through these logistics (and more!) to lay the groundwork for your wedding. Remember: You don't need to tackle all of these to-dos at once (which might feel a little overwhelming), but knowing what choices lie ahead can be helpful so you can mull them over and figure out your preferences.

Ready to start planning? Let's get to it!

dates and timelines

Setting a date is, as you might imagine, the first step toward planning your celebration. While you don't need to have a date set in stone to start venue hunting (or dreaming about your wedding style), the day you decide to host your event is indeed one of the key components you'll want to figure out before finalizing any of your other details. Plus, choosing when you'll wed gives you an answer to the question everyone is probably asking you these days: *Have you two set a date yet?!* Won't it be nice to finally be able to say, "Yes!"?

Top Planning Tips

1. Determine how much time you want to plan. Some couples prefer to leisurely plan in stages, while others want a shorter, more intense timeline that allows them to enjoy the fruits of their labor sooner. Do what works for you.

2. If you're contemplating a destination wedding, give yourself a longer timeline. It's often necessary to allow your guests more lead time for making travel arrangements. Nine months to a year is the standard, but if you have more time to plan, use it to your advantage.

3. Call venues you're considering to check their availability: Ask how long couples typically book in advance to get an idea of how soon you'll need to make a decision and what your potential date range needs to be.

4. Consider health concerns: Of course, you want to try to have all of your loved ones at your vows. If you have an older grandparent or someone with any health issues, you may have to reconsider a destination wedding or even think about moving up the wedding date. Talk to your future spouse and both of your families to get their take on what you can do to make this person a part of your special day.

5. Check significant dates: You may want to get hitched on a special anniversary (first date, first kiss, the day you met, etc.), a holiday, or even a "lucky" date (like 11/11) to give your wedding date even more meaning.

Before You Begin

Look at your calendars for important commitments (other weddings, graduations, birthdays), as well as anything work-related that might conflict. (For example, if you'll return home from a business trip on a Thursday, don't schedule your wedding for that weekend.) Also, map out when you might take your honeymoon, especially if you'd like to go right after the wedding.

Talk to your immediate family and closest BFFs about any conflicting plans as well. You don't want to worry about those closest to you potentially missing this super-important day. While you may not be able to accommodate everyone, you'll be glad you asked.

to-dos

- Contemplate seasonal concerns that could affect when you'll wed. (See page 44 for more on this.)

- Give yourselves enough time to plan without stressing yourselves out.

- Consider the budget (June, August, and September weddings can be pricier).

- Confirm that potential venues are available on the date you'd like to wed.

- Check your date against major events (like Super Bowl Sunday— you don't want guests checking the score during your ceremony).

- Submit vacation time for any days you'd like to take off from work for your wedding well in advance.

- Share your date with your nearest and dearest as an informal pre-save-the-date.

Seasonal Considerations

Whether you get married in spring, summer, fall, or winter is a major decision. To figure out which one works best for you, it may help to start with *where* you want to get married, if location is one of your top priorities.

For example, if you've dreamed of getting hitched in your hometown of Chicago, you most likely won't want to plan a winter wedding, since temperatures there can be bitterly cold (and unpredictable) that time of the year. Even if you're planning to host the fete indoors, it's necessary to consider weather as far as travel goes—snowstorms can often cause airport delays and canceled flights.

Weather can also be a concern for destination weddings. You may be tempted to wed in the off-season of your chosen locale, which can be a more budget-friendly option, but it's important to research whether or not "off" is typically synonymous with "hurricane" or "heavy spontaneous downpours."

Another way to look at what time of year you should wed? Imagine what you want your wedding to look like: Do you see yourself barefoot on the beach, inside a magnificent church wearing a long-sleeved gown, or against a backdrop of autumn's colorful trees? This vision might dictate what time of year would be ideal for you.

Religious parameters could also determine your ideal wedding season. For example, if you're Jewish and would like to wed on a Saturday (the traditional Sabbath day of rest), your own religious traditions and your rabbi may dictate that your ceremony start at sundown, which can happen as late as 9 p.m. during the summer months.

Finally, budget can ultimately be a deciding factor that can impact the season in which you get married. Summer and early fall weddings are sometimes more expensive (since these are the most popular times to wed), whereas December through March can be more affordable.

INSIDER INSIGHT Getting married on a holiday, say Halloween, can add a festive touch to your wedding—costume party, anyone? Long weekends are also good choices since guests won't need to take off additional work days to attend.

The Best Day for Your Day

Once you've determined the season, you'll need to consider the day of the week that works best for you—and will be more convenient for your guests since you'll want loved ones to be able to celebrate with you, of course!

The most popular day to get married is—no surprise—on Saturday, which lends itself well to having a rehearsal and a dinner the night before the main event. It's also the easiest day for guests to attend. However, Saturday also tends to be the most expensive day of the week to wed because it has the highest demand.

To cut costs, some couples choose to host their weddings on Fridays or even Sundays. If you do go down this road, be sure to confirm availability with your place of worship if you're planning a religious ceremony. Some venues and vendors will offer discounted rates if you decide to book on these days. However, these choices might be a little more difficult for your guests, unless Monday is a holiday (like Labor Day) or you're hosting a destination wedding and most guests are planning to spend a week or a handful of days with you.

Another option is to host your wedding during the week, which is usually the most budget-friendly option, yet the least convenient for many wedding guests since they would probably need to take extra time off of work to attend. If you're hosting a smaller, more intimate fete and most guests won't have to travel, this might be a good option for you.

As you might be noticing, many wedding decisions rely on a number of factors you need to consider before choosing what ultimately works best for you. It may feel like a quite complicated puzzle at times, but don't worry. As you mull over the options, you'll soon find the optimal choice for your celebration.

budget

Wedding budgets—and how people choose to spend them—are different for every couple. You might be funding your own nuptials or your parents might be glad to foot the bill or at least help out. No matter what—you'll want to spend wisely to make each dollar count.

It's easy to get overwhelmed and emotional when talking about money, especially when you realize that weddings seem to cost a lot more than you might have expected. Take a deep breath and remember that how much you spend has no bearing on how meaningful and memorable your celebration will be.

Top Planning Tips

1. Create a budget based on what's really important to you, but be flexible and ready to compromise if needed. Refer to lists you made in chapters 1 and 2 to determine if those must-have elements are the ones you'd like to devote the most resources toward.

2. If your budget is tight, consider forgoing a bridal party, which can save you money on flowers and gifts.

3. Negotiate: Vendors' price sheets may have wiggle room. If someone you really want to work with is out of reach, ask for abbreviated service. (A photographer may shoot for six hours instead of eight at a discounted rate.)

4. Find other discounts: Sign up for email newsletters offering 10 percent off your purchase when buying invitations or favors online. You could also designate a wedding credit card through which you can earn cash back or airline miles for your honeymoon. (Pay the balance off in full so you don't incur fees.)

5. Buy used: Websites like NearlyNewlywed.com and BorrowingMagnolia.com are great resources for finding used-only-once (and heavily discounted) décor items and wedding gowns.

Before You Begin

Figure out who is paying, and for what. For many years, it has been the custom for a bride's parents to foot the bill for the wedding costs, while the groom's parents take care of the rehearsal or "welcome" dinner (the latter if you're hosting beyond the wedding party). But since the world isn't one-size-fits-all, and "bride and groom" is, nowadays, not how every couple identifies, the old ways might not be appropriate to your own wedding. Today, more couples are contributing financially to their weddings, while each set of parents or other close family helps out with whatever costs they can afford.

You might choose to each speak with your own family separately to avoid any awkwardness. Once you have hard numbers (or a range) of what your families can contribute, decide if you'd like to offer anything more to the wedding fund yourselves.

Bottom line: If you are paying for the wedding on your own, create a budget based on what you can realistically afford.

to-dos

- Set a hard number for your budget that you can't go over, but include a couple hundred dollars of just-in-case or extra money within your budget in case an unexpected cost comes up. Make sure that everyone contributing is clear on who is paying for what.

- Decide what elements you can cut from your budget (like ceremony programs, if you know you don't want them).

- Continue to tweak and hone your budget line items as you determine how much certain elements/vendors cost.

- Maintain an open dialogue with those contributing so everyone remains on the same page about the budget.

Paying for a Wedding

Over the last 50 years, weddings have transitioned from intimate affairs held in the family living room to over-the-top extravaganzas with hundreds of guests. While your style might be the former rather than the latter, you're still going to have to determine how to pay for it.

You may have heard the recent statistic that the average wedding these days costs roughly $30,000. Depending on your financial situation and what you have in mind for your nuptials, this number might sound too big, too small, or just right. But no matter how much you have to spend, your vows will be memorable simply because it's your special day.

Financing your wedding could come in many forms, but it will likely fall into one of these three categories: One or both sets of parents are paying, you are paying, or you *and* your parents are contributing. No matter what, maintaining honest communication with whoever is involved in the financial side of the wedding is very important: Map out your priorities and must-haves early on to avoid confusion or surprises later.

For some couples, financing their nuptials with a wedding loan from a company like LightStream might be an option to consider. This option will likely require a solid credit score to be approved, but it may help you plan a wedding that is financially stress-free since you won't have to sacrifice what you really want on your big day.

To make sure your budget stretches as far as it can, do your homework. Meet with vendors who fall on the high, mid, and low ends of your budget range to research what you can get at what price point. As you start getting an idea of the costs in your chosen location, you can continue to tweak your budget as needed.

And be sure you're allocating enough money to the elements that mean the most to you. If a certain venue is paramount, you may be willing to spend a little more than the average person while spending a bit less on something not as important to you, like the flowers.

Staying Within Budget

Of course, a budget is only as good as the people sticking to it, right?

Hopefully, one, or both, of you is a numbers person. (If not, it's time to brush up on your math!) The first thing you'll want to do is create a spreadsheet where you can track your budget. The Loverly website has a great budget spreadsheet that's free for everyone and easy to modify to suit your particular needs. Record all of your numbers on it; you can easily refer to it and update it as needed.

"In lieu of gifts, some couples ask their friends and family to contribute something to their wedding, such as help with making favors or baking the cake. If this feels right for you, go for it! Not only can this seriously trim your budget, but your nearest and dearest will feel honored by the opportunity to infuse your celebration with additional meaning." – *Kellee*

DO YOU NEED WEDDING INSURANCE?

No one wants to think about postponing their wedding day for any reason. But while it's a rare occurrence, it *can* happen. Whether it's a family emergency, a stolen gown, or Mother Nature wreaking havoc on your big day, you want to make sure you're covered so you don't lose hundreds or thousands of dollars due to an unexpected event. This can be especially helpful with destination weddings, when extreme weather conditions can cause flight delays and cancellations, damaged items and more. Before you buy, check in with your vendors to see how much coverage they have. If you still feel you need it, or just want it for peace of mind, the cost of a policy won't break the bank: A basic insurance policy that covers loss of specific items and deposits usually costs anywhere between $150 and $550, depending on the amount of coverage.

It may be a challenge, but try try to anticipate every potential cost, from the catering, to the cleanup, to even the ribbon you want to use to tie around the favors. Yes, this sounds nitpicky, but the number-one way couples end up going over budget is by not anticipating those little costs that add up over time.

It may help to designate a wedding money manager who can be in charge of collecting the receipts and inputting them into your spreadsheet, so both of you aren't tinkering with the document separately— this often is how numbers and columns suddenly go missing.

Think of your budget as both a firm line you can't cross and a living, breathing entity. On the one hand, there is a number you don't want to go over. On the other hand, your priorities might shift and change the more you get into planning. You may

have estimated that you'd spend $2,000 on your dress, but you actually only wind up spending $400. That difference can either be money saved or allocated toward something wedding-related that you've just realized you want (like a zillion twinkle lights for your reception venue).

And make sure to include some common (but commonly forgotten) fees as line items—these can sometimes be surprising, depending on your venue and can include a cake-cutting fee (sometimes as high as $7 a slice!), corkage fees for the wine you've already purchased, vendor tips, setup and clean-up charges, as well as any taxes.

find out more on lover.ly
For more help in managing your budget, check out our budget tool at lover.ly/tools/wedding-checklists.

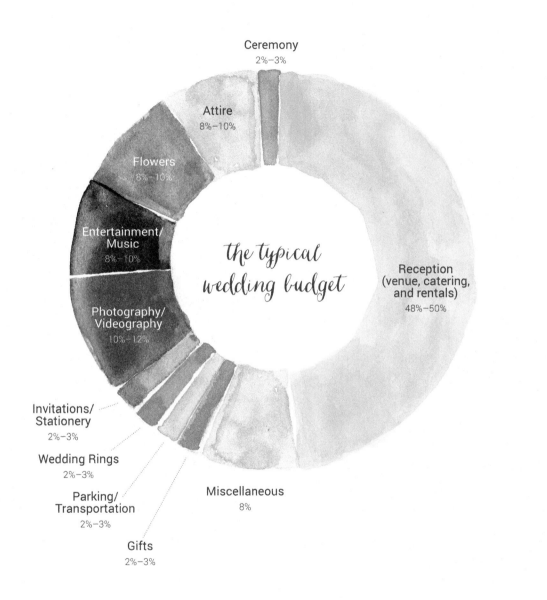

Ceremony
2%–3%

Attire
8%–10%

Flowers
8%–10%

Entertainment/
Music
8%–10%

Photography/
Videography
10%–12%

the typical
wedding budget

Reception
(venue, catering,
and rentals)
48%–50%

Invitations/
Stationery
2%–3%

Wedding Rings
2%–3%

Parking/
Transportation
2%–3%

Gifts
2%–3%

Miscellaneous
8%

REAL WEDDING BUDGETS

Get a sense of what other couples budget for their weddings—as well as why and how they spent their money—with these four real wedding examples.

Bethany and Don

STARTING BUDGET: NONE

LOCATION: HALF MOON BAY, CA

SEASON & MONTH: SPRING, MARCH

DAY & TIME: SUNDAY @ 11:00 A.M.

NUMBER OF GUESTS: 32

RECEPTION VENUE: IT'S ITALIA RESTAURANT

BETHANY'S BIGGEST FINANCIAL REGRET:
"I regret buying a cheap dress. I did, and then spent the month before the wedding scurrying around to find another one. When I eventually found it, I paid more than I wanted because the alterations were almost as much as the dress!"

DON'S FAVORITE FINANCIAL SPLURGE:
"A professional photographer is a must! Although we have friends that are great photographers, and they took amazing photos, we love our professional photos. Remember—they have most likely taken pictures at the site before and know where all the good shots are located at the site."

RENTALS:	Supplied by venue
FOOD AND DRINK:	$4,400
CAKE:	$60
CEREMONY VENUE:	$1,700
OFFICIANT:	$175
ATTIRE:	$1,300
FLOWERS AND DÉCOR:	$100
MUSIC & ENTERTAINMENT:	free (the DJ was a friend)
PHOTOGRAPHY & VIDEOGRAPHY:	$1,200
INVITATIONS & STATIONARY:	$450
TRAVEL & TRANSPORTATION:	$400
GIFTS:	$500
HAIR & MAKEUP:	$120
WEDDING PLANNER:	n/a
WEDDING RINGS:	$350
MISCELLANEOUS:	$200
FINAL BUDGET:	**$11,055**

Brett and Adèle

STARTING BUDGET: $8,000

LOCATION: ATLANTA, GA

SEASON & MONTH: FALL, NOVEMBER

DAY & TIME: SATURDAY AT 6:00 P.M.

NUMBER OF GUESTS: 150

RECEPTION VENUE: THE PARK TAVERN RESTAURANT

ADÈLE'S BIGGEST BUDGET-RELATED REGRET:

"Not hiring a wedding planner. We could have stayed well within our budget had we had someone from start to finish make all of the details work so that everything ran smoothly."

BRETT'S FAVORITE FINANCIAL SPLURGE:

"I'm glad we got a live band. We were able to really enjoy the music and dance, and the interaction with the band is something I really liked."

RENTALS:	Supplied by venue
FOOD AND DRINK:	$3,500
CAKE:	$400
CEREMONY VENUE:	Covered by the cost of food and drink
OFFICIANT:	$0*
ATTIRE:	$1,800
FLOWERS AND DÉCOR:	$1,000
MUSIC & ENTERTAINMENT:	$3,500
PHOTOGRAPHY & VIDEOGRAPHY:	$2,000
INVITATIONS & STATIONARY:	$450
TRAVEL & TRANSPORTATION:	$1,200
GIFTS:	$1,000
HAIR & MAKEUP:	free (done by family)
WEDDING PLANNER:	n/a
WEDDING RINGS:	$1,000
MISCELLANEOUS:	n/a
FINAL BUDGET:	**$13,000**

*Nominal donation to the Catholic Church and the synagogue

Stephanie and Stacy

STARTING BUDGET: $20,000

LOCATION: PALM SPRINGS, CA

SEASON & MONTH: SPRING, MAY

DAY & TIME: SATURDAY @ 6:15 P.M.

NUMBER OF GUESTS: 99

STACY'S BIGGEST BUDGET-RELATED REGRET:
"Not inviting everyone we wanted to come. It was such an amazing experience to be surrounded by family and friends throughout our wedding weekend, it pains us to think of those who we didn't invite because we tried to save a few hundred dollars."

STEPHANIE'S FAVORITE FINANCIAL SPLURGE:
"Hiring a DJ. We decided early to save money on music, make our own playlists, and have Stacy's brother handle the deejaying. But about a month before the wedding, I had a minor panic attack. Weddings are all about getting everyone on the dance floor, and I didn't want to have to worry about technical difficulties. We hired a pro and she was well worth it."

CEREMONY AND RECEPTION VENUE:	$1,000 (same site)
RENTALS:	Supplied by venue
FOOD AND DRINK:	$11,750
CAKE:	$100
OFFICIANT:	free (a close friend)
ATTIRE:	$1,000
FLOWERS AND DÉCOR:	$1,900
MUSIC & ENTERTAINMENT:	$2,100
PHOTOGRAPHY & VIDEOGRAPHY:	$1,100 (photography only)
INVITATIONS & STATIONARY:	$530
TRAVEL & TRANSPORTATION:	$1,150
GIFTS:	$250
HAIR & MAKEUP:	$600
WEDDING PLANNER:	n/a
WEDDING RINGS:	free (family rings for both)
MISCELLANEOUS:	$1,500 (includes cost of rehearsal dinner, next-day brunch, decorations, and welcome bags)

FINAL BUDGET: **$23,000**

Natasha and Greg

STARTING BUDGET: $45,000

LOCATION: SANTA BARBARA, CA

SEASON & MONTH: SUMMER, JULY

DAY & TIME: SATURDAY @ 2:00 P.M.

NUMBER OF GUESTS: 120

NATASHA'S BIGGEST BUDGET-RELATED REGRET:

"It's not so much a regret as it is something we definitely overspent on: alcohol. We were so worried we would run out that we bought double what we thought we'd need just in case. We had so many cases of wine left over that a year later, we're still drinking our way through it!"

GREG'S FAVORITE FINANCIAL SPLURGE:

"A couple weeks before the wedding, Natasha asked me if I thought we should have confetti for our recessional—something we had talked about but didn't think was in the budget. We decided to splurge on it, even if it would put us a little over. It was so worth seeing a cloud of confetti erupt at the end of our ceremony—and the photos were pretty cool."

RECEPTION VENUE:	$5,425
RENTALS:	$5,706.31
FOOD AND DRINK:	$14,122.90
CAKE:	$630
CEREMONY VENUE:	(same as reception)
OFFICIANT:	$800
ATTIRE:	$2,132.96
FLOWERS AND DÉCOR:	$7,769.31
MUSIC & ENTERTAINMENT:	$2,150
PHOTOGRAPHY & VIDEOGRAPHY:	$3,632.50
INVITATIONS & STATIONARY:	$188.26
TRAVEL & TRANSPORTATION:	$1,580
GIFTS:	(not part of our budget— we didn't keep track!)
HAIR & MAKEUP:	$250
WEDDING PLANNER:	$1,400 (day-of coordinator)
WEDDING RINGS:	(gifted by jewelry store)
MISCELLANEOUS:	$500 (*ketubah*)
FINAL BUDGET:	**$46,512.24**

styles and themes

Discovering your wedding style is one of the most fun, creative parts of planning. Here's your chance to decide on a theme, if you want one, or simply a color palette, and get a general sense of the look you're going for with your celebration. It may feel difficult to choose just one direction for your wedding—that's normal! As you start looking at venues and checking out other couples' weddings blogs, you'll likely narrow down your favorite looks and eventually choose the right one for you.

Top Planning Tips

1. Collect images of weddings you love, then look for repetition. Maybe you've saved lots of photos of rustic barn weddings or glamorous city fetes—go with what you gravitate toward.

2. If choosing a theme is just not your thing, pick a few colors (two to three). These hues will dictate your flowers, table linens, and key décor items, keeping the look cohesive.

3. There's a lot of pressure to have a one-of-a-kind wedding. But if you see a style you love, there's no shame in borrowing elements from another celebration. Chances are the final look won't be exactly the same anyway.

4. To keep your style on track, resist the urge to just buy wedding décor items you like—make sure each one fits with the look you want. (If you can't find details you dig, consider changing your style.)

5. If you're stumped on style, consider going chic with shades of timeless white (flowers, linens, candles, etc.). The look will be classic—and utterly romantic. Keep in mind, though—some cultures associate white flowers and white candles with more somber occasions, so be sure your décor doesn't clash with any personal family traditions.

Before You Begin

Book your venue before deciding on a style. Usually, *where* you get married dictates all other choices, from your attire to your décor. While some venues are blank slates, most will have some pretty defining features (architecture, existing furniture, art) that you'll want to work with—not against—as you style your big day. That said, if you *know* in your heart of hearts that you want, for instance, a bohemian-style wedding, you can set your theme and look for venues that might fit it. This is often a bit tougher but not impossible to pull off.

"**Your wedding day may be a celebration of your future, but it's also a day for appreciating the past and the rich relationships that led you both here. You may find that your hometown, cultural heritage, and family histories are a great source of inspiration. By incorporating colors, flowers, fabrics, signage and other décor that's reminiscent of who you are and where you come from, you can craft a celebration that's as special and unique as you are.**" —*Kellee*

to-dos

- Make sure your potential themes are a reflection of you as a couple.

- Once your theme is set, step away from your inspiration boards—too many ideas will confuse you.

- Continue collecting inspiration as you hone your vision.

- Be clear on your style or chosen colors before you buy any décor items.

- Share your vision with your vendors (especially your planner, rental company, and florist) so you're all on the same page.

- Save your receipts: You may buy a décor item early on, only to find something more fitting a month later.

wedding planner

Hiring a wedding planner can take unnecessary pressure off you and save you valuable time. These pros have deep connections within the industry—oftentimes scoring discounts you wouldn't have been able to get yourself and helping you determine which vendors are truly top-notch. Plus, they have insider knowledge when it comes to logistics and expectations.

There are various levels of planning, from full-service, which typically means the planner will orchestrate every task leading up to your event, to day-of coordination, where your planner will take charge on the day of the wedding to make sure everything runs smoothly.

Top Planning Tips

1. Check out your venue's vendor list for recommended planners, and start with those pros. They might be the ones most familiar with your location, which is important on the day of.

2. Go online to read reviews of planners based on other couples' experiences.

3. Meet a few planners in person to see how your personalities mesh. Is this someone you want to spend time with during your planning process and on your big day?

4. Describe your wedding vision in as much detail as you can and see how each potential planner reacts. Ideally, the person you choose should be encouraging and excited about your ideas and not try to steer you in another direction from the get-go.

5. Introduce your planner to your family if they are funding your wedding so that everyone can meet before the big day and talk about logistics together. This way, they know who your family is on the day of your wedding and can easily find them if there's an important question, or if something goes amiss.

Before You Begin

Know what you need: Some venues and caterers actually require that you hire a day-of coordinator to oversee your celebration, while others offer a staff member on-site as part of its fee for the event. Before you enlist a planner for help, get the scoop from your potential venues first.

Even if you don't think you need a planner—or a day-of coordinator—you will want someone running logistics during your ceremony and reception. (You'll be too busy getting married and enjoying your party to be in charge.) Some couples enlist a friend or family member for this task.

PLAN AHEAD Make sure you factor in cleanup time when it comes to your planner's hourly rate. Some planners agree to be at your event for eight hours, then charge extra for added time. Post-wedding cleanup can take an hour or more.

to-dos

- Before you sign, read the contract carefully (especially cancellation and additional hours terms) and store it in your binder.

- Maintain open communication with your planner to avoid confusion or unmet expectations.

- When meeting your planner, always be on time (not only is it courteous, but some planners will charge you a fee if you're late!).

- Try not to bombard your planner with emails and phone calls; consolidate questions into a weekly email, when possible.

- Speak up if your planner makes a decision or suggestion that just doesn't fit with your vision—they may be the professionals, but this is *your* wedding!

ceremony venue

Choosing the location where you'll be married is one of the most meaningful decisions of the planning process. This is where you'll walk down the aisle, say your vows, and leave together in wedded bliss. (If you're like most couples, you might get a little giddy just thinking about it.)

To find your ideal ceremony venue, keep your wedding vision and some logistical considerations in mind to ensure the moment is as beautiful—and runs as smoothly—as possible.

Top Planning Tips

1. Tour a number of potential venues to discover what type of locations speak to you—indoors, outdoors, a house of worship, a museum, a historical house, a gorgeous garden area, and so on.

2. Find out each venue's rules. Ask questions about what's most important to you. For instance: Are there restrictions on music? Can you throw confetti during your recessional?

3. Ask about what's included with the venue: For example, do you need to provide chairs for guests to sit on? If the venue has chairs, who sets those up and takes them down after the ceremony?

4. Revisit potential venues during the day of the week/time of your wedding if you can: Make sure there isn't a train that roars by right as your ceremony is set to begin, or major traffic on the street outside, which could be quite bothersome, to say the least, in the actual moment.

5. Consider providing welcome drinks or bottled water for your guests when they arrive at your ceremony as refreshments. (Just be sure the venue is okay with this idea first.)

Before You Begin

Decide if you want your ceremony and reception in the same place or in two different locations. For some couples, this is a no-brainer: When you're getting married in a church or other place of worship, you may be limited in your reception options. (There is usually a room or outdoor space where additional celebrating can take place, but it might not be large enough to accommodate your guests.)

Logistically, having two venues means keeping track of two contracts, two locations where flowers and potentially other rentals will be to be delivered, and additional transportation, among other considerations.

♥ REAL COUPLES SPEAK

"For us, it was important to pick a location where we'd be treated like any other couple when it came to our wedding planning and wedding weekend. This made Palm Springs, a gay-friendly town that we loved and often visited, the ideal spot for us. Even though gay marriage was not legal at the time in California, you'd never have known it, and for us, that made a huge difference." —Stacy and Stephanie

to-dos

- Carefully read over the contract for terms regarding the rules, especially about music and cleanup, and file the executed version in your binder.

- Take photos of your venue to have on hand as you plan—these might be especially helpful when talking to your florist about ceremony décor options.

- Check the distance from where you plan to get ready to the venue so you know how much time to build into your wedding day schedule for your transportation to the ceremony (and then double it just in case!).

- Plan how and when you'll be able to rehearse on the day before the wedding.

A Location You Love

Ideally, your ceremony venue will be a place that's special to you. The venue itself could have significance, like your childhood home. Or just the general vicinity could be important, such as the town in which you met. Or maybe the type of location might be meaningful, like a park if you went on a picnic for your first date. Or, most typically, you two may just find a place that takes your breath away and you'll make it momentous by getting married there.

All that matters is that you both absolutely love the location. It should be somewhere you can picture yourself getting married and a place that you'd like to see again and again as you revisit your wedding photos.

Logistical Considerations

Not only should you love your ceremony location, but you should be convinced that getting married there will be relatively easy and stress-free. Here are a few practical and logistical considerations to think about as you choose the right venue:

Privacy: If you'd prefer that strangers don't watch your ceremony, consider this factor as you mull over locations. Public parks can be gorgeous settings, but you won't be able to keep uninvited guests from taking a peek at the festivities. The same goes for beach weddings, where you might swap vows in front of a random stranger in a bikini.

Accessibility: If you have elderly guests or those in wheelchairs attending your celebration, consider how they might get to the spot. For example, are there ramps or railings that can make things easier for them? Or, if you're getting married on the beach, will these guests need to be carried (yes, that's been done!) or would you be able to create a makeshift path for them? It might sound a bit over-the-top to wonder about these things, but you'll be glad you made a game plan as the big day gets closer.

You also want to make sure *you're* good to go as far as accessibility is concerned: Check where the aisle would be and what it's made of (cobblestone? grass?). Not only will this impact your footwear choice, but you may feel more comfortable walking on solid ground as opposed to

something with more tripping potential, like gravel or stairs.

Temperature: If you're set on getting married in a small chapel in Florida in the summer or under a gazebo in Michigan in the early spring, consider what you might need to make your guests comfortable (air-conditioning or heaters, specifically). Especially if you're planning a ceremony that's longer than 20 to 30 minutes, you want to ensure that people can focus on you and not how uncomfortable they are.

Contingency options: If you're getting married outdoors, ask what the plan would be if it rains on your wedding day. Do you need to rent a tent? Is there another place on the site that's indoors that you could use in a pinch? It's an absolute must to have a backup plan—even if you're getting married in the summer in a place where it more than likely won't rain—and it may help to take some time letting yourself ponder the plan and feel comfortable with it, too. You never know what will happen on the big day, but if it's bad weather, at least you know your backup plan won't contribute to any stress.

POPULAR LOCATIONS

Not sure where to get hitched? Here are some ideas to get you started.

Public outdoor spaces: parks, beaches, harbors, ski slopes, mountains, lakes, riverfronts

Private outdoor spaces and establishments: botanical gardens, ranches, farms, golf courses, zoos, backyards, rentable courtyards or rooftops of hotels or other buildings

Traditional indoor spaces: restaurants, hotel ballrooms, places of worship, city halls, private event spaces, private homes, Elks/Lions Clubs

Eclectic indoor spaces: museums, aquariums, lodges, art galleries, wineries, country clubs, alma maters, historic buildings, beer halls, warehouses, barns

reception venue

Perhaps you've chosen to get hitched at, say, city hall or in a church, and now it's time to figure out where to host your after-party—a.k.a. the reception. The reception is where you'll, more than likely, feed your guests and provide some kind of entertainment, like a DJ, live music, or games.

Receptions can range from buffet brunches to all-night dance parties. Likewise, the venues are just as varied. Whatever you decide to do is up to you, and you'll want to make sure the venue you choose is the best possible location to accommodate your vision.

Top Planning Tips

1. Ask about how people typically set up for weddings in the space. Is there enough room for dining tables—as well as a dance floor, if desired—for your prospective guest count?

2. Find out from the venues you're considering if they have tables and chairs you can use or if you'll need to rent those on your own.

3. Some neighborhoods, cities, and venues have noise restrictions: Ask about when the music needs to be turned off in case that could impact your ideal reception.

4. Check out the bathrooms: If you're planning on hosting 200 guests, two single-stall bathrooms are probably not going to cut it no matter how much you love the venue.

5. Inquire about the bar situation: Some venues don't actually have liquor licenses and require that you hire a catering company that does. Some venues permit you to bring your own alcohol in, which may include a corkage fee, and other venues may require you to purchase alcohol through them. Some venues don't allow alcohol at all. Get all the details if you plan on serving booze.

Before You Begin

Before making appointments to tour venues, check their availabilities for your wedding day or for a selection of your potential options if you're still deciding on your date. Also, research price points for your top contenders by emailing each venue's person of contact if the information is not available online. Ask how many hours that price includes and whether or not you would be able to buy additional hours if needed, and how much that would be. This way, you won't fall in love with a venue that's unrealistic for your budget.

CHECK AGAIN Most venues will have what's called a "hard out" listed in the contract: This is the time you (and your guests) must be out of the venue on the night of your wedding, or you'll get charged an additional fee.

to-dos

- Build a timeline around when you're allowed to enter the venue—and what time you must be out by—and communicate these times with your vendors.

- Determine how guests will get from the ceremony to the reception.

- Ask the venue for a room layout so you can plan the setup—at least get dimensions if you need to rent tables and chairs so your rental company can advise you accordingly.

- Visit the venue closer to the ceremony with your planner or day-of coordinator to go over logistics (your caterer, photographer, or florist might want to come with you as well).

find out more on lover.ly
Modify one of our sample timelines from lover.ly/tools/wedding-checklists to help you build your own customized timeline.

reception catering

Years ago, all a reception entailed was post-ceremony punch and cake for guests to enjoy. Now, options abound for feeding your friends and family after you've said your vows.

Before delving into the types of food and drink you'll have at your wedding, it's necessary to discuss how to choose the person (or people) who will provide it, from sourcing ingredients and devising the menu, to hiring the staff, cooking, serving, and cleaning up on the day of. Your caterer is one of your key wedding vendors, so do your due diligence before determining who you'll choose for the big event.

Top Planning Tips

1. Many caterers offer their menus online (or you can request them). Make sure there are at least a few items you would serve at your wedding before you schedule a meeting to avoid wasting everyone's time.

2. Find out what catering resources your venue offers: Is there a kitchen? A refrigerator you can use? A warming oven? In turn, find out if your caterer provides dinnerware, flatware, linens, and other necessary items.

3. Ask caterers to give you referrals to couples who have used their services at their own weddings. If they don't have any to give you, this is a red flag.

4. Talk about service charges with potential caterers before you sign a contract. Some build tips for staff into their pricing, while others expect that you will determine that extra cost on your own.

5. Ask about the staff: Who does your caterer employ to serve food? There can be a difference in quality of service between temporary hires and full-on staff members.

Before You Begin

Have an idea of your needs before you meet caterers. Some things to figure out in advance: How many people you'll need to feed (a range is fine), what time of day you're hosting (brunch, lunch, and cocktail receptions are most affordable options, but less traditional), your prospective budget, and how formal you're thinking (for instance, a buffet versus plated four-course meal). Certainly, you don't have to have every detail decided, but a general overview will not only help you research options, but also allow the people you meet to give you the best possible information about what they can offer.

INSIDER INSIGHT You may have a chef or restaurant owner pal who offers their catering services (or other friends who volunteer their services for your photography, officiant duties, et al). But before mixing friendship with vendor-ship, make sure this is a person you can give candid feedback to and feel you can work with professionally.

to-dos

- Read reviews for potential caterers online, as well as check to see which caterers your venue recommends.

- Schedule tastings with two or three caterers to try out their food.

- Check your contract for service charges, and get the scoop on exactly what those mean.

- Work with your caterer to determine a food timeline and how that will fit into the other elements of your reception (like speeches and special dances).

- Talk with your caterer about rental coordination, setup, and cleanup: Be clear on what aspects they take care of, and what would fall to your planner (or you).

guest accommodations

These days, many people travel to attend loved ones' weddings, and the responsibility to coordinate lodging for your out-of-town guests can fall on you. Figuring out where your friends and family members will stay during your wedding sounds like a tall order—but don't worry, it's not as challenging as it seems.

Once you start calling local hotels to find out about their policies on room blocks, you'll be able to determine which ones best fit your needs. From there, each hotel will guide you through the process—they've likely done this many times before!

Top Planning Tips

1. Tour a few local hotels and ask to see different room types. Then, choose two different hotels for guests to choose from, making sure one is on the more affordable side. In some areas you can rent houses or villas for guests, which may be a less expensive option.

2. Consider the distance to your ceremony and reception from the hotel to determine if transportation will be needed and what kind.

3. Make sure you block enough rooms. Hotels will often offer a mix of double (two beds) and single (one bed) rooms, and it's crucial to do a little math to make sure the combination works for your guests.

4. Some higher-end hotels include fine print saying that after a certain date, you are responsible for paying for any rooms your guests don't book. Read your contract carefully and ask about if and when you can "release" your unused rooms back to the hotel.

5. If you'd like, create welcome bags for your out-of-town guests with a local map, snacks, and an itinerary for your wedding weekend. The hotel can deliver these bags to guests' rooms or hand them out upon check-in.

Before You Begin

If you're hosting your ceremony, reception, or even your rehearsal at a hotel, start with that establishment when coordinating a room block. (If you haven't set locations for these events, you may want to do that first before determining guest lodgings.)

More often than not, you can get better rates on a hotel block when you're also renting out the hotel's ballroom or a restaurant for one of your wedding-related celebrations. Before finalizing anything, speak with the event coordinator of the hotel you're considering to ask about bundling or other available discounts.

TREND ALERT If you won't have many out-of-towners, you may not meet the minimum room requirement for a hotel block. Fortunately, there are other options. Consider directing guests to the websites of popular lodging alternatives like Airbnb, VRBO, and HomeAway for vacation rental options instead.

to-dos

- Determine how many rooms you need and book accordingly.

- Keep your signed contract(s) handy in your wedding binder for easy access.

- Share hotel information with your guests via email or your wedding website in advance, including the group name or code they will need to book under your room block.

- Check in with the hotel(s) to make sure the reservation process is going smoothly, as needed.

- Release rooms before the deadline, if applicable, so you don't get charged.

- Make and deliver welcome bags to hotels the week of your wedding.

guest list

For many couples, a huge part of what makes a wedding special are the guests. Having those you love witness this awesome step in your life—and celebrate with you afterward—is a must.

But deciding how many of these loved ones make the guest list can be tricky, especially when you mix in your family's expectations. Not to worry: Determining the guest list might be a super-stressful task, but once it's done, it's done.

Top Planning Tips

1. To figure out your ideal guest list, each of you should take a piece of paper and write down everyone who must be at your wedding, separately. Then, compare your lists and circle the overlaps—these are your VIPs.

2. Decide if you're going to invite plus-ones and kids. You may want to extend the rules to everyone, but some choose to give plus-ones only to the bridal party or to invite kids in the family only.

3. Compromise on the maybes: You and your partner may have different ideas of how many guests to invite from each "side," so if you're having trouble cutting it down, try to talk through the maybes without too much judgment and hear each other out.

4. To minimize parents inviting too many extras, give each side a set number of people they may invite, keeping it equal for both sides. Of course, if one set of parents is footing the bill for the entire event, they'll likely believe that they can invite whomever they want—a reasonable assumption in theory. But if you're worried about their guest choices, gently share your concerns with them. They may be willing to compromise and agree to limit their invites.

5. Create a second tier or B-list: You may learn after you send out save-the-dates that some guests won't be able to make it. At that point, you can pull more invitees from a second-tier list if you choose.

Before You Begin

Sit down with your families to discuss expectations as far as your guest list is concerned. No matter who is paying, if you and your future spouse want a more intimate affair, then it's perfectly acceptable to insist that your parents or family not invite 200 of their closest friends to the wedding. That said, this day means a great deal to your parents, too, and there may be family, friends, or even work colleagues they feel strongly about including. Discuss these possibilities early on before you start thinking about ordering invitations so you can manage how you'll go about accommodating both of your families and their needs—as well as your own, first and foremost.

♥ **PLAN AHEAD** Unless you're having a small, local wedding, roughly 10 to 20 percent of your list may decline, depending on your wedding location, how many people you invite, and how close you are to those invitees. Remember this as you finalize your list, especially if your venue has a maximum or minimum limit for the number of guests!

to-dos

- Trim your list until you hit your ideal max guest count (accounting for declines).

- Share your final list with your families, if desired.

- Input your list into a spreadsheet along with guests' addresses (ask for the ones you don't have).

- Use this spreadsheet to track save-the-dates and invites as you send them out, as well as RSVPs, gifts, and thank-you notes later on.

- If you still have outstanding replies after your RSVP date, contact those guests personally to find out if they are coming or not.

- Give your final guest count to the planner, caterer, rental company, and other vendors who request it.

VIPs, Exes, and Extras

When you begin creating your guest list, you'll be able to easily name your wedding VIPs—in other words, the people who, no doubt about it, will be invited. These are typically parents, grandparents, siblings, best friends, college roommates—you'll know who they are as you start this process. The same thing goes for people you *don't* want to invite—you'll be able to call them out quickly.

What makes the guest list difficult is what to do about the people in between: friends you used to be tight with, but haven't talked to (except on Facebook) for years, or second cousins you know your mom wants you to include.

For some couples, it may help to set criteria: For instance, if you haven't spoken on the phone with someone in the past 18 months, then that person is a no. Or, maybe you decide that you're going to invite first cousins, but no one more distantly related. Others, however, prefer to go on a case-by-case basis. Only you know what's right for you.

When it comes to including children, many couples have questions regarding what's expected and appropriate. In some cases, couples may not want to have children at their wedding; however, there may be a number of guests with children who won't be able to attend unless their kids are included. Others may want to include kids, but their budget doesn't allow them to extend an invitation to *all* of their guests' children.

There are a couple of things you can do in these situations: First, if you choose not to have children attend your wedding, be sure to let guests know as soon as you can so they have the best possible chance of making other arrangements, like having a parent babysit or seeking out local nanny services.

You could also decide to have kids only at the reception, not the ceremony, and provide nanny services or a babysitter for just that portion of the festivities. (Usually, couples opt to have a sitter watch the children at the wedding accommodations hotel.)

GUEST LIST ETIQUETTE

Inevitably, your guests—and even people you didn't invite—will have some questions and requests related to who you choose to include on your list. Here's a cheat sheet of what to say (and do) if you encounter these common guest-related issues:

Someone who's not invited asks where their invite is	Hopefully this person doesn't ask you directly (how rude!) and makes a comment to another family member or friend who can handle the situation gracefully. But if you are asked this question, simply say: "I hope you can understand that this was a very difficult decision and, unfortunately, we weren't able to include you."
Someone asks to bring a child who was not included on the invite	Say, "We appreciate you asking, however, we unfortunately cannot accommodate children. We will have information regarding local child-care options on our wedding web-site, should you need them." Then, be sure to provide information—it can be as simple as listing a few local nanny services—for this person and other parents who may need it. (But know that you're not responsible for figuring out guests' child-care situations. Just sharing some options is a generous gesture.)
Someone asks to bring an uninvited plus-one	The best thing to say is this: "We're sorry, but unfortunately, we aren't able to include any more guests at our celebration than those we've specifically invited."

Finally, if budget is the concern, but you want to include kids, you might set boundaries as to which children get invited—typically couples choose to include kids who are family, as well as children of those in their bridal parties. The important thing to do is choose a rule and stick to it to avoid hurt feelings among guests.

To keep your little guests occupied at the wedding, consider providing dedicated kids' meals (your caterer can show you picky palette–friendly options), as well as something fun for them to do during dinner, like coloring books and crayons.

Luckily, there are some general wedding "rules" when it comes to trimming your list, though you can ignore them if you wish. First, you are not obligated to extend plus-ones to single guests. When it comes to those in relationships, you technically need to invite significant others only if the couple is living together or married. (However, you may *want* to invite a friend's boyfriend—whom she doesn't live with—if you know him very well.)

As far as exes are concerned, many couples opt to leave them off the guest list, unless they happen to be engaged or married to another close friend, or if you and your partner have maintained a close friendship with them. There are no hard and fast rules, so do what makes you all most comfortable.

to sum up . . .

Use this table to record the wedding elements described in this chapter as you tackle (and complete) them.

Item Requiring Attention	Your Decisions Thus Far
DATE & TIMELINE	*Labor Day weekend next year, gives us 12+ mos to plan*
DATE & TIMELINE	
BUDGET	
STYLE & THEME	
WEDDING PLANNER	
CEREMONY VENUE	
RECEPTION VENUE	
RECEPTION CATERING	
GUEST ACCOMMODATIONS	
GUEST LIST	

Notes and Reminders

Must start planning by the end of next month!

RSVP
BY
04 24

TOGETHER
WITH THEIR FAMILIES

JONI CHRISTINE CONNER MARK
PARMER HARGRAVE

REQUEST THE HONOR OF YOUR COMPANY
AT THEIR WEDDING
SATURDAY, THE TWENTY FOURTH OF MAY
TWO THOUSAND AND FOURTEEN
AT FOUR O'CLOCK

———

BOTANIC GARDENS
230 QUAIL GARDENS WAY
ENCINITAS, CA
92024

DINNER & DANCING TO FOLLOW

ACCOM
ODATIO

chapter four
spreading the news

9 TO 11 MONTHS OUT

*N*ow that you've made some key wedding planning decisions, it's time to share this information with your guests-to-be. Just like how the marriage proposal solidifies your engagement, sending out the details about when and where you're getting hitched means that the countdown is officially on!

In this chapter, we'll cover all aspects of spreading the happy news of your celebration, as well as some insight into one of the most beloved wedding traditions—choosing your bridal party. This is the time when your best pals and closest family members will start rallying with you, making your planning experience all the more fun.

wedding website

You may want to create a wedding website where you can easily share information about your nuptials with guests. Your site can be a fun introduction to the details of your celebration, as well as a great way to introduce everyone to your wedding day style or theme.

Clearly, building a website can seem like quite the task even if you're tech savvy, but there are a number of platforms—including Loverly's—available to make building (and updating) your site a breeze.

Top Planning Tips

1. Decide if you want a custom URL using your names (for example, chrisandkellygetmarried.com). Loverly offers personalized wedding websites that are mobile-friendly, too.

2. Use your website to share your engagement photos (more on those on page 82), information about how you met, your proposal story, and fun activities to do in the wedding city, as well as all the necessary details about the wedding, any other related celebrations (welcome dinner or post-wedding brunch), transportation, and accommodations.

3. If you don't know a key piece of wedding info yet (e.g., what time the welcome dinner will start) put "TBA" rather than estimating, which will only cause confusion.

4. Consider having an FAQs section on your website: Here's where you have the chance to lay out important info, such as hotel accommodations, transportation options, weather for that time of year, etc.

5. Make sure the colors and fonts are easy to read, especially for older folks.

Before You Begin

Research available website-building options before putting something up online. You might also consider checking out more general website builders (not just wedding platforms) that give you more flexibility to show off your style.

Luckily, there are a couple of user-friendly—and totally chic—platforms that will make everyone think you've hired an expert to design your site for you. Check out Loverly's wedding websites, powered by Splash, which offer free website building with tons of customization built in. Another website builder, Squarespace, also offers sleek, professional-looking templates, but their services cost money.

find out more on lover.ly
For beautiful, free, highly customizable wedding website templates with custom domains, check out Loverly's wedding websites at lover.ly/tools/wedding-websites.

to-dos

- Choose your web platform, and create your site.

- Double-check spelling and all information to make sure it's accurate and correct.

- Determine your URL.

- Test your site to make sure everything loads on your computer and phone.

- Share the URL via email or on save-the-dates/invitations.

- Check and update your site as needed.

"Your wedding website is a fabulous way to centralize information like your registry or RSVP details and to let guests communicate with each other and share photos. Remember to pick a mobile-friendly site like Loverly's since so many people browse the Web from their phones and will want to be able to access info on the go." — Kellee

engagement photos

Depending on your personality, you may think that taking engagement photos is either a must or not worth the effort or cost. Whether you want to take part in this recent trend or not, know this: The more professional pictures you take together before the big day, the more relaxed and comfortable you'll look in your wedding photos, which we can all agree is a good thing.

These photos can be as casual and laid-back or as planned and orchestrated as you want. Do what works best for your personalities and you'll end up with price-less images that truly reflect you.

Top Planning Tips

1. Bring props: Some couples opt to create a picnic scene or another fun "set" as a backdrop for their photos.

2. Choose a location meaningful to you, if you desire. If you love nature, shoot outdoors on your favorite local hiking trail, for example.

3. When deciding what to wear, check with your photographer to be sure your outfit will shoot well. Typically, jewel tones (bright pinks, greens, and blues) show up best on camera, while white T-shirts, for example, can look washed out.

4. If you plan on having your hair and makeup done for your wedding, consider scheduling your beauty trials (more on this on page 126) for the day of your shoot so you can be professionally done-up in your engagement photos.

5. Many people want to include pets (dogs especially!) in their weddings, but this, as you can imagine, is not easy to manage. Instead, consider having your furry friend as part of your engagement shoot, which will be more convenient, yet still very special.

Before You Begin

Some photographers offer discounted (or even free!) engagement shoot sessions for their wedding clients, so it's a good idea to choose your wedding photographer before scheduling an engagement session with someone else. Typically, a photographer will offer a set number of retouched images from an engagement shoot as part of a wedding package. Taking advantage of this gives you a chance to work with your photographer and get comfortable with them before the big day. (See page 106 for more about wedding photographers.)

"Engagement shoots are a great way to give your family and friends a peek into your relationship and the special things that make it tick. Whether you guys are quirky and cute or outdoorsy and adventurous, you'll be glad that you captured this special time in your life. Ask your photographer for suggestions on how you can make your pictures really stand out. If you really want to go over-the-top, maybe consider skydiving or one of your other, more thrilling hobbies!" *—Kellee*

to-dos

- Decide if you want engagement photos and, if so, what style or vibe you like (check Loverly and Pinterest for inspiration).

- Find out if you can get your engagement shoot included with your wedding photography.

- Set the time and date of your shoot. If it will be outdoors, you might want to set a "rain date" or Plan B in case of inclement weather.

- Choose your shoot attire.

- Go to your shoot (smile!).

- Choose your favorite images for your wedding website.

- Give your photographer feedback they can apply to your wedding photos, as needed, and see if you can get photos early so that you can use them for save-the-dates, holiday cards, wedding invitations, and more.

save-the-date

Your save-the-date—which you should send out 8 to 12 months before your wedding date—is a pre-invitation to ask your guests to mark your big day on their calendars. As your friends all start to hit the marrying age, it's important to give everyone a heads-up as far in advance as you can so other people planning their "I dos" won't overlap you—and, of course, everyone important to you can plan to be there. While not everyone chooses to send a formal save-the-date announcement, many couples go to professional stationers to find theirs, especially if they want all of their wedding day paper to match. It's a fun way to get your guests excited about your celebration.

Top Planning Tips

1. Think about putting your engagement photos to good use by choosing your favorites for your save-the-date.

2. Use online resources for designing and printing: Websites like Wedding Paper Divas and Minted have affordable, easy-to-design templates that help you create save-the-dates in various styles.

3. Go the DIY route: Check out Etsy for designed templates (typically $10 for the downloadable file), which you can then customize and print yourself or at your local printing store.

4. Include key info like the date (of course!), the city in which you plan to wed (and even the venue if you've locked it down), as well as your wedding website URL so people can check it out.

5. While some wedding resources suggest sending cards out 8 to 12 months before, that's really the minimum: You can never be too early about making your date known, especially if you're having a destination wedding or getting married on a holiday weekend or during peak wedding season (June through September). And if you're not sending out a formal save-the-date, be sure to at least send out an email to guests with important info about the wedding.

Before You Begin

If you're still on the fence about inviting a certain friend or relative, consider not sending this person (or group of people) a save-the-date. If they are not close to any of your other guests (and won't know that you've sent these cards out), you can mull over whether or not you want to include this person when it's time to send invites. Not everyone expects to get a save-the-date. Plus, if you get some verbal declines after these cards go out, you might have more flexibility to include more guests.

♥ **PLAN AHEAD** If any friends or family members have moved since you requested their addresses (which you should have done while making your guest list), be sure to double-check where to send their save-the-dates.

to-dos

- Choose the template, photos, fonts, colors, and wording that you want to include on your save-the-dates.

- Create cards yourself, or order through a company, getting extras just in case.

- Double-check spelling and key information for accuracy.

- Buy postage. (If your cards aren't standard size or you used really thick paper, have one weighed at the post office to be sure—don't just guess!)

- Address cards, and note who on your list is receiving one.

- Send them out!

- Save any extras, and send out to additional guests if needed (if you get early declines).

invitations

Use the design process of your wedding invitation as a chance to start thinking about other stationery items you may want on the big day (place cards or menus, to give some examples). Many invitation companies will either offer these extras to match your invitation suite or be happy to create them for you as part of a bigger package.

Top Planning Tips

1. If you choose a more affordable invitation but want it to have some flair, hire a calligrapher to write out guests' addresses by hand—which will make a standout first impression!

2. Determine which extra cards you need to include with your invite, like transportation info, your wedding website, or hotel accommodations. If you're having a welcome dinner, you can include the invite to that as well.

3. Be sure to weigh your invitation at the post office to ensure you use the correct postage. And don't forget to buy stamps to place on your RSVP return envelopes to make it easier for guests to reply.

4. Rather than have your guests send back traditional RSVP cards, you might consider using a digital RSVP platform—via websites like Loverly and Postable—that are eco-friendly, easy for tech-savvy guests, and could be more convenient for you.

5. Wrangle those stragglers: A few days after your RSVP deadline has passed, email or call anyone who has not responded. You can also designate this task to a parent or wedding party member if you'd prefer.

Before You Begin

Since your stationery should, in theory, reflect your wedding itself, you want to be clear on your colors and theme before you design your invites. This way, you can incorporate some elements of your celebration onto your invitation and give your guests a taste of what's to come at the actual wedding. If you're still unsure of the look and feel of your wedding and need to get those invites ordered, choose neutrals (ivory, gray, white) to keep the look classic.

"If you want to get your guests excited for the big day, ask a fun question on your RSVP card in addition to accept/decline and meal choice. Not only will you have fun reading their answers (even for lighthearted questions like, what song do you want to hear at our wedding?), but you'll also get some insight on what your guests think, too. These little connections will make your wedding feel that much more meaningful." — *Kellee*

to-dos

- Look for invitation inspiration online, but see and feel papers in person.

- Determine what invites you want to order, as well as any extra cards to go with your suite (be sure to order a few more than you'll need).

- Assemble invites.

- Take one fully assembled invite to the post office to have it weighed, then buy postage as needed.

- Address envelopes yourself, or hire a calligrapher—or have them professionally printed.

- Send your invites!

- Contact anyone who hasn't RSVP'd once the deadline passes.

Paper and Printing

When it comes to wedding invitations, you'll have a spectrum of styles to choose from. First, there are the paper types, which vary from standard card stock (a bit thicker than regular paper), to parchment, shiny glassine, or even textured linen. Then, you get to choose your printing style—this can be anything from standard offset laser-style printing to embossed, raised or foil lettering, or the oldest (and often most expensive) style, custom letterpress printing.

Clearly, the fancier you get, the more costly your invitations will be. Your decision comes down to two things: (1) how important your wedding stationery is to you, and (2) how formal (or casual) your wedding will be.

To address the first: Some people are paper aficionados. If you absolutely love stationery, you may have listed invitations as one of your top wedding priorities and have already built this into your budget. Of course, now that you've likely already put down deposits for some of your big-ticket items, you might have to revisit that budget. Don't worry—you can still have gorgeous invites without spending a small fortune.

On the second note, you want your invitation to set the tone for your celebration. If you're having a casual affair, a thick, letterpressed suite is more than likely unnecessary. If you're having a formal fete, you'll want to go a bit more luxe than a standard paper and ink invite.

To be sure, before you order anything, check out some paper and printing options. Most online invite services offer bundles of their paper types for free or a small fee, while local printing companies in your area should have examples and materials for you to peruse. Check things out, and you should have a better idea of what will work best for your wedding.

INVITATION ETIQUETTE AND WORDING

How you word your invites is another indication of how formal or casual your celebration will be, as well as who's hosting.

Traditionally, when a bride's parents are paying, your invite will read for instance: "Mr. and Mrs. [bride's parents] request the pleasure of your company at the marriage of their daughter [bride's name] to [spouse's name]." But depending on who's paying and how you identify, similar wording may be used for grooms, too.

If you're in a situation where both sets of parents are hosting the wedding, you would write: "Mr. and Mrs. [parents of spouse A] and Mr. and Mrs. [parents of spouse B] request the pleasure of your company at the marriage of their children [spouse A] to [spouse B]."

If you have divorced parents, if your parents have different last names, or if other family members are also contributing, it might easier to write: "Together with their families [spouse A] and [spouse B] request the pleasure of your company at their marriage."

If one of you has a parent that has passed away, you might use wording such as, "Please join us at the wedding of [bride's name], daughter of [bride's mom] and the late [bride's dad]."

If you two are paying yourselves, your invite could simply read: "[spouse A] and [spouse B] request the pleasure of your company at their marriage."

The "pleasure of your company" phrase can be tweaked however you see fit: Other options include "would like you to join them/us," "invite you to celebrate their/our union," or "are delighted to invite you to." If the wedding will be held in a house of worship, "the honor of your presence" is usually used. You can also change "marriage" to "wedding" or "marriage celebration," or you can get creative with it.

Finally, formal invitations tend to have the date and time completely written out, like "Saturday, the twelfth of July [next line] two thousand and fifteen [next line] four thirty in the afternoon." Casual invitations look more like this: "July 12, 2015, at 4:30 p.m."

wedding party

Choosing your wedding party is a fun, happy task where you both can figure out who you want to be your support systems and celebration-throwers during your engagement. The best part is that, now, there are no rules: You don't have to have an even number of attendants for the sake of having two matching sides. Instead, make this a way to honor your closest friends and family members how you see fit. After all, these are the people that will be by your side on one of the most important days of your life!

Top Planning Tips

1. There is no rule when it comes to your wedding party—you can have as many, or as few, attendants as you see fit.

2. Typically, having a wedding party is an added cost. Double-check that you've budgeted for flowers (bouquets and boutonnieres), gifts, and other wedding party—related expenses for the number of people you want to include.

3. *Anyone* can be in your wedding party: It's fine to have bridesmen or groomswomen, for instance. You can even ask your grandma if you want!

4. To keep things simple, you may contemplate having just a maid of honor and/or a best man rather than a full wedding party.

5. Consider asking your attendants in a creative way: Check Loverly or Pinterest for ideas on how to "propose" wedding party-ship, like sending sweet cards or writing the question on mini champagne bottles.

Before You Begin

Be very sure that, first, you want a wedding party (it's not a requirement!) and, second, that you're 100 percent sure who you want to be in it before you ask. There's nothing worse that being on the fence about a bridesmaid, asking her anyway, and then regretting it later. Having just your siblings, or siblings and best friends, might be a good way to keep the group cohesive and drama-free. But feel free to have as many attendants as you wish; just be realistic that it means more coordinating for you.

INSIDER INSIGHT You may get some pressure from family members or friends about including certain people in the bridal party. This is your day, so don't feel obligated to ask anyone to be a bridesmaid or grooms-man. Stay true to yourself and do what you want.

to-dos

- Figure out who you want to ask.

- Ask away!

- Be clear on responsibilities and expectations right from the get-go, as well as expected costs. (Do you want your ladies to throw you a shower? Are you cool with having your groomsmen choose their own suits?)

- Maintain communication with your wedding party, giving plenty of lead time for ordering/renting their attire.

- Buy thank-you gifts to give to the wedding party before the big day.

- Communicate information about the rehearsal and rehearsal dinner as needed.

- Have a blast with your besties on the day of!

Bridal Party

Before you got engaged, you might not have given a lot of thought as to whether or not you'd have a wedding party and who might be part of it. That's okay! Basically, here's what you need to know: Your wedding (also called bridal) party is often made up of those closest to you, anywhere from 1 to 12 people on each "side." Each cast of attendants will respectively plan your pre-wedding festivities (shower and bachelor/bachelorette), help you with wedding planning if needed, and support you on the day of the nuptials. They can also stand up with you at the altar during your ceremony, if you'd like.

Asking loved ones to be part of your wedding party can be as simple as picking up the phone or as creative as you wish. Some couples choose to send cute cards in the mail asking those they want in the wedding party to be their bridesmaids and groomsmen, while others invite everyone to a special brunch, lunch, or happy hour to ask if they'll be attendants. You might even choose to think of a more elaborate "proposal" by sending printed handkerchiefs, mini bottles of champagne, engraved flasks, or personalized baseball hats to them. Anything goes!

Of course, being part of a wedding party is a huge honor and most people are excited to be included. What you guys need to be mindful of, as the bride and groom, are your attendants' budgets, both money- and time-wise. Buying a dress and renting a tux (as well as shoes), can be pricey, as is shelling out cash to throw and attend pre-wedding events. While it's up to your attendants to decide if they can afford to be part of your party, it's up to you to be flexible if someone is unable to participate in certain aspects of it.

Another important consideration is how much you'll want to (or have to) manage your bridal party. Your honor attendants (more on them in the next section) are typically the ones to coordinate fittings; however, you might feel more comfortable handing this yourself. Do what feels right to you and what you have time for—don't let the bridal party tasks overwhelm your actual wedding planning.

Honor Attendants

Traditionally, each of you will choose one extra-special person to lead your side of the wedding party. This might be a best man or maid of honor, but feel free to choose a best woman or man of honor—or, depending how the person identifies, they may wish to have a different title altogether (have fun with this, if so!). Ultimately, labels don't matter, though. What matters is that the role is filled by a trusted friend or family member. (Note: Some people refer to female married honor attendants as "matrons" of honor, but others feel that this term is outdated and stick with "maid" for both married and unmarried women.)

As with most things wedding-related, there are no rules for this. You can choose anyone you please and you could even have two (or more) best men or maids of honor if you want. The important thing is that you choose people you want by your side and who will keep you calm and collected as nerves start unraveling closer to the big day. In addition, because these special people will be in charge of keeping the rest of the bridal party on track, you should choose fairly organized people.

WHO DOES WHAT?

Here's an overview of customary roles and responsibilities for these key players:

Maid of honor: Takes the lead on planning the bridal shower and bachelorette party with the bridesmaids, assists bride as needed by attending dress fittings, and helps keep her organized (and sane) on the big day. She typically signs the marriage license as well.

Best man: Takes the lead on planning the bachelor party with the groomsmen, coordinates tux rentals (and returns), and gives a toast during the reception. Like the maid of honor, he may sign the marriage license. He may also coordinate the getaway car and any luggage that needs to be in it for the honeymoon.

Flower girl: Throws petals down the aisle before the bride walks out. Some couples may choose to have their little escort blow bubbles instead, an increasingly common custom.

Ring bearer: Carries the rings down the aisle.

Ushers: Seat guests before the ceremony, giving assistance as needed to older attendees.

Parents and Children

Aside from your attendants, you'll also want to find some ways to honor parents and children who are special to you. (For information on how to honor parents or family members who are deceased, turn to page 204.) Also, note that while this particular section speaks in the language of "bride and groom," these traditions can be customized to suit your own particular identities both as individuals and as a couple.

First, a bride's parents: Your father might be walking you down the aisle, in which case, you're already covered. Your dad will also, customarily, give the father of the bride speech at your reception, as well as join you in a special father/daughter dance during the festivities. Your mom might be escorting you with your dad (as is traditional in Jewish ceremonies), but, if not, ask her to sign your marriage license or to hold your bouquet during your ceremony instead of following the custom of giving both tasks to your maid of honor.

The groom's parents can be similarly honored: His mother could also sign your marriage license (if your state allows for two witnesses), or you might ask her to arrange your dress when you get to the end of the aisle. You could offer his father the chance to say a few words at the rehearsal dinner (which the groom's parents typically host).

No matter what you choose, it's thoughtful to bestow at least one meaningful task on each one of your parents so they all feel involved in the day as much as possible.

As far as children go, you could select a younger family member (or even a couple) to be your flower girl and ring bearer. (Ages four to seven is the usual range for these jobs.) You can also include a tween or teenaged niece to serve as a junior bridesmaid. Usually, the parents of these children are responsible for getting their attire (which you would choose) and assisting them with their day-of jobs as needed.

Other easy, yet nonofficial, jobs for kids who are a little older include passing out programs (or something to toss at the ceremony), greeting guests, and directing people to sign the guest book.

PLUGGED IN OR UNPLUGGED?
A SOCIAL MEDIA ETIQUETTE GUIDE

Couples today need to consider technology and social media while wedding planning—namely how they want these things to fit into the big day. Many couples now opt to have "unplugged" weddings (or just ceremonies) during which they ask guests to stay present and refrain from taking photos or otherwise using their smartphones. One of the main reasons for this is because larger phones and iPads can really get in the way of the photographer's (and videographer's) task of capturing your wedding.

If you'd like guests to keep their phones tucked away, you might include language on your wedding website and in the program such as: "We invite you to put down all your favorite devices and just be present in the moment with us. We're happy to share our professional wedding photos later, but the greatest gift you can give us today is just being fully here with us in this special moment." You could also ask your wedding planner/day-of coordinator or officiant to make a quick announcement to this effect before the ceremony begins.

While many couples request that guests "unplug" at least for the ceremony, social media does play a major role in weddings these days, especially when it comes to hashtags. A number of couples ask their guests to use a special tag when posting photos to social media, which can be really helpful for collecting loved ones' photos of their wedding day.

If you choose to create a wedding hashtag, spread the word via your website, your program, and maybe even display a cute sign near your guest book. Also, be sure to talk to your wedding parties and any family members who will be getting ready with you to make sure they don't post snaps of either of you online before the ceremony (or your first look!). Finally, remember that some of your guests' social accounts may be public: If you don't want any photos of your wedding day online, it's best to go the totally unplugged route.

gift registry

Gift-giving is a long-standing wedding tradition, as is creating a wish list of items for guests to choose from. While some couples feel awkward about outright asking for stuff (understandable), your friends and family will want to honor your marriage with gifts. It's better to give them an idea of what you want and need rather than receive a bunch of random things you don't. Embrace this ritual. Plus, every time you use a registry gift, you will most likely remember the person who gave it to you for years to come.

Top Planning Tips

1. Include items at low, medium, and high price points so guests can choose gifts that fit their budgets.

2. Some universal registries seem convenient, but they can be a hassle for guests since they don't easily automate when an item is purchased (gift-givers have to input that info themselves). It may be less of a hassle to create two or three registries from a few stores/websites instead.

3. Consider a honeymoon registry: Sites like Wanderable allow you to ask for money for your honeymoon, without breaking any etiquette rules. Just know that some of these services charge small fees, meaning that you won't actually get all the money guests give.

4. Visit stores: Some gifts that appear great online could look different in person. If possible, try to see everything you're registering for— don't just rely on photos.

5. Etiquette says don't tell people to give you gifts or NOT give you gifts. If you feel strongly about it, you can say, "your presence is present enough," but people will likely still buy you gifts.

Before You Begin

Take a few weeks to research and create a registry. First, it is a time-consuming process, and trying to do it all at one time will seriously stress you both out. It's better to go slowly and think about what you actually want and need instead of simply trying to put something together quickly. Be mindful of what you have in your home and what you could really use the next time you're hosting, or even just cooking, a dinner. Use your hobbies as inspiration: For example, if you love to bake, check your cabinets to see what items could be upgraded (or would be nice to have). If you want to start camping, register for a tent and lantern.

♥ **ETIQUETTE ADVICE** According to wedding etiquette experts, it is poor form to put your registry information on your invitations. Instead, include the URL for your wedding website and then list your registry info there.

to-dos

- Research what you want and need.

- Choose stores and online retailers.

- Select items together.

- Share registry info with guests via your wedding website and tell your parents so they can tell your older, less Internet-savvy guests.

- Add more items if one of the price point categories (low, medium, high) starts getting low.

- Create a column in your guest list spreadsheet to record who gave you what gifts so you have a record for your thank-you notes.

- Save all receipts in case you get duplicates or things you don't ultimately want to keep and need to do any returns.

find out more on lover.ly
To make gift registries fun and easy, Loverly has partnered with a curated group of registries, which you can see at lover.ly/tools/registry.

to sum up . . .

Use this table to record the wedding elements described in this chapter as you tackle (and complete) them.

Item Requiring Attention	Your Decisions Thus Far
WEDDING WEBSITE	*lover.ly—go with "boho" style*
WEDDING WEBSITE	
SAVE THE DATE	
INVITATIONS	
WEDDING PARTY	
GIFT REGISTRY	

Notes and Reminders

Upload engagement photos this weekend

chapter five
booking before it's too late

9 TO 11 MONTHS OUT

*Y*es, this time period is a busy time for planning, but rest assured, the major decisions are almost behind you. A few more key vendors need to be booked to ensure that the companies or people you want to work with aren't already reserved for other weddings.

Another major aspect you'll tackle? Your wedding wardrobe. If you didn't believe you were really getting married before, you certainly will once you start trying on a bevy of gorgeous gowns, especially if your personal style includes this kind of fashion choice. While many may opt for more casual attire—and many folks, no matter how they identify, choose to wear a suit—for a certain kind of person, there's no comparison to the unique wedding experience of finding your perfect outfit.

officiant

Other than the two of you, the only other absolutely essential people you need at your wedding are the person who is actually going to marry you and the witnesses of this momentous occasion. This is why you want to get this individual figured out—and booked—sooner rather than later. (Unless, of course, you already picked out who would marry you well before your proposal, in which case, awesome!) For those of you still seeking that special someone who will prompt you to say "I do," here's what you need to know about choosing an officiant.

Top Planning Tips

1. Before booking an officiant, or even meeting them, check online for any YouTube videos of them performing ceremonies, or ask if you can get a few referrals and speak with past couples.

2. Get a sense of variety by asking to see sample ceremony texts that they have written and performed. You will get ideas, as well as a sense of their range.

3. If you're speaking with religious officiants, be sure to ask about flexibility regarding wording and marriage-related rituals. Find out what's mandatory for them and what's not. For instance, you may ask if it is okay to write your own vows or omit or modify certain prayers.

4. Check with your potential officiant about travel costs if they don't live in the location of your wedding. Some are more than willing to travel for a fee.

5. Go with your gut: You want to feel comfortable with the person who's going to marry you, especially if you two will be doing premarital counseling with them as well (which some officiants require).

Before You Begin

Check in on which wedding traditions, whether religious or secular, you want your ceremony to include. Go back to your priorities list and talk about your wedding vision together with this aspect in mind. Some officiants are quite picky about when and where they perform ceremonies, as well as what language and rituals must be included (or can't be). Before choosing someone, have a clear idea about the type of ceremony you want and any dos and don'ts that are essential to you.

REAL COUPLES SPEAK "We loved having both a priest and a rabbi at our wedding. They helped us write the ceremony and were very involved. We wish we'd tried pre-marriage counseling with another interfaith couple, though, not because marriage is hard but because a wedding involves a lot of emotions, and when you add religion into the mix, things can become stressful. Just remember that while it's important to take your families' feelings into account, what really matters is what you and your partner want."—Adèle and Brett

to-dos

- Sort out your ideal ceremony, whether it's spiritual, non-denominational, religious, etc.

- Research officiants who fit this style, and ask for referrals/samples.

- Meet officiants to see who you click with.

- Book your officiant and ask about any extra travel costs/donations/fees.

- Continue meeting with officiant, as they request, to discuss the ceremony or arrange premarital counseling.

- Give officiant wedding day and rehearsal details.

- Rehearse with officiant.

- Get married!

Having a Friend or Family Member Officiate

Many couples opt to have someone close to them—a family member or friend—preside over the wedding ceremony instead of hiring a professional officiant. This can be a very meaningful way to include someone important to both of you, like a parent, sibling, or even the person who introduced you. Here's how to do it:

1. **Check with the marriage bureau where you'll wed to make sure a friend or family member can officiate.** Some states, like Virginia, don't allow people who get ordained online to perform marriages. Calling the county clerk is a surefire way to get the info you need.

2. **Get the person ordained—and registered, if necessary.** Take a look at online resources like TheMonastery.org, through which the officiant-to-be can become a minister of the Universal Life Church. Once they have become ordained, check with the county or city to see if they also need to be registered in order to legally perform a marriage.

3. **Check ceremony parameters.** Be sure to check with the city for any requirements that the service itself must fulfill. Some cities actually require a public declaration of spouse-hood during the ceremony for the marriage to be legally binding.

4. **Sign and submit the marriage license.** It's not official until the paperwork is sent! After the ceremony, you two will sign your marriage license with your officiant, as well as a witness or two (depending on city requirements). Then, it's up to your officiant to submit the license to the city within a certain period of time, so make sure they know what those parameters are.

photography

While the actual day of your wedding goes by in a flash, the photos you'll have from that day will last a lifetime. Because pictures are the best way to preserve and remember all the special moments from your celebration, figuring out who will capture those memories (and how) is something worth spending some time—and wedding funds—on. After all, these are the images that will hang in your home, the ones you'll happily look back on for years to come. In other words, it's worth it to spend some extra money on a fabulous photographer.

Top Planning Tips

1. Research photography styles to understand which one appeals most to you. (See page 108 for more.)

2. When you meet with photographers, don't just rely on their portfolios, which may contain only a tiny percentage of the actual number of photos they took at a given wedding. Request to view a full wedding to get a sense of range and ability.

3. If your budget allows, consider hiring a photographer who includes a second shooter. This way, there will be two people capturing every moment for the price of one. You'll also want to go over specific shots that you want taken during the event. (See our list of must-have shots on page 109.)

4. Choose a photographer who gives you full rights to images so you can obtain the digital files, share them with family, and print photos yourself. (Make sure the images will be delivered via a medium you can access—a CD won't do if you don't have a disc drive.)

5. Many photographers offer packages that include your photos and the albums they create—at a premium. If budget is a concern and you don't feel strongly about having formal albums, then you may be better off making them yourself.

Before You Begin

Evaluate your expectations and mentally prepare yourself to learn the cost of a real pro. If you budgeted less than $1,000 for your wedding photographer, be aware that, chances are, the person you book will be more of an amateur—they could be a student or an aspiring professional who may have never shot a wedding before. Wedding photography is *expensive*—some of the top pros charge as much as $50,000. (Yes, you read that right.) Clearly, the average couple won't spend that much, but for quality photos with no regrets, expect to potentially pay upwards of $2,500.

"If you feel a little intimidated by the costs involved in hiring a professional photographer, it's okay. Like any good professional, your photographer wants to do a great job and make you happy. To help them succeed at this, be clear about your expectations. If you want them to focus on certain shooting details, such as candid images of people, be sure to make your requests known." *– Kellee*

to-dos

- Meet photographers to see their work, and determine who you feel most comfortable with.

- View full weddings for evaluation of skill.

- Book your photographer, carefully reading over the contract for clauses about travel, how many hours they will be on-site, and who owns your wedding images.

- Do an engagement shoot with your photographer.

- Ask to review your photographer's shot list and add any images you know you want.

- Discuss any logistics (times and places) for pre-wedding photos, including getting ready and your first look.

- Be clear on the delivery time and the delivery medium of your images after the wedding.

Photography Styles and Subjects

There are three shooting styles that wedding photography typically falls into today:

The first is **artistic**—this is the style you will see on many blogs and on Loverly and Pinterest. These images are all about the composition of the space and, even though they are very much posed and thought-out, they look very natural.

The second is **traditional**: These are the photos you might see in your parents' wedding albums where everyone is lined up and smiling for the camera. (Many photographers today will shoot a mix of artistic and traditional).

Third is **photo-journalistic**: For this style, the photographer quietly captures moments without staging or prompting their subjects for more of a candid approach.

Editing style is another factor to consider: Do you prefer blown-out, soft, or even ethereal images? Photos that are grainy and almost remind you of Instagram filtered pics? Or are you drawn toward super colorful or very stark black-and-white pictures? As you look through a photographer's work, you'll discover what you like if you're not sure yet.

Finally, you'll want to consider digital versus film: Because technology has come a long way, these two mediums are less different than you might think. (A real pro's digital camera won't give you pixel-y images.) But depending on your taste, you may have a preference either way—make sure you find a photographer who can meet this need. As you research and examine images from photographers, ask them what they shoot with and why.

Your photographer should be well-versed in the aforementioned terms and be able to confidently discuss style and medium with you. Because images are so important to most couples, it's advisable to hire the best pro you can afford. While it might be tempting to have a friend shoot your wedding to ease your budget, photography is usually one area in which you won't regret spending money.

Creating a Shot List for Your Photographer

Most professional photographers have shot lists of must-get images for every wedding they shoot: pictures like a group shot of the bridal party, a bride walking down the aisle, the first dance, and the honor attendants' speeches.

But it's always a good idea to create your own supplemental shot list if you have specific wants or needs. Here are three types of photos to talk about and possibly add to your list, which you should go over with your photographer a few weeks before the event.

Group or people combinations: If you have a particularly large or blended family, be sure to write down all the group combinations you might want your photographer to capture during family photo time, making sure to jot down people's actual names (not just "Mom" or "Dad"), so your photographer can call people out to organize group pictures. This ensures you get all the photos you want with all of your parents, grandparents, siblings, and so on. You may

also want special photos with people—like one with both of your grandmothers or college roommates. Talk with your photographer about when and how these photos can happen.

Handmade details: Only *you* know that your grandfather's wedding band is tied on your bouquet, or that you're wearing your great-uncle's wristwatch. If you want your photographer to snap photos of these meaningful details, add them to your shot list.

Special moments: Let your photographer know about any rituals or ceremonies that may be happening before and at the wedding, from getting henna applied to your hands pre-ceremony to dancing the hora at your reception. That way, they can prepare to best capture these moments.

flowers and decoration

The blooms you choose for your wedding will likely be the hallmark of your décor. From the altar, huppah, or archway at your ceremony to the arrangement on each table at your reception, your flowers highlight the colors and tone you've set for your celebration. Your other décor items—signs, banners, place cards, and so on—will ideally complement the florals you've chosen to create a cohesive feel for your soiree.

If you don't know much about flowers, don't fret. With a little research, you'll be able to easily name the entire range of flora at your wedding by the time the day arrives.

Top Planning Tips

1. Work with your florist to find ways to reuse your ceremony blooms at your reception. The flowers festooning your arch might make excellent centerpieces for your head table, and your aisle-marking garlands could look lovely on your dessert table. Repurposing ensures that nothing goes to waste.

2. Money-saving tip: Instead of a flower bouquet, opt to carry one made out of vintage brooches or paper flowers if this fits your aesthetic—plus, you can keep it forever.

3. Take on DIY projects with caution and realistic expectations. (See page 113 for more on this.)

4. Purchase décor items with care: Many wedding-related details and craft supplies might not be returnable, so it's better for your budget to wait if you're not totally sure. Don't be tempted by a good deal.

5. Carefully read over the floral proposal: Your florist will put together a detailed document for you that includes pricing per stem, how many will be used in each arrangement, and other important details. Make sure you go over it thoroughly before signing off.

Before You Begin

Flowers are a major décor component for your big day, at least for many couples. Since they're typically used in both the ceremony and reception, you'll want to get familiar with various blooms to decide what you like. However, before getting your heart set on certain types of flowers, check what will be available during the time of your wedding. In-season flowers are more affordable, they're typically in higher supply, and they may even be in better condition. (See "Flowers by the Seasons" on page 114 for more.)

CHECK AGAIN Your floral contract may include language regarding bloom substitutions in the event that the flowers you request aren't available for your wedding day. Be clear about what this would entail—including any additional costs—before you sign.

to-dos

- Research flower options and start compiling blooms you love as inspiration for your floral meetings.

- Meet florists and talk about the aesthetic you want—choose the person you feel will be able to carry out (and enhance!) your vision.

- Determine which décor items you want to buy (or make) and start purchasing/creating.

- Store décor items in labeled boxes so you don't lose anything.

- Finalize floral choices by the date your florist gives you.

- Find out if your florist will deliver your bouquet(s)/boutonniere(s) to you (and your maids/men) personally or to your venue—you will want these for pictures.

Bouquets, Boutonnieres, and Blossoms Galore

One of the major ways you'll use blooms is for the flowers you and your attendants will wear or carry during the ceremony.

First, the bouquet: Your personal flowers should be the highlight of all the attendants. You can opt to choose blooms to match those on your reception tables or you can make your bouquet totally unique by using just one color or adding in a special flower. (Some brides opt to put pricier flowers in just their bouquets to cut costs since they'll be holding their flowers in many of the photos.) Your bridesmaids may also have smaller bouquets that coordinate with your own, but this isn't a requirement. You may decide to have your maids each hold one big bloom instead—anything goes!

If you're really into flowers, you may also ask your florist to make you a flower crown—a super-popular trend of late—for a sweet bohemian touch.

The groom and his men traditionally wear boutonnieres pinned to their suits or tuxes. Like your bouquet, a boutonniere could coordinate with the rest of the wedding florals or it could be totally different—some men opt to include succulents, feathers, even Lego figures. The groom's should be a bit more elaborate than the rest of his party.

You may also consider having your parents and grandparents wear or hold flowers, like giving boutonnieres to the fathers and grandfathers, and corsages or nosegays (mini-bouquets) to the mothers and grandmothers. These additional blooms are not required but can be pretty in photos as well as serve as a way to honor these family members.

And don't forget your flower girl(s) and ring bearer(s)! Your flower girl will need petals to toss, and your ring bearer (depending on his age) could wear a small boutonniere.

DIY—Within Reason

Adding personal touches to your wedding décor has become a major trend in the past few years, especially with the increasing popularity of lifestyle bloggers and sites like Loverly or Pinterest. So, chances are you may be inspired to create one (or a few) elements of your big day on your own.

Incorporating DIYs into your wedding can be super special and even save you money—if you choose your projects wisely. Be honest with yourself about your craftyness: If you've never wielded a glue gun before, your wedding centerpieces are not the place to start.

Instead, choose manageable projects that require fairly inexpensive materials. This way, if whatever you make doesn't turn out so great or you have a few false starts, you're not out a ton of time and money. Read all directions of a given DIY carefully to evaluate what's involved: Check for items describing any tools you might need and how long the project takes to set or dry in between stages. You might even want to read other people's comments, if available, before you forge ahead.

And, unless you're a pro yourself, it's generally not advised to DIY your flowers. This process usually involves going to a flower mart or farmers' market the day before your wedding, creating all of your centerpieces, bouquets, boutonnieres, and so on yourself, storing them in a refrigerator overnight, and then finding a way to get everything to the venue(s) the morning of your wedding. While it might sound like a great way to save money, you don't want to be working all day and the night before you get married trying to create the most important décor elements for your big day. No one needs that kind of stress. If you do it, make sure to get help and allot plenty of time.

REAL COUPLES SPEAK "Our décor budget was pretty high because my mom, stepdad, and I made most of the décor components for the wedding, including the photo booth backdrop, the chuppah, and the favors. We also bought milk glass vases for the flowers, cake stands for the dessert table, and votives, which I now use often when entertaining! It was totally worth the time to make and source everything." —Natasha and Greg

FLOWERS BY THE SEASONS

Here's a handy guide so you can choose your wedding flowers wisely. Remember that seasons are flipped in the Southern Hemisphere if you're having a below-the-equator destination wedding. And always check with your florist about availability. Cold spells and bad crops can sometimes limit your choices, no matter the season.

Spring: Agapanthus, Anemone, Apple Blossom, Bird of Paradise, Brodea, Calla Lily, Cherry Blossom, Corn Flower, Cosmose, Dahlia, Delphinium, Delwood, Forsythia, Freesia, Gardenia, Heather, Helleborus, Hollyhock, Hyacinth, Larkspur, Liatrus, Lilac, Casa Blanca Lily, Gloriosa Lily, Stargazer Lily, Lisianthus, Narcissus, Peach Blossom, Peony, Phlox, Poppy, Protea, Pussy Willow, Ranunculus, Solidago, Statice, Stephanotis, Sweet Pea, Tulip, Viburnum, Wax Flower, Zinnia

Summer: Alchemilla, Allium, Alstromeria, Amaranthus, Baby's Breath, Bird of Paradise, Campanula, Cockscomb, Cosmos, Dahlia, Delphinium, Dianthus, Didiscus, Euphorbia, Foxglove, Freesia, Gardenia, Genista, Ginger, Gladiolus, Hallaconia, Heather, Hydrangea, Hypericum, Iris, Kangaroo Paw, Larkspur, Lavender, Liatrus, Lilac, Calla Lily, Casa Blanca Lily, Gloriosa Lily, Stargazer Lily, Lisianthus, Marigold, Sunflower

Fall: Acacia, Allium, Alstromeria, Amaranthus, Anemone, Bittersweet, China Berry, Cockscomb, Cosmos, Echinops, Freesia, Gerbera Daisy, Gladiolus, Hypericum, Iris, Juniper, Kangaroo Paw, Kalancheo, Liatrus, Lily, Asiatic Lily, Gloriosa Lily, Misty Blue, Pepper Berry, Protea, Queen Ann's Lace, Quince, Rover, Rowen Berry, Salvia, Solidago, Statice, Star of Bethlehem, Sunflower, Yarrow, Zinnia

Winter: Acacia, Alstromeria, Amaryllis, Cyclamen, Evergreens, Gerbera Daisy, Ginger, Helleborus, Holly Berry, Lily, Asiatic Lily, Casa Blanca Lily, Narcissus, Orchid, Pansy, Pepperberry, Phlox, Protea, Queen Ann's Lace, Roses, Star of Bethlehem, Statice

Year-round (sometimes imported but likely available): African Violet, Baby's Breath, Carnation, Chrysanthemum, Daisy, Gardenia, Hibiscus, Orchid (most varieties), Rose, Stock

Light It Up

An often-overlooked décor element when it comes to weddings is lighting. In its many forms, lighting is a detail that can make your ceremony or reception space really take shape. Here are some of the ways you might consider incorporating lighting:

Uplighting: If you have no clue what this is, rest assured that most couples are probably in the same boat. Basically, uplighting could be anything from portable lights you rent from a company to existing lighting your venue already has that you can use to highlight certain features in the room. (For example, you could place lights to flank a flight of stairs you'll walk down for your grand entrance or at the base of columns that sit on either side of the buffet.) Usually, you can program the lights to shine in a specific color or even put what's called a "gobo" on them to create a pattern. Your venue, DJ, or local lighting company can assist you to figure out what you might want and need.

Twinkle lights and lanterns: The easiest, most affordable way to dress up your venue—and create a really festive vibe—is by stringing up tons of lights and/or lanterns. Just double-check with your venue(s) before purchasing or renting lights to make sure there aren't any restrictions or issues with hanging or plugging in strands.

Candles: Another great way to set the mood at your celebration is with candlelight. From strategically placing them at your ceremony to setting them on receptions tables, candles create an utterly romantic vibe. Check with your venue(s) for the rules on candles: Some require you place them in votives (which may have to be a certain height), others don't allow them and you'll need to use flameless options only.

Inspired Ideas

While you'll likely get tons of ideas on flowers and décor from blogs and websites, as well as Loverly and Pinterest, these aren't the only places to find wedding inspiration.

If you're a fashion-forward couple, for example, runway shows might have some fun elements you can incorporate into your big day, from colors to fabric textures to lighting. You may also find ideas from watching movies or even star-studded awards shows (and their accompanying over-the-top after-parties, of course). If you love history, you might be moved by a painting or an old building with details you could draw from. If you're artsy, you could even sketch out ideas yourself.

As you get into the thick of planning, you'll probably start finding ideas everywhere you look, from the candles on the tables of your local restaurant, to a cool display at your favorite boutique, to the flowers blooming in a nearby park. Soak in all of these ideas, and let them encourage you to build your vision.

If you're not feeling so inspired—maybe you're even uncomfortable with all the pretty stuff—that's totally fine, too! That's the great thing about wedding planning: If you're super into the details, you're going to have a blast figuring out every last part of the décor. If you don't really care all that much about all of those intricate little details, your nonchalance won't in any way ruin your big day. Basically, it's a win-win no matter what you're feeling!

10 DIFFERENT WAYS TO DECORATE INEXPENSIVELY, BUT BEAUTIFULLY

1. **Crepe paper:** From making paper flowers to creating a festive photo booth backdrop, this affordable décor item can be used in a number of creative ways.

2. **Garlands:** Use them to flank your aisle or huppah, dress up a bannister, section off areas of the venue, or decorate tables.

3. **Cake stands:** Create levels by placing arrangements atop stands of plates of different heights, which adds interest and allows you to use smaller amounts of blooms while getting the same impact as one large arrangement. Find vintage plates, if that's your style, for even more savings. You can then use them yourself post-wedding or re-sell them.

4. **Greenery:** Succulents and potted trees are great décor options because they can be planted at your home post-wedding. Plus, they're hearty enough to withstand cold in the winter and heat during the summer.

5. **Branches:** Create texture and height to your arrangements by incorporating a woodsy element.

6. **Pretty napkins:** Rather than shell out money to rent pricey table linens, opt for high-end napkins that can provide a pop of color or interesting texture.

7. **Table runners:** Use burlap, kraft paper, or cheesecloth, depending on how formal or casual your wedding is, to give your reception tables more dimension.

8. **Photos:** Decorate with images of you two, from projecting a slideshow to displaying printed photos on a fun display.

9. **Wood crates:** Distress or paint craft-store crates and use them to hold programs, flowers, or favors.

10. **Ribbons:** Cut long strands of different types (and tie them to an arch-like structure) to create a stunning, fluttery ceremony backdrop or tie them around each of your favors.

the wedding dress

Many women look forward to wedding gown (or suit) shopping—and have been dreaming of it well before they even met their beloved! There can be a whole lot of hope riding on one white outfit that you're going to wear for only one (amazing) day. Naturally, you might get a little nervous: Will you find *the* dress? Will you feel the way you expected to while wearing your wedding attire? Or, maybe, you're *so* not the shopping type and the thought of trying on fancy outfits for hours sounds awful. However you're approaching this process, rest assured you'll make it through with the right wedding attire for your day.

Top Planning Tips

1. Consider your venue, the time of year, and other logistics: A long-sleeve silk gown is not going to work at the beach, nor will a boho-chic strappy number fly in church.

2. Don't limit yourself to gowns if you're not the formal dress–wearing type. White or ivory separates—like a top and skirt, a white suit, or even a jumpsuit—may be more your style.

3. Once ordered, a designer gown could take at least six months to make. Then, you'll need to budget time for at least one set of alterations (roughly a month each round). If you're short on time, consider buying a dress off-the-rack at a sample sale or from a retailer like Lovely Bride, which may have a quicker timeline.

4. Tailoring your dress will be pricey: Just hemming your gown could be at least $300. Be sure to include alterations in your budget.

5. Don't feel pressured to buy all of your wedding accessories with your gown if you're still deciding on your veil or headpiece.

find out more on lover.ly
For beautiful dresses that add a unique spin to your bridal look, check out Loverly's collection of wedding dresses at shop.lover.ly/collections/all.

Before You Begin

By now, you've probably found a few gowns or styles you love. (If not, start there!) Once you have some favorites, go ahead and research the designers who've made your top choices to check out their price points. You're right, this doesn't sound like fun at all. But it's far better to know in advance if you can afford your dream dress *before* you go try it on rather than get sticker shock while you're actually wearing the gown, which you've fallen completely in love with already.

♥ **TREND ALERT** Suits, two-pieces, and shorter dresses (from cocktail to tea-length) are becoming increasingly popular, as is donning a wedding gown that's not even—gasp!—white. Follow your heart, and your fashion sense, to choose the style that speaks to you.

to-dos

- Research styles, designers, and price points.

- Pull together images of your favorite outfits to bring with you while shopping.

- Make appointments at bridal salons to try on gowns.

- Evaluate potential gowns based on how you feel in them and if they'd fit your wedding style.

- Buy your attire!

- Buy accessories: veil, headpiece, undergarments, shoes, belt/sash, etc.

- Try on your gown to start the alterations process (bring your shoes and undergarments).

- Attend your next fitting and request further alterations if needed.

- Pick up your dress at least a week before your wedding (make sure it has been pressed well—no wrinkles allowed!).

- Rock your wedding finery with pride!

Dress Shopping 101

Searching for your wedding dress is a once-in-a-lifetime experience. To make it the best it can be, first gather your inspiration. Be sure to take photos with you to the bridal salon—or bring a smartphone or tablet with digital photos—to guide the salesperson in the right direction. Be firm on your budget, and ask the salon associate to stick to it.

Next, choose your shopping tribe—a handful (five or fewer is best) trusted family members and friends. Bring who you think will give you honest feedback yet encourage you to choose the dress *you* love. This should be a positive experience, not an excursion for big personalities or the sublimely over-opinionated.

When you go to your appointments, don't worry about having shoes or undergarments just yet (although it might be smart to wear nude underwear and a strapless bra)—the salon will provide you with anything you need. Take your time trying on gowns (and even various accessories) focusing on how you feel in each one— some indicators that you've found a good one are when you feel beautiful, confident, and comfortable.

It's okay if you don't have a "*this* is my dress" moment. More than likely, you're just choosing a gown you love without having a life-altering experience. (And with all the pressure and anticipation surrounding this shopping trip, it's natural to second-guess yourself a little bit.)

Another part of your attire shopping is finding your accessories: your veil (and/or headpiece), your shoes, and any other add-ons, like a belt or sash and jewelry. Check out what each salon you visit offers, then take a look at some popular stores and websites (like BHLDN, Etsy, Nordstrom, and J.Crew) for additional options. You may also want to ask family members about heirlooms or accessories you can borrow instead of purchasing items anew.

♥ REAL COUPLES SPEAK

"Like wedding dresses, bridal accessories are pretty pricey. Fortunately, we discovered that JoAnn Fabrics sells bridal veils for a fraction of the cost—just $15 to $20 for one. We didn't have to pay $250 for a veil, and it totally worked out because no one ever knew the difference!" —Bethany and Don

A Glossary of Terms (for Veil Types, Fabrics, Colors, etc.)

As you visit bridal salons or start looking at gowns online, here are some terms that might keep coming up—and what they actually mean.

Blusher: Single layer of tulle attached to veil that folds over your face when you're walking down the aisle and is then flipped back

Bolero: Cropped, open-front jacket

Bustle: Means of gathering up your gown's train so it attaches to the back and falls in line to create a floor-skimming hem all the way around

Chantilly: Fine mesh lace used for detailing

Champagne: Beige-like gown color that can have pink undertones or gray-yellow undertones

Charmeuse: Lightweight, luminous fabric that feels like satin

Chiffon: Delicate fabric made from silk or rayon, popular for overskirts and sheer sleeves

Diamond white: Softer than pure white and can be more of a light ivory depending on the designer (also called natural or silk white)

Duchesse satin: Lightweight fabric blend of silk and rayon (or polyester) that looks like satin

Ivory: Creamier in color than diamond white and can have a slightly yellow undertone (also known as eggshell)

Ruching: Gathering or pleating in fabric; typically seen on bodices at the waistline

Sample sale: Store or designer events where last season's gowns are sold as-is and heavily discounted; some stores offer sample dresses for purchase year-round

Silk: Most expensive and coveted wedding gown fabric; several textures and types are available

Tulle: Netting seen on ballerina tutus that you'll find used for gown skirts and veils

SHAPES, LENGTHS, AND SILHOUETTES

Get familiar with some of the more common cuts and shapes for gowns and veils so you can choose the best ones for both your celebration and your body type.

necklines

HALTER

Deep V that secures at the base of your neck; good for broad shoulders

V-NECKLINE

Elongates the neck; provides coverage for large chests

SQUARE

Typical on capped sleeved gowns; ideal for petites

SWEETHEART

Soft V-shape; flattering for small chests

QUEEN ANNE

Combination of sweetheart and halter; helps elongate petites

ILLUSION

Can be sweetheart or square; provides more coverage

STRAPLESS

Shows off neck and collarbone; not for small chests

silhouettes

BALL GOWN

Think of the typical
princess dress with
a fitted bodice and a
full skirt. Flattering on
most shapes, but can
overwhelm petites.

A-LINE

Fitted bodice then flows
gently out like an upper-
case "A" and is flattering
on all body types. (A mod-
ified A-line stays close to
the body through the hips,
then gradually flares out.)

TRUMPET

Fitted to the body until
flaring mid-thigh;
accentuates stomach
and hips

silhouettes

MERMAID

Fitted from chest to knee, then flares out to the hem; best for slender and hourglass body types

SHEATH

Fitted to the body completely; best for slender and hourglass body types

TEA-LENGTH

A-line or ball-gown shape with a skirt that hits between the ankle and knee; works on all body types

veil lengths

BIRDCAGE

Short, retro veil
covering just the face

ELBOW

Hits at the elbow;
can be a less formal

FINGERTIP

Hits down at the fingertips;
most popular veil choice

CHAPEL

Hits at the bottom of
your gown; more
formal option

CATHEDRAL

Most formal veil;
usually hits at the end
of your gown's train

hair and makeup

Your wedding day beauty routine is really the icing on the cake of your wedding day look. Just as you wouldn't wear a full face of makeup and an elaborate up-do when you're hanging out in a T-shirt and jeans, you wouldn't go sans-makeup and pull your hair into a ponytail when you're donning a wedding gown. So, more than likely, you'll hire a professional (or two) to get you all glammed up for the big day.

Top Planning Tips

1. Determine your ideal bridal look by finding photos of hair and makeup styles you love (keeping how formal your wedding will be, your dress, and your personal style in mind).

2. Do one or two trials before you choose a pro: Makeup artists and hair stylists will offer discounted rates so you can do a trial run of your bridal look and decide who you want to work with.

3. You may want all of your bridesmaids, your mom, and your mom-in-law-to-be get their makeup/hair done—know that this will likely extend their man-hours. Ask your stylist how much time will be needed for each person.

4. DIY: You may want a very simple bridal look and feel that you can just do it yourself. While you can choose to DIY to save money, keep in mind that the pros know all the tricks—especially concerning what looks photograph the best.

5. Prep work: If you want to grow your hair out or begin a special skin-care regime to make sure your skin has a healthy glow on the big day, start doing this ASAP.

Before You Begin

Ask your photographer for recommendations. They will have worked with various hair and makeup pros at weddings and professional shoots, so they should have a contact list of reliable and talented people. You should also ask family members and friends who have recently gotten married for their recommendations, especially if you attended their nuptials and loved their look. Start with these recommendations first to meet them and schedule trials with those you gel with.

♡ **ETIQUETTE ADVICE** If you're requiring your maids to get hair and makeup professionally done, you should consider footing the bill—especially if they're already shelling out dough for a dress and shoes.

to-dos

- Gather images of hair and makeup looks you love.

- Get recommendations from your photographer, as well as recently married brides.

- Meet hair and makeup professionals.

- Schedule trials.

- Choose your pro(s) based on how the trials went (and make a deposit to lock down your wedding date, if applicable).

- Prepare your hair and skin as needed.

- Figure out day-of logistics for who needs hair/makeup and create a timeline, including whether or not the pros will be coming to you on the big day or if you and your bridal party will be required to go to the salon. If it's the latter, then work in the extra time you'll need to travel back and forth into your schedule.

- Make everyone getting beautified aware of the timeline.

- Get gorgeous on your big day!

the wedding suit

A fabulous suit, an English tux, a well-pressed uniform, a family tradition such as a kilt—whatever direction you choose, finding your perfect wedding suit is every bit as important as a wedding dress. This is your chance to show off your personal style and wear a great outfit that not only reflects who you are, but also makes you look and feel your best. You will have a number of considerations: how formal your suit will be, the color, the cut, and, of course, the accessories.

Top Planning Tips

1. Determine if renting or buying is best for you: If you've always wanted a custom-made suit, for example, this is a great time to get one. If your attendants are scattered all over the country and you want everyone to match (including you!), renting is ideal.

2. If you have pre-wedding weight-loss or bulk-up goals, wait to get fitted for a suit as long as you can to avoid multiple rounds of tailoring.

3. Even if you rent your suit/tux, consider getting a custom-made shirt: It will fit you perfectly, and you'll likely take off your jacket during your reception anyway.

4. Be comfortable. This may sound impossible when you're wearing a so-called monkey suit, but if you work with a tailor, you can ensure that you have the right fit. (More on this on page 130.)

5. The shopping-averse may like buying online: Retailers like Zappos, Nordstrom, and Amazon offer free return shipping, which means you can purchase a number of options for your shirt, shoes, and tie with the click of a button, try them on at your convenience at home, and then send back what you don't need.

Before You Begin

Check out some attire inspiration, using your partner's outfit as a guide. If your partner is wearing a dress, consider its shape, size, and color when making your choices in possible suit or tuxedo styles. Then, look for images that feature that type of gown alongside various suits. This will help give you both an idea of what pairings appeal to you, allowing you to narrow down options before hitting the stores.

♥ "Weddings are a chance for both brides and grooms to strut their stuff. If you're like many grooms, then this is one of the few times that you'll get dressed to the nines and party in style, so don't be scared to incorporate—or even mix—patterns and textures. From linen to tweed, stripes to polka dots to paisley, there are many more options than traditional wool and solid colors." – *Kellee*

to-dos

- Determine what you want to wear and if you're renting or buying.

- Try on various options (colors and styles), and pick your attire.

- Get fitted for your attire.

- Try on your attire, and get additional tailoring as needed.

- Buy/rent shoes, tie, vest, cummerbund, pocket square as needed.

- Try everything on as a trial run.

- Get your suit pressed (if applicable/needed).

- Look dashing on the big day!

- Return rented suit/tux post-wedding (if applicable).

IT'S ALL IN THE FIT

You want to look your best on your wedding day, and one of the ways you can do that is by making sure that your suit fits you perfectly. Your tailor will guide you in finding the right fit, but it may be helpful to know the following rules of thumb for suits:

Your jacket should lie flat on your shoulders and the buttons in the front should close without straining or wrinkling. The jacket's hem should land at the middle of your hand when your arms are relaxed by your sides and the jacket's sleeve should end a half inch above your shirtsleeve.

Your pants should lie flat over your bum without wrinkles or bunching and break subtly at your shoe.

Bringing It All Together

Renting or buying a suit for your wedding sounds like a simple process, but there are perhaps just as many options and considerations for suits and tuxes as there are for dresses. (Okay, maybe not *quite* as many.)

First, there's the style: If you're having a formal wedding, you'll likely want to go with a classic tux (tails optional). If you're having a semiformal affair, you'll probably wear a suit, but then what type? Two-button jacket or three-button? Single-breasted or double? Wool, linen, or tweed? Consider these options and choose the best fit depending on the time of year, time of day, and your preferred style of choice.

Then, there's color: Many are veering away from basic black to wear blue, beige, or a shade of gray, especially for less formal weddings. Your accessories come into play here, too: You can pair a navy suit with a green tie, or a gray suit with a pink pocket square—anything goes! (Though, usually you'll want to coordinate with the wedding colors, if applicable.) That said, if you're not feeling a color, you simply cannot go

wrong with a black suit with a white shirt and black tie. This is a look that *never* goes out of style!

Finally, another consideration is if you want to incorporate any traditional or cultural attire. Scottish grooms may want to wear kilts on their wedding day, for example. And Jewish grooms usually don yarmulkes. Your heritage (or your partner's) may include some specific wedding attire you never even knew about! Have fun, do research, and ask your family questions. Depending on how important your heritage is to you (or your family) and where you're planning to wed, these elements may come into play.

to sum up . . .

Use this table to record the wedding elements described in this chapter as you tackle (and complete!) them.

Item Requiring Attention	Your Decisions Thus Far
OFFICIANT	*Reverend Michaelson*
OFFICIANT	
PHOTOGRAPHY	
FLOWERS AND DECORATION	
WEDDING DRESS	
HAIR AND MAKEUP	
GROOM'S ATTIRE	

Notes and Reminders

Call to discuss vows

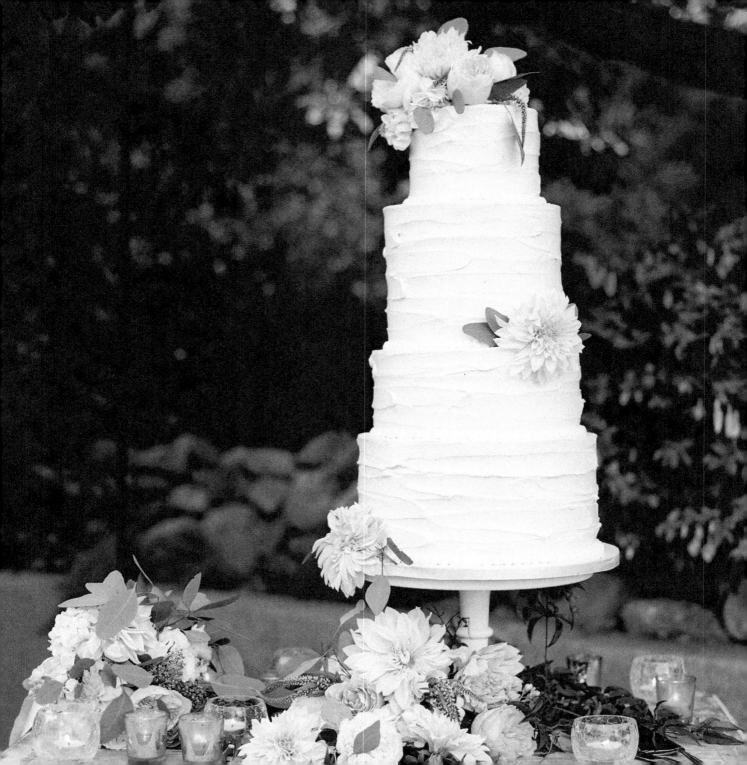

chapter six

additional vendors and big-ticket items

6 TO 8 MONTHS OUT

As your wedding date gets closer, you might be feeling a bit overwhelmed about all there is still left to do. Take a deep breath, because now's the time you get to listen to potential bands and DJs, as well as taste some mouthwatering food—and cake!—options so you can decide how you're entertaining your guests and what you're serving them at your reception. Even the groom will agree this is the best part of the planning process, so get ready to enjoy it together.

the videographer

The one thing that almost everyone will tell you about your wedding day—that it goes by so incredibly fast—is absolutely true. So, if you have room in your budget, consider having a videographer on hand to capture live moments from your day. You will not regret shelling out the extra cash when you get the video back and realize that you have the chance to relive your wedding day anytime you please, as well as see some of the moments you might have actually missed during the event. Can't afford a videographer? See if a friend can film your ceremony and speeches.

Top planning tips

1. Ask each pro you consider if you can see an entire edited recording from a wedding they have done so you can get a sense of their style and abilities.

2. Be clear on elements you don't want in your video, such as the videographer prompting guests to say a few words for the camera (most people don't like being put on the spot) or video manipulation like slow-motion and color filters on the final product.

3. Go the semi-DIY route: Companies like Cameo offer rented cameras for guests to capture images and video of your wedding. You'll send footage back to the company and then receive an edited video.

4. Find out what your potential pro shoots with: Will your video be in HD? What kind of camera do they use? Will the footage be shot on a handheld unit or is there a steadicam to use as well?

5. Consider ceremony-only coverage if you're on a budget. Yes, getting dance floor video would be fun, but what you'll really want on film for years to come is a record of you getting married.

Before You Begin

Talk with your photographer to get referrals before looking up video vendors on your own. More often than not, your photographer has worked with a number of videographers before and can point you to someone they enjoy collaborating with. The photographer/videographer relationship should be such that both professionals can work together without sacrificing their own camera angles and abilities to capture your day. If your photographer and your videographer butt heads, the final product may be affected by a not-so-great working relationship.

TREND ALERT Some companies now offer drone videography through which a remote-controlled camera captures your day from a birds-eye-view perspective—an angle that most couples have never been able to see when working with traditional video pros.

to-dos

- Meet with videographers your photographer suggests.

- View and evaluate their work.

- Decide on a pro at least six months in advance.

- Go over the contract carefully for clauses about how many shooting hours you get, the video format you'll receive, and if you'll be able to give feedback on edits before getting the final product.

- Talk logistics regarding where your videographer will shoot from during key wedding moments.

- Connect your photographer and videographer so they can coordinate shooting your celebration.

- Explain any dos and don'ts your videographer needs to know beforehand.

music and dj

Your wedding entertainment is a major component that can define your celebration, from the type of music you play to the person (or people) playing it. You might hire a string quartet for an elegant, classical vibe for your ceremony, then kick things up a notch with a dance party DJ at your reception. Or, you might choose a specialty group that plays a specific kind of music you two really enjoy, from an AC/DC cover band to a jazz ensemble. Let your personalities and your ideal wedding dreams lead the way.

Top Planning Tips

1. Listen in person to potential bands or DJs to get a sense of their styles. Ask about gigs they're playing around town or venues they're spinning at and request entry so you can consider them for your celebration.

2. Ask about bundling: Some musicians and DJs may offer special rates if you hire them for both the ceremony and reception, and they might even have other services, like uplighting or photo-booth rentals, which you can bundle to help save money.

3. Short on cash? The guitar player at the local coffee house might play well enough to contribute a few tunes to your ceremony and could be hired for a nominal fee.

4. Spend time on your play and do-not-play lists. If there are certain songs you must have at your wedding (and songs you really don't want to hear), make a note of them and share this info with your music vendor.

5. Don't overthink your down-the-aisle music. Choose something meaningful to you or something classic if you can't decide.

Before You Begin

Decide on whether you want to hire a DJ or a band. Usually, this is a fairly easy choice you may have already made inadvertently. Music is either very important to you and you've budgeted out the (often) thousands of dollars you need to hire live musicians, or you've chosen to spend money elsewhere (or had no idea bands were so pricey) and plan to hire a DJ. There's no wrong way to go here: No matter what, your guests will dance (if that's part of the festivities) and have a blast listening to the entertainment you hire.

PLAN AHEAD If you choose to DIY your music with a Spotify playlist, an iPhone, and speakers, designate someone responsible to be your wedding's music manager. That way, if the tunes suddenly stop (or don't suit the vibe), this person will get the party back on track.

to-dos

- Determine what kind of music you want (live? recorded?) and when.

- Go see professional musicians play live to help you decide whom to hire.

- Choose your music vendor(s) and read over the contract to be sure you're clear on setup times, sound checks, how long they're hired for, and whether or not they will attend your rehearsal.

- Decide on your music for key moments: processional, recessional, first dance, any other special dances, cake-cutting, last dance.

- Put together must-play and do-not-play lists.

- Practice your first dance to the song you chose, if you're rhythmically challenged.

- Get ready to hit that dance floor!

food and drink

Many guests look forward to the food and drink they will be served at a wedding. Whether it's a sit-down dinner or simply cake and champagne, you should provide some type of refreshments for your guests. Of course, determining how and what to serve isn't an easy decision since there are so many acceptable formats and ideas that fit every budget. Luckily, you've already hired a caterer to guide you through this process. This section will help you come up with some ideas and go over important to-dos so that you can make your conversations with your food pro super-productive.

Top Planning Tips

1. Even if you're a foodie, you may not want to serve raw meat, exotic sushi, or anything unpasteurized. You want every dish to be appetizing to most guests, and you definitely don't want anyone getting sick.

2. Ask the caterer to create a food option for kids, if applicable, like chicken nuggets and fruit salad, which would appeal to even the pickiest of palates.

3. Be mindful of vegetarians, and be sure to also ask your guests if they have any food allergies or other requirements (kosher, vegan, lactose intolerant, etc.) on your RSVPs for the reception. Ask your caterer well in advance if they can handle special food requests, and if they can't, look into making separate arrangements for these meals.

4. Talk about presentation: Your caterer might have some fun ideas about how to dress up your meal with creative garnishes or unique touches to give every plate extra personality.

5. Print out menus: Your loved ones will want to know what they're about to be served. Plus, menus can even double as place cards if you write guests' names at the top and put one at each place setting.

Before You Begin

First, determine what meal you want to serve—breakfast, brunch, lunch, or dinner—depending on the time of day you're getting married. Then, consider the format for your meal as it fits with the vibe of your celebration. A sit-down dinner takes longer from start to finish than a buffet, for example. (If you're hoping to get the party hopping ASAP, opt for the latter.) Finally, consider budget: A buffet isn't necessarily cheaper than a plated meal, since caterers have to account for people going for seconds and usually offer more food to account for that.

ETIQUETTE ADVICE Without exception, you need to feed your catering staff—and your other vendors and wedding staff—during your reception. Caterers typically offer discounted meals you can add to your tab.

to-dos

- Brainstorm menu ideas, using your caterer's offerings and past events as your inspiration.

- Determine what type of cuisine(s) you want to serve and in what format you'd like to serve your meal.

- Work with your caterer to hone your menu, scheduling a second tasting if needed.

- Finalize the menu by the deadline your caterer sets.

- Buy alcohol (if applicable), and coordinate delivery to venue.

- Remind your caterer about any food allergies/special requests from guests and let them know where those people will be seated.

- Order or print menus (if applicable).

- Dig in at your wedding and enjoy!

Menus and Service

Deciding what food to serve, when you have basically limitless choices, is not easy. Luckily, there are a few guidelines and tried-and-true ideas that can get you started.

First, you'll want to choose local, in-season ingredients for the best flavors and prices, which may help narrow down your options.

Second, you should choose foods that you like to eat. Even if you're having a black-tie, sit-down wedding, and you love hamburgers, you should serve them. (Seriously—there are elegant restaurants that serve fancy Kobe beef burgers and gourmet fixings.) The worst thing ever would be sitting down at your wedding and not truly wanting what's on your plate. It's your day—you should eat what you enjoy!

If you're still stuck on what to serve, you might consider incorporating cultural or family recipes into your menu. Maybe your mom makes a mean mac and cheese or you'd like to honor your Turkish heritage by serving a meze (a Middle Eastern version of tapas). Your caterer should be open to your suggestions, especially if they are meaningful to you.

The other component to your food is who will be serving it, and how. The three most common options are sit-down, family-style, and buffet. All of them are great—they really just depend on how long you want the meal to last, how many food options you want to provide, how formal your wedding is, and your budget. Typically, for a sit-down meal, your caterer will dedicate one server per 15 to 18 guests to ensure everyone is served together. For buffet, you need fewer staff members, but more tables and linens, as well as chafing dish rentals.

There are no hard-and-fast guidelines about what options are universally "better"—since every wedding is unique— so it's important to go over the possibilities with your caterer.

Budget-Friendly Options

If you're tight on cash, consider these budget-friendly options for each aspect of your food and drink.

Cocktail hour: When it comes to before-reception fare, passed appetizers can sometimes be more convenient and budget-conscious than stations, which can have long lines and require you to rent additional tables, linens, plates, and silverware. That said, if you want people happily fed with no frills, go with a few big tables bearing a cheese, fruit, and bread spread that guests can nibble on—no extra dishes necessary.

The bar: To cut down on costs (and too much rowdiness), consider hosting beer and wine only, as opposed to a full bar. If you want to have a little booze, include one or two specialty cocktails—fun names are always appreciated—that reflect your personalities.

The meal: Serving breakfast or brunch is usually the most affordable wedding meal option, as is offering only appetizers and dessert. But if you want to host dinner, you can still do so on a budget. Family-style can be less expensive than plated (you don't have to hire as many servers), and buffets can be less expensive than family-style (fewer additional rentals). Just be aware that adding more rentals can cause buffet costs to go up.

Other options would be to have a cookout, or a barbeque-style meal. This approach can work great for a less formal affair and would still be tasty. You could even hire a food truck to serve dinner, which is a fun, trendy way to save money without looking like you're trying to.

Finally, you might consider having a potluck-style wedding where guests each bring a dish instead of gifts. Coordinating this could be tricky (depending on how many guests you have and where they're traveling from), and etiquette experts are still split on this idea, but if you're having a smaller, laid-back wedding and most guests are local, it could be awesome.

the wedding cake

While we still refer to wedding desserts as "cake," today there are so many more options than your standard, tiered confection. Couples might go the classic route with a towering treat, or mix things up by choosing cake pops, cupcakes, cookies, donuts, ice cream, pie, or some combination of these sugary delights instead. Figuring out what you want is the best part, of course, because you have to sample all potential options—maybe even more than once to be sure!—before deciding what delicious dessert you'll serve.

Top Planning Tips

1. Don't feel pressure to go over-the-top with a trendy dessert bar if you just want to cut your traditional wedding cake and eat it, too. It's a ritual for a reason, right?

2. Determine what's feasible: A gorgeously decorated, buttercream-frosted cake, for example, will soon become a puddle at an outdoor summer wedding.

3. Go for nostalgia: Find inspiration in desserts you loved as a kid or treats that remind you of your relationship. For example, if you went for frozen yogurt on your first date, you might consider having an ice cream sundae bar as a nod to your sweet beginning.

4. Offer variety: If you have the means, you might appeal to more than one type of sweet tooth by giving guests chocolate and vanilla options, or serve something rich as well as something light or fruity.

5. Be mindful of food allergies: If you have a handful of gluten-free guests, for example, offer a small selection of macarons or another wheat-free treat. If your guests have severe allergies, you may need to talk to your caterer about other ways to accommodate their needs.

Before You Begin

Plan out your food menu before tackling dessert: If you're having a heavy, four-course dinner, a dense chocolate cake right after might be a bit too much for guests to enjoy. Consider ingredients and flavors, too. Work with your caterer (and dessert maker, if that's a separate person/company) about how your sweets can complement your meal. Taking this step will make sure that everyone's palates will be excited and ready for the dessert course.

PLAN AHEAD If you want to save the top of your cake (or piece of dessert) for yourselves, tell your caterer and day-of coordinator in advance so they can be sure to set it aside, so it doesn't get mistakenly served.

to-dos

- Brainstorm dessert ideas.
- Eat tons of desserts to sample vendors' offerings. (This is the fun part!)
- Choose a vendor, carefully reading the contract or invoice about when dessert drop-off will happen (if applicable) so you can tell your caterer.
- Communicate any décor, color, flavor, or style desires to your dessert vendor.
- Tell dessert vendor your final guest count, and adjust your order accordingly.
- Enjoy your wedding sweets!

transportation

Getting you and your guests to and from your wedding can feel like a big logistical puzzle. You may even be thinking, *Wait, I have to provide transportation, too?* Like many aspects of weddings today, shuttling your guests to your celebration has become somewhat expected. (But that's not to say it must be done—see "Before You Begin" to determine your needs.) Like any other wedding decision, what you choose for transportation can reflect your celebration's vibe, if desired, and requires a bit of forethought so you can have total peace of mind on the day of.

Top Planning Tips

1. Ask your transportation company if there are smartphone docks in its shuttles. If so, you can designate a friend to play DJ to and from the wedding, making the ride part of the celebration.

2. If you're into cars, use your getaway vehicle as a way to cash in on a bucket list item: Maybe you've always wanted to ride in a '57 Corvette or a Hummer limo—if so, now is the time to do it!

3. If you definitely want to have a decked-out and decorated getaway car at the end of the night, check with companies before booking to make sure they'll allow it.

4. Pad your schedule in case of traffic or a late driver, and check with your transport company to ensure they're not running a too-tight schedule (which could happen if they book multiple clients in one night).

5. If there are no cool shuttle options available to you (like retro school buses or old-time trolleys), try not to sweat it too much. Your guests will be pleased and grateful for any transportation options you offer, retro school bus or otherwise.

Before You Begin

Evaluate your transportation needs, if any. If you're having your wedding at a hotel at which most guests (and you!) are staying, you can skip this section. However, if most of your guests are flying in and your venue is a solid 45 minutes from the accommodations, you should consider offering shuttles. Using a ballpark figure of how many guests you expect, research what type of vehicle you'll need for guests (a smaller van versus a large bus) and what you might need for you, your bridal party, and others who need to be at the wedding early, if applicable.

♥ **PLAN AHEAD** If you're planning on a rowdier celebration, stock the shuttle with bottled water for guests to sip on the way back from the reception—especially if you want everyone to attend a brunch the next morning!

to-dos

- Determine your transportation needs.
- Contact transportation companies for rates and information.
- Check out vehicles in person (shuttles, limos, vintage cars) before you book.
- Sign contracts, and be clear on details like hourly rates, minimums, and wait-time fees.
- Create a schedule of who needs to be picked up, where, and when.
- Confirm all pickups and drop-offs with the company.
- Give the company your wedding planner or coordinator's phone number, as well as a couple of points of contact for the day of (like the honor attendants and a parent).

Transportation for You, the Wedding Party, and Immediate Family

There are two types of transportation to figure out: transportation for you, the wedding party, and immediate family, and then transportation for your guests.

First, let's cover you and your VIP crew: Loosely map out who needs to go where at what time. This will help you start creating your wedding timeline, as well as get the ball rolling on the day-of logistics.

Typically, you will each arrive to the ceremony venue separately with your respective attendants. However, one logistical piece that might change this is whether you're going to do a first look or if you'll see each other for the first time at the ceremony. If you plan to do a first look before heading over to the ceremony site, you two can actually travel *together* to the venue with your wedding parties, which might save you from having to figure out two different modes of transportation to get you there. (If you're getting your first look at the venue, then you'll still need to travel separately.)

If you're taking family photos before the ceremony, you may need separate transportation to pick up and drop off your relatives, depending on the type of vehicle you want to rent and where everyone is staying. Or you can ask the company to make multiple trips if you're paying by the hour and have a minimum to meet.

After the wedding, it's a bit easier: You two might take your own getaway car, and your VIP crew will likely get on the guest shuttles (more on this in the next section), or you will forgo your own separate car and take the shuttle, too. If you're having an after-party, the latter is a good option, plus it allows you to hang with your guests a little longer.

Transportation for Guests

Getting your guests to and from the festivities is pretty simple: You just need to get everyone there on time, of course!

If your ceremony and reception are in the same venue, shuttling is really easy. You'll designate a pickup time and location for any guests staying at another hotel; they

will hop on the shuttle and end up at your wedding. If your guest accommodations are close to your venue(s), you may be able to ask your shuttle to make multiple trips instead of having to potentially rent more vehicles to accommodate a large party. (However, the first shuttle of guests should arrive no earlier than 45 minutes before showtime to keep people from getting too antsy.)

Usually, if your ceremony is separate from your reception, guests are responsible to get themselves to the vows, and you are responsible for getting them to and from the party safely. But, depending on your time minimums and the company you choose, it could be just as cost-effective to do both.

If you have elderly guests, it may even be necessary to provide transport *at* the venue. If the property is large, or there is a big hill leading from the drop-off location to the ceremony site, consider renting a golf cart to help older folks (and anyone with mobility issues) arrive safely and swiftly.

Whatever you do, make sure you clearly display transportation information on your website and consider even putting it in with the invitation and welcome bags (if applicable) so everyone is aware of the details. If transportation is simply not part of the budget, provide local taxi (or Uber) information for guests instead so they know not to expect a drop-off and pickup.

wedding rings

Picking out your wedding bands is an extremely exciting—and romantic—part of the pre-nuptials process. Set aside a couple of hours to head to a local jewelry store and try on as many styles as you can: Rings come in a variety of metals and materials (even wood), band widths and thicknesses, with gemstones or without. (Some couples even go a different route and get ring tattoos!) And since you'll be wearing yours for many, many years, it's worth spending some extra time to get what you want.

Top Planning Tips

1. Don't eat salty foods before you get fitted for rings. Yes, water retention can make your fingers swell.

2. If you're really active, you may want to get secondary rubber rings (available online) that you can wear while playing sports, hiking, and so on, so you don't lose or ruin the real ones.

3. You may opt to order rings online through a company like Blue Nile or on Etsy. But visit a jewelry store first to get your fingers fitted. You don't want to guess your ring size, especially if you choose a ring design that makes resizing difficult or impossible.

4. After you pick up your rings and put them somewhere safe, set a phone alert reminding you where they are. It might sound like overkill, but as the days tick down, you'll have so much on your mind that you'll be glad you did this!

5. Before your ceremony, you may opt to rub a bit of lotion on your hands—especially if it's a hot day—to ensure your rings will go on smoothly while you say "I do."

Before You Begin

Consider your lifestyles before choosing your rings. Certain metals (like titanium) are stronger than others and some (like white gold) scratch easily. When it comes to bling, a pavé ring with diamonds all the way around can be stunning, but it's not the best option if you work with your hands a lot—you don't want to be scared of wearing your wedding ring because the stones might pop out. You want to pick ones that work for you on a daily basis—and will last with minimal upkeep.

♥ **PLAN AHEAD** Having your rings engraved can add additional days or weeks to your pickup timeline. Be sure you ask before you request add-ons or upgrades to ensure your bands will be ready for the big day.

to-dos

- Research ring materials and styles.

- Try on rings in person, taking special consideration of how your wedding band will coordinate with your engagement ring (and if any adjustments to your ring need to be made to accommodate your band).

- Decide on and order your rings.

- Pick up your rings and store in a safe place.

- Give rings to your best man to hold (he can give them to the ring bearer/ring bearer's parents right before the ceremony).

wedding party attire

Not only do you get to pick out your own wedding outfits, but it's also your duty to choose what your attendants will wear. Drawing upon your colors, theme, or overall vibe for inspiration, you can decide on dresses and suits that will coordinate with your wedding and make your closest friends look stunning. There are so many options for figuring out attire—no more one-size-fits-every-wedding attendant wardrobe rules these days—so have fun with this task. Maybe even look at this to-do as an unexpected opportunity to play dress-up with your nearest and dearest.

Top Planning Tips

1. For the attendants' outfits, offer a few options from a designer's or store's collection that can flatter different body types. Giving a choice keeps everyone happy.

2. Ultimately it's your decision as to what your attendants wear. You may have a formal affair that requires formal attire, and your pals may not be stoked about long gowns and tuxes. However, they should be respectful of your wishes (just like you should be respectful of their budgets!).

3. To make honor attendants stand out, give them their own special accessory as a gift; for instance, you could give a maid of honor a cool belt or sash, or give a best man a different tie or boutonniere than the other attendants.

4. One way to keep things playful, no matter how formal your wedding is, is to have your attendants wear fun, colorful socks or shoes—these can really pop in photos, too.

5. While parents and grandparents don't need to get coordinated attire to wear, you may want to request that they wear a certain color, or have them match in some small way. For example, dads, uncles, and grandfathers might don a similar tie to the groomsmen.

Before You Begin

Get your own attire finalized first. You'll want your attendants' dresses and suits to complement each of yours, not clash or overshadow them. Once you've chosen a gown and a tux or suit, then you can start looking for styles that will work for your entire party of attendants. Look online for colors and cuts you like, as well as designers and stores that offer items that will work. If you have attendants all over the country, make sure they will be able to get attire where they live—for maids, each designer will list what stores carry their dresses nationwide.

♥ **INSIDER INSIGHT** Your attendant gifts could be something they can wear at your wedding, like a piece of jewelry or a tie. Giving them an item like this helps ease their budgets, too, as there's less for them to buy.

to-dos

- Collect inspiration!

- Ask attendants about their budgets.

- Determine if you're helping attendants pay for attire and how much if so.

- Attend try-on sessions and fittings and coordinate appointments for out-of-town attendants.

- Check to make sure everyone's attire will be tailored to fit them and that the modifications will be completed in time for the wedding.

- Look awesome with your amazingly outfitted attendants on the big day!

- The best man will coordinate returns for rented suits (as will the maid of honor if you rented dresses).

Gorgeous Outfits

Bridesmaids' dresses have come a long way since the so-bad-they're-amazing puffy creations that were popular in the 1980s. While many women may have dreaded having to buy one of these dresses, the days of awful attendant attire are long gone.

Now there are so many gorgeous options out there that your ladies will be more than happy to re-wear what they don at your wedding. Check out designers like Jenny Yoo, as well as Loverly's collaboration with Donna Morgan and Watters for some great options.

The biggest shift in bridesmaid attire isn't just the fact that a number of designers now create amazing styles just for your ladies—the *types* of attire that your girls can wear have expanded from monochromatic dresses to patterned and metallic gowns, separates (including crop tops), suits, and even jumpsuits. The options are endless. And super chic.

Another major change is the idea that everyone needs to wear the same thing: While traditionally, all bridesmaids donned the same dress, there's been a major move toward including different styles and necklines, as well as wearing varying shades of a certain color (or colors!) to create a gorgeous spectrum. Bridesmen and bridesmaids could even mix and match colors with a pattern, like floral, polka dots, or stripes, depending on your wedding vision.

If having your attendants wear different dresses, separates, and suits appeals to you, choose a couple of styles and colors you think would work for your group—and fit your wedding palette and vibe—to keep the look cohesive. Setting some styles in advance also makes things easier for your attendants as they decide between shades and silhouettes. It may also help to assign colors you think will look best on certain people or have them "claim" hues to keep the overall look balanced.

If you decide to ask everyone to choose attire on their own, rather than through a specific designer or by getting all together at a bridal salon, it helps to send visual examples as well as color swatches so everyone is on the same page.

Another trend is to have your attendants show off their personal style with their accessories, shoes, and hairstyles, rather than having everyone wear the same hairstyle and jewelry. Again, it's great to give some guidelines as far as color and style go (especially heel height for shoes), which will make it easier for everyone to know what to shop for and ensure that they coordinate.

One more thing to keep in mind: Try to be mindful of price point when asking maids to shell out money for a dress. You may even consider asking your maids to rent their dresses from a company like Rent the Runway or Union Station, which can be very budget-friendly.

TIPS FOR BUDGET-CONSCIOUS ATTENDANTS

Given the number of weddings people get invited to each year and how many of those also require their participation *in* the celebration, you should be as budget-conscious as possible for your attendants' sakes.

Nearly everyone owns a black suit or dress. Ask attendants to wear what they already have. (Though, know that black fabric might differ from garment to garment.)

Think about asking attendants to wear neutral shoes they already own instead of purchasing a special pair. (Long dresses cover shoes anyway.) You can even decide to ask them to wear whatever they want.

In lieu of gifts for your attendants, you might consider paying a portion of their attire—or for their alterations—instead.

Aside from giving your attendants a break on attire, you might ease their budgets a few other ways: For example, you could ask an a relative of means to throw you a shower if your attendants can't afford to do so, or you could purchase dresses or rent suits for them.

Fine Formalwear

One decision to make is if you want to rent or buy. In some cases, suit rental—when you include vests, cummerbunds, ties, and other add-ons—can cost as much as $200. Depending on how you and your buddies feel about it, you could ask everyone to purchase, for example, the same black suit.

Another decision is what you actually want them to wear. Standard suits in black, gray, cream, or navy always look sharp and, for black tie, a tux is the norm. But, depending on your personality and where you're getting married, you may want to switch things up. This can vary from seersucker suits, khakis with dark-blue blazers, or even board shorts, if you're having a very casual celebration. Don't settle for what you might consider boring formalwear if that doesn't speak to you or to what you want the feeling of your wedding to be.

Then, you'll want to choose accessories. Traditionally, they'll wear solid-colored ties in one of the wedding colors but, again, do what fits your wedding and get as creative as you want to be. As for shoes, you may want everyone to rent the same ones or at least wear the same color shoes in the same sheen (patent leather versus regular, for example).

For groomsmaids, there are no set rules on what to wear. For some women, wearing a matching suit with the men is an attractive option. Other women might prefer to wear a dress that shares similar colors, patterns, or characteristics to the men's suits. As with anything else, go with what feels right to you.

REAL COUPLES SPEAK "Because we didn't want our attendants to spend too much money on our big day, we found great deals on dresses that were on sale at Ann Taylor, and we let our groomsmen wear their own black suits." —Bethany and Don

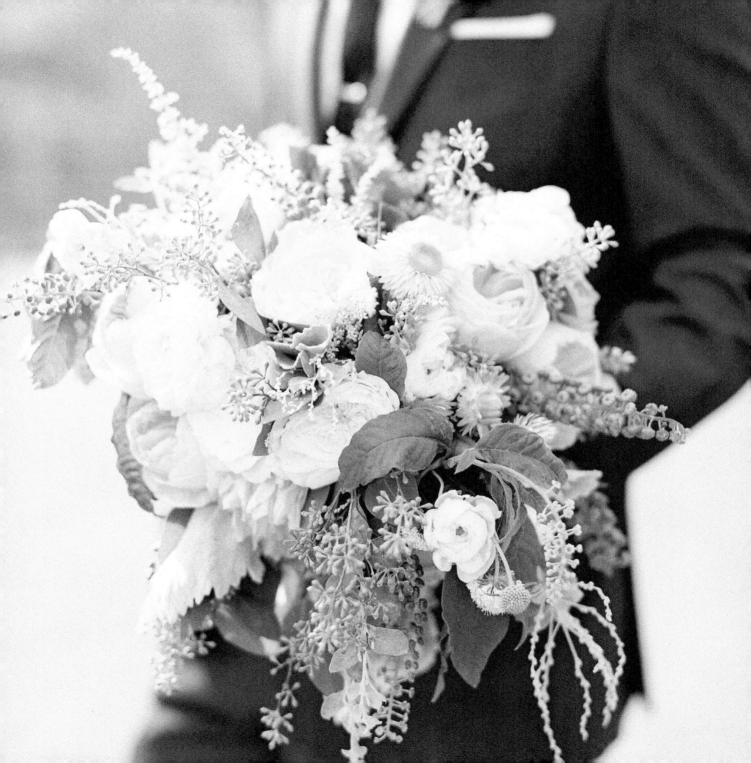

to sum up . . .

Use this table to record the wedding elements described in this chapter as you tackle (and complete) them.

Item Requiring Attention	Your Decisions Thus Far
THE VIDEOGRAPHER	*Still deciding*
THE VIDEOGRAPHER	
MUSIC AND DJ	
FOOD AND DRINK	
THE WEDDING CAKE	
TRANSPORTATION	
WEDDING RINGS	
WEDDING PARTY ATTIRE	

Notes and Reminders

Ask photographer about referrals

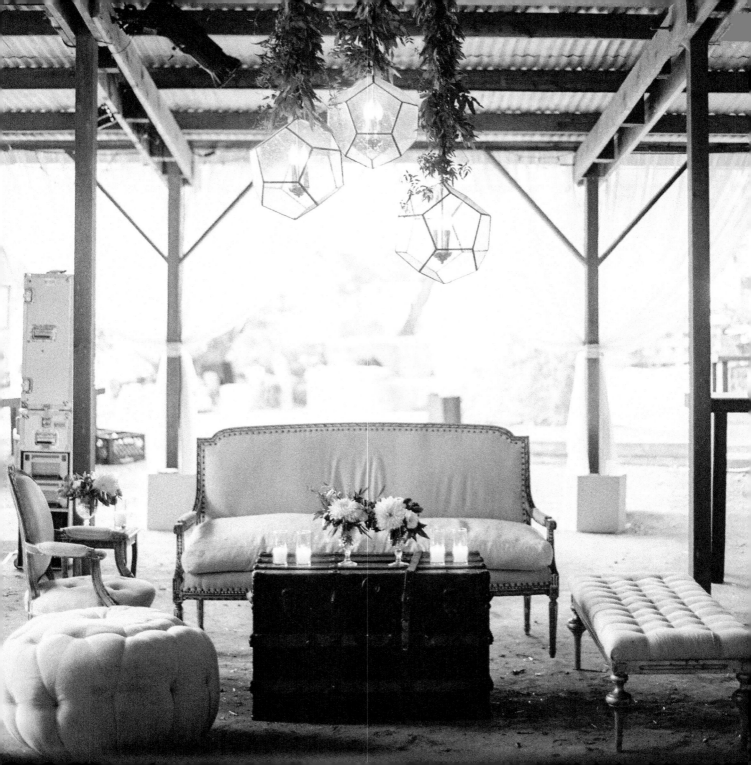

chapter seven

in the
thick of it

4 TO 5 MONTHS OUT

*Y*ou're really entrenched in the planning process now! Luckily, all of the huge decisions are pretty much behind you. At this point, you can even divide and conquer some of your to-dos with your partner so you can tackle them and focus on getting excited—and staying well-rested—for the big day.

At this stage, you're not only planning the wedding, but also handling pre- and post-wedding events, including your rehearsal dinner and honeymoon. There's a lot to look forward to, from actually getting hitched to the first vacation you'll take together as a married couple.

rental equipment

Unless you're getting hitched at a venue that has everything you could possibly need for your ceremony and reception—and everything that matches your desired wedding aesthetic perfectly—chances are you're going to need to coordinate some rentals. Rather than look at this as a daunting task, use it as an opportunity to personalize your event further and add even more style. From table linens to glassware to chairs, all the items that make up your event can reflect—and enhance—your wedding vibe, becoming part of the décor and overall look of your celebration.

Top Planning Tips

1. If you're on a tight budget, it's best to go with a basic package. But if you have some wiggle room, choose a few standout items (like elegant stemware and plates), then go with simpler, more standard options for the rest. This way, your dinner tables still have some fun texture or color without you having to break the bank.

2. Let chairs do double-duty: Rent one set and ask that your catering staff move them from the ceremony to the reception if you can.

3. Check your contract for fees: Rental companies often charge extra for setup and cleanup, as well as damage fees. In some cases, companies may also tack on optional insurance to your bill without being totally forthcoming.

4. If pretty linens are your thing, look for specialty companies, like La Tavola and Wildflower Linen, that exclusively rent tablecloths and napkins.

5. Don't forget the bar: You may need to rent tables, as well as additional glassware. To save money, opt for bottled beer over kegs or consider the trendy option of giving each guest a glass with a custom charm at the beginning of the event, which everyone can refill throughout the day/night.

Before You Begin

Check with your venue about any rental stock on-site that's available for use as part of your overall fee. (There may be tables, chairs, or benches you can use.) If you're having your wedding at a hotel or venue that you know is already fully stocked, ask to take a look at everything it has, from silverware to linens, to make sure everything fits the event style you envision—and is in good condition. Your caterer may also provide rentals for dining-related items, so it's a good idea to check with them as well before putting down a rental deposit.

CHECK AGAIN Some venues have stipulations about when rental items may be dropped off and picked up: Make sure to talk to the person who handles events to get the full scoop on this before you finalize any rentals.

to-dos

- Revisit inspirational images for your ceremony and reception.

- Check with your venue and caterer about what tables, chairs, glassware, etc., comes included.

- Scope out rental companies to see and touch their offerings, as well as compare prices.

- Choose items and put down deposits/sign contracts (after reading carefully!).

- Coordinate rental deliveries and needs with the venue and caterer (after you've set your wedding timeline and menu).

- Talk to your caterer about any items that need to be moved, cleaned, or repurposed during your event.

- Give your rental company your final number of guests by the date requested so you have everything you need on the day of.

games and entertainment

Aside from your musical entertainment, you may be considering additional engaging elements for your wedding day, like a photo booth, a cartoon artist, or lawn games. These extras are by no means necessary or expected: Some couples really just have a passion for a certain activity or maybe even saw something at a friend's wedding that they really loved and would like to have at their own celebration. Here's a handy guide to help you plan the fun and games.

Top Planning Tips

1. Photo booths are very popular these days: You can choose from renting a booth from a company to creating a DIY setup. Guests can take home their photos or add them to your guest book!

2. Let your wedding theme, if you have one, dictate your extra elements: Playing corn hole or horseshoes, for instance, would be a great activity for a backyard BBQ.

3. Think carefully about anything messy: Thumbprint-stamp guest books and even canvases guests can paint are trendy right now, but the logistics of these activities aren't always worth it.

Have emergency cleaning supplies on hand because if people are wearing their finest, you don't want to risk their nice duds getting ruined.

4. Remember that anything extra causes more work for you (and your vendors): Be sure to set all logistics in advance to ensure that fun and games don't become a hassle.

5. If you have a longer cocktail hour (perhaps because you're taking photos during this time), it could be fun to have a couple of games, like Jenga or Connect Four, on cocktail tables for guests to play.

Before You Begin

Think about your games and entertainment wants, then give yourself a reality check on what's feasible for your venue and budget. You may want your wedding to feel like an old-time carnival and dream of renting a Ferris wheel—which would be awesome—but you may also have to rent a generator and pay for additional insurance to pull this off. (Not to mention get your venue to sign off on the idea.) Also consider logistics: How will your games or other items be getting to the venue? Who will monitor them, if needed? Plus, who will clean and pack everything up post-wedding?

TREND ALERT Many couples are asking guests to fill in wedding-themed Mad Libs (a humorous phrasal template word game) in lieu of signing a traditional guest book: You can download wedding-related templates on Etsy or other sites (just Google it!), and print them out. This activity keeps guests occupied and you get some great keepsakes, too.

to-dos

- Check Loverly and other wedding blogs for inspiration on various games and other entertaining elements couples are incorporating into their weddings.

- Decide on the games and entertainment you want and weigh whether they're worth the logistics involved.

- Research vendors, as needed, for add-ons like a photo booth.

- Buy games, if applicable, and store in a labeled box that you (or a designated helper) can later transport to the venue.

- Designate who will set up your extra elements, as well as clean them up and remove them from the venue once the wedding is over.

honeymoon travel arrangements

Your honeymoon is not only one of the most anticipated vacations of your life, it's also the first trip you'll take as a married couple. Whether you plan to go all out with a three-week holiday to Bora-Bora or have the time and funds only for a local long weekend, the time you take together to relax and enjoy being newlyweds will undoubtedly be extra special. But first: You must plan. Like any trip, you'll need to find the best deals possible, but you'll also want to make this one a bit more special than your standard getaway.

Top Planning Tips

1. Think outside the box: Your honeymoon can be anything you want it to be, so feel free to get creative. If you're not the type who likes to lie on a beach or go to a resort—which is what most people think of when they imagine a honeymoon—consider an adventurous backpacking or scuba trip. Like your wedding, this vacation should reflect you.

2. Consider geography: If you have only a week for travel, you may want to stay closer to home so you don't spend significant time on an airplane or in a car.

3. If you can, do something special (maybe even splurge) on a really sweet hotel room, a fancy dinner, or an incredible excursion to make your honeymoon extra memorable.

4. Tell everyone you're on your honeymoon so you can get special upgrades, discounts, and, yes, free champagne!

5. Use your honeymoon as an opportunity to try something new together, whether it's taking a local cuisine cooking class or bungee jumping.

Before You Begin

Decide on timing: Some couples love the idea of taking off the day after their wedding, while others prefer to focus on one thing at a time—plan the wedding first, then tackle the honeymoon a few months later. There's really no right or wrong way to do it. But no matter which route you choose, you'll still want to put something on the books and request any time off from work, if necessary, so you at least have the dates settled. (And so you can officially start looking forward to your getaway!)

PLAN AHEAD While weddings should be about joy, it's important to be frank: Queer and transgender people have to think a little harder about places to travel for their own safety and security. Research LGBT-friendly travel honeymoon spots through websites such as Ilga.org and Thegayweddingguide.co.uk, or find a local LGBT-focused travel agent. Many airlines also offer all-inclusive LGBT-friendly honeymoon packages; look at your preferred carrier's website.

to-dos

- Scan your bucket list and top must-go locales for trip ideas.

- Set a budget and how long you can be gone for.

- Choose the destination, and start booking flights and hotels.

- Make sure your passport is valid (or will be when you travel), and renew if needed.

- Pack in advance to avoid rushing right before your trip.

- Arrange how you're getting to and from the airport, if needed.

- Contact USPS about holding your mail, and make arrangements for pets and plants, as needed.

- Double-check that you have your IDs, passports, cell phones, visas, and any other travel-related necessities packed and ready to go.

wedding accommodations

If your wedding is taking place outside of the city in which you live, you'll need to arrange some kind of accommodations. Even if you're getting hitched just down the street, you still may want to splurge on a hotel stay for the weekend of your wedding. (That way, you're not tempted to wash those dirty dishes in your sink the night before the big day!) Also, depending on how traditional you are, you each may need your own accommodations, especially if you're not planning on seeing each other until the actual ceremony.

Top Planning Tips

1. Save money by bunking up with your siblings or honor attendants the night before the wedding—especially if you and your soon-to-be-spouse want to have separate rooms the night before.

2. Decide if your accommodations will double as where you'll get ready before the wedding—if so, you'll want housekeeping services to come before your photographer arrives to avoid having a messy room in those photos.

3. If you decide to get ready at home, make your abode feel festive with fresh flowers in your wedding colors (and maybe even have a house cleaner come the day before so everything is spick-and-span).

4. If you're staying at a hotel, ask if there are any complimentary upgrades available since you're getting married— most places are more than happy to throw you a freebie or two.

5. Consider accommodations that are separate from where guests are staying so you're not tempted to party into the night with your pals and can avoid getting trapped in conversation at breakfast with relatives when you need to be upstairs getting ready.

Before You Begin

Talk about your ideal pre-wedding sleeping arrangements: Do you want to spend the night before your wedding together or apart? For some, this is a no-brainer and you want to go the traditional route by splitting up. For others, especially those who already live together, are on a tight budget, or just sleep better when together, getting one room works better. Don't worry about superstitions or the way you think things "should" be done—do what *you* want!

PLAN AHEAD If you want to stay at the hotel at which you've blocked rooms, don't forget to make your own reservation—your rooms may book up and leave you without a place to sleep!

to-dos

- Figure out if you're going to stay together or apart the night before your wedding.

- Check out local hotels to see rooms if you're planning on getting ready and being photographed there on your big day.

- Determine the logistics for your wedding night (if you slept apart the night before with friends or siblings), as your night-before roommates may need to switch to new rooms, or you may need to transfer to a wedding suite.

- Book hotel room(s).

- Confirm your reservation the week of and let the hotel know it's your wedding weekend.

- Pack overnight bags for your stay.

rehearsal dinner

Traditionally, the night before the wedding, one set of parents or a beloved family member will host a rehearsal dinner, at which you, your immediate family, and your wedding party will dine and celebrate. However, these days, this event can take many forms: You might be footing the bill for this dinner yourselves, or you may want to include a wider circle of people. The rehearsal can also be a brunch, lunch, bowling, BBQ—just like the actual wedding, you can make the rules for this event. In any case, it is something that you will need to plan, at least in part, in conjunction with the wedding itself. If you have the option of parents paying, consider letting them take over the planning to give yourselves a welcome break.

Top Planning Tips

1. Holding the event at a restaurant, especially if you're planning on serving dinner, might be the easiest route. That way, you need to select only one vendor for the event instead of having to coordinate a venue, catering, and rentals.

2. Make it early. You want to be sure you get enough shut-eye the night before the wedding, so hosting a dinner that starts at 8 p.m. isn't advised.

3. Keep décor minimal: The main event is the wedding, and while it may be tempting to go all-out the night before, too, you definitely don't need to. Some simple flowers might be nice, but they're not necessary.

4. Use the event as a way to incorporate elements you couldn't work into the wedding. Perhaps you really wanted to do an Italian buffet for your reception but logistics didn't work out. Consider hosting your rehearsal fete at a pizzeria or Italian restaurant to make up for it.

5. Have speeches: A great way to incorporate more family members or friends into your celebration is to ask them to give toasts at the rehearsal dinner.

Before You Begin

Determine your scope: Do you want to host an intimate gathering with the traditional rehearsal dinner crew or do you want to hold a welcome party for the entire guest list? (The latter is probably a good idea if you're hosting a destination wedding.) Let your preferences—and your budget—be your guide. Since most people don't expect to be invited to a night-before affair, a smaller event won't be offensive or come off as exclusive.

PLAN AHEAD If you were eyeing those chic short wedding dresses while gown shopping, consider wearing one to your rehearsal dinner. Your night-before soiree is the perfect excuse to don something that's bridal but less formal.

to-dos

- Decide on your guest list and the scope of the event.
- Pick a venue, and book it!
- Send out invites or include a card with your wedding invitations.
- Choose the menu and coordinate any necessary rentals (if applicable).
- Gather any décor items you'd like to include at the event.
- Ask friends or family members to give speeches (if desired).
- Shop for your attire.
- Give the venue your final headcount the week of the event.
- Enjoy your rehearsal dinner!

WELCOME PARTY

Because so many people now fly in (or drive significant distances) to attend weddings, a new trend of hosting a welcome party, in addition to or in lieu of a rehearsal dinner, has emerged. Essentially, this event can include everyone invited to your wedding, or just the out-of-towners, depending on what makes sense for your guest list (or budget).

You might be thinking that this whole welcome party business sounds expensive—you're already wining and dining all of your guests the following evening, after all! However, a welcome party doesn't need to be a full-on dinner or even a meal. In fact, it doesn't even need to be hosted (as in, paid for by you or your parents).

In fact, you could plan just a wine and cheese reception at a local restaurant, a backyard BBQ at a family member's home, a beach bonfire where guests can roast marshmallows, or just ask your guests to meet you at your favorite bar to toast you before your wedding. (For the last option, you don't need to even pay the bar tab—just be clear on the invite by saying "please join us" rather than

"please be our guests" and leaving out wording like "hosted by so-and-so.")

The point of this gathering is to spend as much time as possible with those who made the effort to attend your wedding.

Choosing a Venue

Deciding where to host your pre-wedding fete can seem like a repeat of trying to find a wedding venue. The location depends on a couple of things: if you plan to serve a meal, how many people you're hosting, and your budget. (Or the budget of whoever is paying.)

First, if you plan to serve a meal, a restaurant is the most convenient, as mentioned in the "tips" section. However, it may not

be the most cost-effective, especially if you have a high head count. If you can find an event space for a couple hundred dollars, you may consider catering in (food truck, pizzas, or a cheaper food option, like a great local Mexican place). Some restaurants will not only require a fee to reserve their space, but they may also have food and drink minimums per person. Friday nights especially can be tough for booking a restaurant in terms of availability and markups on pricing. Scope out a few options to compare the costs per person before you book anything. Once you have some quotes, you may even be able to negotiate a lower price from a restaurant or venue you love.

Another great location, budget-wise, is a free one, whether it's your own home, a family member's house, or a public park. Catering in or serving light snacks and drinks would work well at these venues— just be sure you have a willing crew to help clean up afterward. (And be sure to check out rules for serving/drinking alcohol in a park.)

Another consideration is proximity: If you have a number of out-of-town guests, you want to find a venue that's close to their accommodations, if possible. This way, people don't need to drive (or rent cars) and could easily walk or Uber/taxi to your event.

post-wedding brunch

Another wedding event gaining popularity is the post-wedding brunch, at which your guests will gather one more time to wish you well and send you off into married life. For some couples, hosting a brunch is a must, especially if they're having a destination wedding. For others, this event feels more like an obligation. (And an infringement on sleeping in.) So, before you jump into planning, really think about whether or not you want to attend a brunch the morning after your wedding.

Top Planning Tips

1. Find a happy medium on time: You don't want to have to wake up super-early right after your wedding, but you don't want most of your guests to miss the event because they have flights to catch.

2. Make it as formal or as informal as you want: Your brunch can be a huge hotel buffet or pastries by the pool—whatever makes the most sense to you. (And that ever-looming budget!)

3. If you don't want a big to-do, host a small brunch with just close family and friends to recap the wedding highlights.

4. Know that some guests won't make it. Even though you'll have a certain number of RSVPs, chances are that at least 10 percent will sleep in instead of going to your brunch.

5. Have your attire planned and ready. You won't want to show up in rumpled sweatpants (right?), so be sure you pack an outfit for this event, just as you did for the welcome/rehearsal dinner and wedding.

Before You Begin

Talk to your wedding accommodation hotel(s) about breakfast and brunch options before seeking out other venues. First, one of these hotels will be the most convenient location for your guests. Also, some already offer complimentary breakfast for guests, which would be a super budget-friendly option, while others have various dining rooms or restaurants you can rent out. Because you've asked guests to stay there—bringing the hotel an influx of business—you may be able to get a discounted rate on your brunch. It never hurts to ask!

TREND ALERT Some couples forgo a brunch and have their wedding accommodations hotels deliver Starbucks cards or a basket of muffins to guests the morning after their weddings.

to-dos

- Decide if you want a brunch and the scope of it (full breakfast buffet or just bagels; everyone or only a few VIPs).

- Figure out who is hosting (you, a parent, another family member).

- Coordinate the event with your wedding accommodations hotel (the easiest possible option).

- Book the brunch/breakfast location (if necessary).

- Decide on the menu (if applicable).

- Send invites or let people know about the event on your wedding website.

- Collect RSVPs, and let the venue know the final count.

- Get your outfits together and pack with your overnight bag.

- Enjoy your brunch!

marriage license

A marriage license is a document from the government that basically says you're cleared to get hitched. Both parties need to be over 18 and unmarried (or officially divorced, if you've been married previously). Depending on where you live, there will be additional stipulations that you'll need to research and consider. Queer and trans couples will also need to look into specific states—and sometimes counties within certain states—where their marriage will be legally binding.

Once you figure out the practical stuff, you don't have to make a big to-do over obtaining the license—unless of course, you decide to make it special, which is definitely encouraged. Look at this to-do as more than just required paperwork; it's one more step toward officially spending your lives together!

Top Planning Tips

1. Bring your IDs when you go to get your license. If you forget, you won't be able to complete the process.

2. Budget some time: In many cases, getting a marriage license is a first-come, first-served deal. You may need to use your lunch break during work hours to stand in line (since the office won't be open on the weekends).

3. Turn the process into something fun by asking the person behind the counter to snap a photo of the two of you signing or just holding your document. Why not, right?

4. Make sure you understand the rules: Check your city/county's website for stipulations on anything else you might need to bring with you, information on confidential marriage licenses (if you want yours to be private, not public), and how long the document is valid for.

5. Be clear on who's submitting the license after the ceremony. Typically, your officiant will do this. Ask your venue if there's a copy machine they can use so you can get a copy of the signed document and they can mail in the original.

Before You Begin

Check out the government website for the city you're planning to get married in and carefully read about the marriage license process, including how to make an appointment (if applicable) and what you need to bring. For destination weddings, you may have additional requirements to meet, especially if you're planning on getting married in another country. (You may even opt to secretly wed in your hometown before the big day, if that's more convenient—which you'll need to plan as well.)

❤ **PLAN AHEAD** Know your state's specific rules: Your license will expire after a certain period of time and some states also make you wait a few days before receiving your license post-application, while others make you wait to get married a few days after you receive the license.

to-dos

- Research marriage license protocol in your city/county.

- Make an appointment (if necessary).

- Go to your appointment (and bring your IDs).

- Make sure you're clear on when the license expires and when you can use it.

- Decide who is going to sign your marriage license as a witness.

- Determine who is sending your license back in to the city/county after you sign it (usually your officiant).

- Sign your license at your wedding.

- The person who is supposed to send it back will then turn it in.

- Pick up or order copies of your license when it's been processed (it usually takes two weeks).

to sum up . . .

Use this table to record the wedding elements described in this chapter as you tackle
(and complete) them.

Item Requiring Attention	Your Decisions Thus Far
RENTAL EQUIPMENT	*Use hotel's tables + chairs; need linens and tabletop items*
RENTAL EQUIPMENT	
GAMES AND ENTERTAINMENT	
HONEYMOON TRAVEL	
WEDDING ACCOMMODATIONS	
REHEARSAL DINNER	
POST-WEDDING BRUNCH	
MARRIAGE LICENSE	

Notes and Reminders

Call rental companies this month

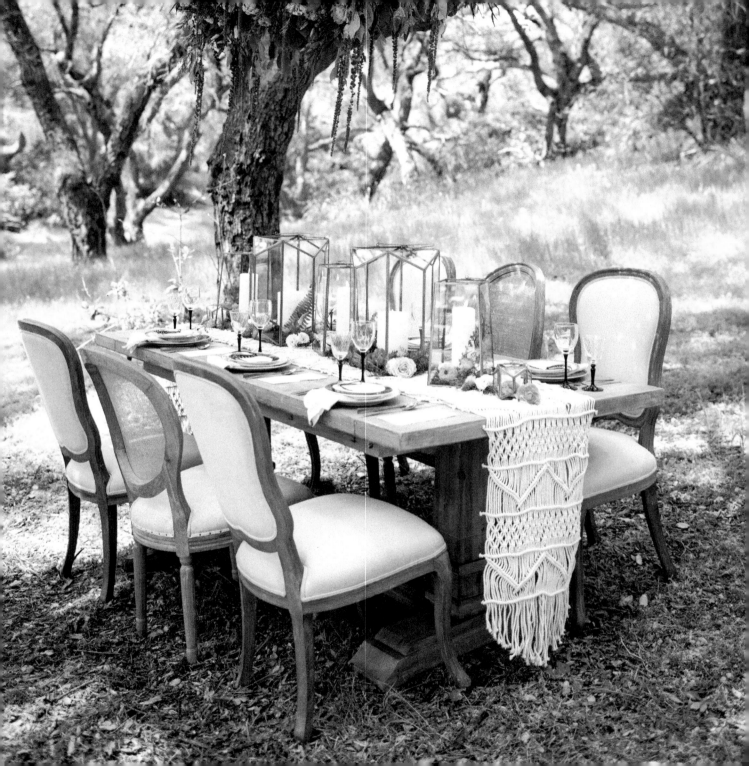

chapter eight

parties and gifts

2 TO 3 MONTHS OUT

It's finally time for the parties before the main event! After months and months of planning, it's time to take a quick break and focus on you! Your nearest and dearest will help you in celebrating your almost-married status, while you will honor these people, who have no doubt helped you and supported you along the way. Let yourself enjoy this time. Yes, there are still a few key decisions that you still need to make, but don't let any planning stress keep you from truly enjoying your pre-wedding events. These are memories you'll hold on to for years to come.

the shower

Traditionally, a bridal shower is an event where a bride's best girlfriends will, as the event's name suggests, shower her with gifts and advice for married life. Nowadays, however, many people are choosing more inclusive couple's showers, where each of you can be feted at the same party.

A shower can take many forms: It could be a formal tea, a casual brunch or lunch, a dessert bar, an outdoor BBQ, or a combination. This event is all about you, so you decide how dressy or laid-back you want your shower to be. In fact, you can be as involved in the planning (from games to food) as you want—or you can let your host(s) take the reins, and simply show up.

Top Planning Tips

1. Holding your shower at a family member or friend's home can be a great way to pull the event off on a budget and lends a cozier feel to the event.

2. Have a designated person write down who gives you what when you're opening gifts—and save all the receipts just in case.

3. Shower games run the gamut from traditional to silly; check out blogs for ideas, free downloads, templates, and more, then share the ones you love with your host to give some direction.

4. Get the guest list just right: Back in the day, every woman invited to your wedding was invited to the shower. Nowadays, brides usually invite their bridal party, close family members, and close friends.

5. Have a potluck: A fun, budget-friendly idea might be to have everyone bring a favorite dish—in a serving platter you can keep—along with the recipe so you can make each item yourself in the future.

Before You Begin

If you're a bride, and you have your heart set on your own shower, talk to your maid of honor and bridal party to see if throwing a shower is feasible for their budgets. If not, a sibling, aunt, or cousin can host instead. Traditionally, your mother is not supposed to host this event (an old etiquette thing), but if Mom is itching to throw you a pre-wedding bash, then by all means, let her! Some brides-to-be even decide that they prefer not to have a shower and would rather host a day of putting together some of your key wedding DIY projects instead. Do what feels right for you!

♥ **ETIQUETTE ADVICE** Include only people invited to the wedding to your shower; otherwise, it might seem like you're pandering for more gifts.

to-dos

- Give your host(s) a few dates that work for you. Your host(s) will set a date.

- Put together a guest list for your host(s) with everyone's addresses. Host(s) will send out invitations.

- Share any must-haves or do-not-wants with your host(s) (as far as games and activities are concerned).

- Choose your shower attire.

- Enjoy your shower!

- Send out your shower thank-you notes.

bachelor and bachelorette parties

Woo hoo! Time to go out on the town for your last hurrah as unmarried people! Well, at least that's the idea behind these typically raucous shindigs. Bachelor and bachelorette parties are notoriously wild weekends, and yours can be just as exciting, or as low-key, as you'd like them to be. The important part is that you're surrounded by your closest friends and have the chance to unwind from the stress of planning. Anything goes for these events—do what sounds fun to you!

Top Planning Tips

1. Typically, your bridal party will foot the bill for your portion of this fete, but talk to everyone first and see if this is feasible. If you request an over-the-top bachelor(ette) party, you should probably pay your own way as a courtesy to your pals.

2. Pick a central location so everyone is more likely to make it. If your wedding party is all on the East Coast, New York or Miami could be fun. If everyone is scattered across the country, meet in the middle in Denver or Austin.

3. Tell whoever is planning what you envision for your celebration and be clear on what you don't want (whether that's strippers, taking shots, wearing a crown out on the town, etc).

4. Limit your guest list to your bridal party and close friends. The more people involved, the more you'll have to coordinate.

5. Highly consider keeping this event off social media and telling your guests to do the same. Not only do you want to keep those who weren't invited from feeling left out, but you also don't want your co-workers to see photos of you at a strip club (or sipping a cocktail out of a phalllic straw).

Before You Begin

Figure out your bachelor(ette) style. Do you want a crazy weekend in Las Vegas, or is wine tasting more your style? Would you prefer watching your favorite sports team play or enjoy the great outdoors while camping? Maybe you'd rather relax by hitting the spa or going golfing? This weekend (or day or night) is about honoring you, so pick the activity that would make *you* the happiest. There can be a bit of pressure to have some crazy, over-the-top weekend, but the event should be about what you think is a good time.

PLAN AHEAD Surprise each other by sending flowers, a bottle of wine, a round of shots—whatever makes sense—to your partner when at the bachelor(ette). It's a fun way to let the person know you're thinking of them.

to-dos

- Choose who you're inviting, and send out an email with some potential weekends so everyone can make it.

- Decide where to go and set a date, then let everyone know the plan.

- Talk to the planners about ideas, wants, and don't wants, and let them take the lead from there.

- Book travel, if needed.

- Buy necessary attire for the celebration.

- Have a blast!

- Write a thank-you email—or personal notes—to everyone who attended.

bridesmaid luncheon

As part of the pre-wedding festivities, you may decide to host a lunch for your besties as a way of thanking them for all they have done for you thus far. This event is by no means required, and it doesn't even need to be a lunch—you could host a nostalgic sleepover at your house or grab cocktails at your favorite spot downtown, whatever makes the most sense for your budget and your group of attendants. Think of this as less of an obligation and more as a way of getting yourself away from the last-minute details so you can have some fun together! If you like, you can also make this a couple's party, in which both of you host your honored friends. Remember, it's your party—do exactly what you want!

Top Planning Tips

1. Plan an activity: Instead of a meal, you could visit an art gallery, a botanical garden, even a concert—the point is to treat your bridesmaids to something fun and to allow you to relax and unwind with your pals before the big day.

2. You may consider using this time to give your girls their gifts (more on these on page 190), rather than at the rehearsal dinner. That way, they don't have to carry their presents around with them all night.

3. Forgo this event if you're stretched too thin budget- and time-wise. It's not worth being stressed over something that really isn't necessary.

4. Open the event up to moms, grandmothers, and aunts if you have a smaller bridal party (one or two attendants) or other honored guests.

Before You Begin

Set a date and spread the word as soon as you can. Typically, this event is held a day or two before the wedding, but you may have a lot going on (you know, with your impending nuptials), and some of your attendants may not plan to fly in until the afternoon before your big day. Coordinate as best as you can so as many of your girls can be there—without cramming too much into one day.

FUN FACT It's an old custom at bridesmaid parties to serve a pink cake, with a coin, thimble, or ring baked in. Whoever finds the object in her slice of cake is said to be lucky in love.

to-dos

- Decide on the scope of this event and who's invited.

- Pick a date and time, and let your attendants know.

- Plan the event itself, and coordinate any food and beverages you want served.

- Finalize head count, if needed.

- Enjoy hosting your guests, and give them their gifts.

wedding favors

To thank guests for attending your wedding, it's customary to give out favors, or small tokens of appreciation. Depending on how important this wedding element is to you, your favors might be an afterthought or a key element in your décor. Either way, if you're going to have them, consider spending a little bit of time determining what mini-gift ideally suits your celebration. Since they're optional, make a conscious choice to pick something unique, stylish, or useful to ensure that the money and time you put toward this wedding element is well-spent.

Top Planning Tips

1. If fitting your favor in with your décor appeals to you, choose something that works with your wedding colors—or put the gift in packaging that ties in with your theme or wedding style.

2. Make it personal: Create a custom label for your favor if you're giving something edible, like mini honey jars or chocolates. This covers up the existing label and is a great way to easily add an extra style element. (Etsy has some great, affordable downloads you can easily personalize.)

3. Websites like Etsy have great favor options and low prices when you buy in bulk.

4. A good rule of thumb with favors is giving something people can use right away—food or sparklers for your send-off—or something they'll want to keep, like a bottle opener or picture frame.

5. Let your favors do double duty: Escort cards or place cards are great options for using your favors and checking two things off your list. (See more about escort and place cards on page 216.)

Before You Begin

Revisit your budget, and tweak how much you want to spend on favors. At this point, you may have realized that some big-ticket items cost more than you planned, and your favors can be a great way to recover some costs. You may even decide that favors aren't necessary and can cut them altogether to relieve your bottom line. Unlike other more important wedding elements, favors are not going to make or break your big day.

TREND ALERT Many couples opt to forgo favors and instead donate to a meaningful charity. If you'd like to go this route, simply make a note in your ceremony programs—or create a sign near your guest book to tell everyone.

to-dos

- Check your favor budget and adjust if needed (or decide to forgo favors).

- Divide your favor budget by the number of guests you expect to have (then add a couple extra just in case).

- Use this number to guide you as you research favor options.

- Choose your favors and check shipping times (if buying online).

- Place your order.

- Package, label, or otherwise put together your favors and store them in designated box(es).

- Figure out who is delivering favors to your reception venue and how.

gifts for the wedding party

As a thank-you to your attendants for being part of your big day, it's customary to give everyone a gift. Shopping for these gifts a few months in advance gives you time to research and choose what you want to bestow upon these wedding VIPs, or enough time to make gifts, if you want to go the DIY route. Whatever you choose, pick something meaningful that your pals can cherish for years to come.

Top Planning Tips

1. Unless you have two or three attendants and can pick out truly personalized presents, it's usually best to give everyone the same gift to avoid comparisons and hurt feelings. You might give the wedding party leaders (or best woman or man of honor) a little something extra, however, since they likely had more responsibilities during the planning process.

2. DIY gifts: If you're a good sewer, crafter, etc., consider hand-making gifts with love, like embroidered handkerchiefs, clay ring dishes, or woven bracelets. There are a number of blogs with excellent tutorials you can follow.

3. For a handmade touch, without the work, look on Etsy for multiple gift options that would suit any wedding party.

4. A great option for gifts is to give your attendants something they can wear at your wedding—and beyond—like socks and ties, jewelry, or clutches.

5. Even if your budget is tight, make your gifts look festive with pretty wrapping, which can be as simple as butcher paper and brightly-colored kitchen twine or lace ribbon.

Before You Begin

Work backward from your budget to determine how much you have to spend on gifts, adjusting for any overages you've spent on other items. While you don't want to skimp on attendant gifts, you don't need to go over-the-top. Something sweet and thoughtful is all you need to give to show your appreciation. You may even decide, at this point in the process, to choose attendant gifts *or* a luncheon/event for the entire wedding party. Determine whether your group would prefer tangible gifts or something experiential, then do that.

"You don't need to break the bank to give a special gift to your wedding party. A meaningful card is likely just as, if not more, special as the gift itself. Take some time to share your appreciation with your VIPs, and jot down some heartfelt words for each person. They'll love that you took the time out of your busy schedule to share your thoughts and feelings with them." — *Kellee*

to-dos

- Revisit your attendant gifts budget.

- Decide on the gift type: something bought, something made, or something experiential.

- Research ideas on blogs, Loverly, and Etsy.

- Buy materials, gifts, wrapping, etc., as needed.

- Make (if applicable), and wrap gifts.

- Write cards.

- Give gifts!

gifts for parents

Another customary pre-wedding gift is to honor your parents with a token of your appreciation. Generally, this is done because they paid for your wedding and/or rehearsal dinner. However, if you paid (or are paying) for your celebration, you may still feel the urge to honor your parents for any non-financial support throughout this process. Or, you might think this tradition doesn't apply to (or work) for you if your family is not big on presents. As with all aspects of wedding planning, do what feels right to you.

Top Planning Tips

1. To make things easier on yourself, and save money, you might consider getting your parents a joint gift, if possible.

2. Parents love photos; therefore, a great gift idea might be a double frame of you with them as a child, with a blank space where you can add a photo of you with them on your wedding day.

3. In lieu of a tangible gift, you might book both of your mothers mani-pedis or treat them to lunch, and you could gift your dads a round of golf or a massage. Spending time with you is the most valuable gift you can give your parents, after all.

4. Consider something wearable and unique to them, as you might have done for your attendants. A piece of jewelry, a pair of shoes, or a tie bar could all be great gifts. You can even engrave the item with a monogram, a personal message, or the wedding date to make it more special.

5. If gifts are not in your budget, a meaningful letter to each of your parents would be something they'd treasure forever.

Before You Begin

Shopping for parents is always tough—they never tell you what they want when it's gift-giving time!—so you may need to do a little sleuthing. Either talk to your parents separately or pay extra attention when see them or talk to them (especially when you're discussing wedding day attire).

ETIQUETTE ADVICE If an aunt, uncle, grandparent, cousin, or other family member hosted a wedding event for you, be sure to thank them with a token of appreciation as well.

to-dos

- Revisit your budget and determine how much you have to spend on each parent.

- Decide on the gift type: something bought, something made, or something experiential.

- Research ideas on blogs, Loverly, Pinterest, and Etsy.

- Buy materials or the items themselves as needed.

- Make (if applicable) and wrap gifts.

- Write cards.

- Give your gifts!

gifts for each other

Finally, the last gifting tradition for a wedding is presents for each other. Some couples choose to have their wedding bands fulfill this custom, while others choose to shop for another item or experience to commemorate their venture into married life. Whatever you do, remember, it's the thought that counts. Gifts don't need to be lavish or over-the-top to be special. Shop (or DIY) with care, and whatever you decide to give will be just right.

Top Planning Tips

1. If you'd like to bestow wedding day accessories on each other, talk about what you might want beforehand—that way, the gifts will coordinate perfectly with your wedding attire.

2. If you're moving in together for the first time after your wedding (or even if you already share a home), you might purchase something special for your abode, like artwork or a piece of furniture.

3. Write each other letters: Nothing is as meaningful as sharing why you're so excited to marry each other and how much this moment in your lives means to you. Plus, this gift costs absolutely nothing!

4. Prefer the gift of experience? Consider booking each other honeymoon surprises, like a cool excursion, a private tour, or a special meal at a famous restaurant.

5. Whatever you get each other, decide how you want to give your gifts. Would you like to open them together the night before (if applicable)? Or would you prefer to have the presents delivered to each of you when you're getting ready the day of?

Before You Begin

Set a budget. That way, one of you doesn't end up with a new watch to wear for the wedding, while the other gets a *Bridesmaids* DVD to watch while getting ready. Having unmet expectations right before you walk down the aisle would be no fun, to say the least. Plus, it's important to talk about spending habits before you get married in general—this conversation might lead to a deeper discussion on your financial values, which is never a bad thing.

♥ **PLAN AHEAD** If you live with your spouse-to-be, be sure to hide your gifts in a safe place so they aren't found before it's time to give them. (Just don't make them too hard to find for yourself!)

to-dos

- Revisit your budget and determine how much you have to spend on each other.

- Decide on the gift type: something bought, something made, or something experiential.

- Research ideas on blogs, Loverly, Pinterest, and Etsy.

- Buy materials, the items themselves, or book the experience (as needed).

- Make (if applicable) and wrap gifts.

- Write cards.

- Coordinate how you want to exchange gifts.

welcome baskets

A newer wedding trend is providing welcome baskets or bags for guests when they arrive at your wedding accommodation hotel(s). The rise of destination weddings has brought the idea of giving those who flew in some necessities—bottled water, a map of the area, some snacks, and so on. Now, however, some couples decide to provide goodie bags for guests whether they're getting hitched out of the country or stateside. It's not a must, but if you have room in your budget, welcome baskets are a nice touch.

Top Planning Tips

1. Use the basket to introduce your wedding location with local food items, a list of sights to see, and a fun trinket that's unique to your city (like a miniature Empire State Building statue if you're getting hitched in NYC). You can also give a "morning after" basket, complete with water, Advil, mints, etc. to help guests recover from the great time they had the night before.

2. Be mindful of your budget: You don't want to waste valuable wedding funds on this detail, so visit warehouse stores and discount online retailers for deals.

3. Give baskets only to those who had to travel into town to cut costs, not to everyone on your guest list.

4. If you're having the hotel distribute your baskets, ask about fees: Usually, there will be a charge for actually putting the baskets into guest rooms and there many even be a charge for holding them behind the front desk.

5. Make it disposable—and recyclable. Putting your "baskets" together in paper bags is a great option to cut down on costs and waste. Guests can recycle their bags with their morning newspapers at the hotel. (More than likely, guests won't try to pack an actual basket into their carry-ons, so this item would likely end up getting tossed.)

Before You Begin

Figure out the logistics. If you have one wedding accommodation hotel, and the majority of your guests are staying there, distributing welcome baskets will be an easy-peasy task. However, if you have multiple accommodation locations and guests are scattered among those, other hotels, and vacation rentals, you'll have a harder (and more time-consuming) task making sure everyone indeed receives a bag—unless you distribute them at a welcome party.

♡ "Making welcome baskets sometimes gets relegated to last minute—like the week of your wedding. To tackle this to-do quickly and early, invite some friends over, break out a bottle of wine, and spend an hour putting everything together. Most couples find that wedding planning cuts into their social life, so enlisting friends in this task will let you have fun without falling behind on your to-do lists." — *Kellee*

to-dos

- Decide who gets a welcome basket and how many you need (you should plan to make a few extras just in case, especially if not all of your RSVPs are in).

- Coordinate with wedding accommodation hotel(s) about distribution and fees.

- Choose items and the basket/bag you'll put them in.

- Place orders online, or go to stores to buy items.

- Pack items and wrap or embellish as needed.

- Deliver baskets to hotel(s) or bring to welcome party to distribute.

to sum up . . .

Use this table to record the wedding elements described in this chapter as you tackle (and complete) them.

Item Requiring Attention	Your Decisions Thus Far
THE SHOWER	*Bridal party planning*
THE SHOWER	
BACHELOR AND/OR BACHELORETTE PARTIES	
BRIDESMAID LUNCHEON	
WEDDING FAVORS	
GIFTS FOR WEDDING PARTY	
GIFTS FOR PARENTS	
GIFTS FOR EACH OTHER	
WELCOME BASKETS	

Notes and Reminders

Buy new dress

chapter nine

finalizing key decisions

1 MONTH OUT

*Y*ou're in the home stretch now! This month will be a whirlwind of finalizing details and making some important logistical decisions to ensure that your day runs super smoothly. If you're feeling a bit burnt out from planning, don't worry—that's completely normal. (You've been at this for months, maybe even a year, after all.) Rest assured that there is a light at the end of the tunnel: your wedding, which you've carefully planned. Keep envisioning that dream celebration as you finish up these bigger components and can really see your event come together.

ceremony

Your marriage ceremony is the most important part of your wedding, even though it seems to get second billing to all the pretty details and décor of the reception these days. By this point, you've chosen who will preside over your wedding and feel confident that they will write and deliver a ceremony that reflects you as a couple. However, you may want to give this person some direction to ensure that the content and flow of the "I dos" is exactly what you hope for. A short phone call or meeting a month before the big day is a good idea.

Top Planning Tips

1. Be sure your officiant knows some key details about your relationship: where and when you met, who introduced you, the proposal, things you love to do together, etc., so they can incorporate some personal anecdotes into your ceremony.

2. Ask your officiant for an overview of your ceremony if they haven't yet provided one: You should be able to give the okay on all components, from prayers to readings, to be sure it's what you want.

3. If there are certain vows you want to say (or write), talk to your officiant about what these are and make sure you're all on the same page. (See page 210 for more on vows.)

4. If you'd like to ask people to read prayers, poems, or passages, clear your ideas with your officiant, then alert these people ASAP to make sure they're up for it.

5. Talk about timing: Unless you're having a full religious service, you want to shoot for about 20 to 30 minutes total for your ceremony.

Before You Begin

Hash out any must-haves before finalizing things with your officiant: Do you want certain songs or hymns during the proceedings? Readings from certain friends or family members? Are you looking to do any rituals that your officiant may not be aware of? You likely spoke with your officiant about some of these things when you first met and chose this person to preside over your ceremony, but now is the time to revisit your wants and needs to really hone your vision into a final concept.

♡ **PLAN AHEAD** If you plan on doing rituals that require purchasing items (and bringing them to the ceremony) be clear on who is providing what: For example, a unity candle ritual requires three candles, a candleholder, and matches or a lighter.

to-dos

- Revisit ceremony wants and needs.
- Talk to officiant about ceremony components.
- Fill out any questionnaires about yourselves/your relationship from your officiant or offer information on your own for them to use.
- Select readings, and ask people to deliver them, if desired.
- Choose additional rituals you'd like to include, and buy any necessary items for them.
- Decide on vows, or write them yourselves.
- Confirm timing with officiant.
- Have final meeting with officiant to go over any last details.
- Get married!

CREATIVE WAYS TO HONOR THOSE WHO HAVE PASSED

You may want to pay tribute to those who couldn't be with you on the big day. It's completely up to you as far as how you'd like to honor and include these special people—as well as how public or private you would like to make your remembrance. Here are some ideas to help you brainstorm.

Wear something special: Including something your loved one gave you—or something of theirs—in your attire is a subtle yet meaningful way to honor them, whether it's jewelry, a headpiece, or a pocket square.

Include a personal detail: This could mean anything from serving your grandfather's favorite rum at the bar to using your grandmother's teacup collection as part of your dessert table décor. You could choose to call out the detail to guests or have it be something that only those who knew the person will notice.

Put a note in the program: You can write something to include in your ceremony program that gives a nod to those who have passed, deciding to specifically list their names as well, if you wish.

Display photos: Some couples choose to set out family wedding photos at their nuptials, which can be a great way to include those who have passed. You could also just display photos of those who cannot be with you along with a candle, if you prefer a more dedicated remembrance.

Save a seat: A very public way to honor a loved one is to dedicate a chair to that person at your ceremony. The seat could hold a sign or placard, as well as a photo, explaining that it's "reserved" for that person.

Traditional or Not-So-Traditional

Marriage ceremonies are by no means one-script-fits-all; there are many wedding traditions in many cultures. Still, your own personal feelings must come into play here. if you aren't comfortable with certain aspects of these traditions—or even if you're having a super-religious ceremony—there may be ways to incorporate certain readings that are a bit more secular or just more personal to you. Think of your ceremony options like a spectrum that goes from traditional to not-so-traditional, and determine where on that spectrum you fall.

It all comes down to your values and what your vision is for your ceremony: If you are both religious and your faith means a great deal to you—and is a big part of your relationship—a more traditional ceremony might be the ideal way to go.

If you're not so religious but you appreciate your religious background(s) (or your families') you might consider incorporating certain elements without having an overly religious ceremony. For instance: A glass can be broken in a nod to Jewish heritage; couples can light a unity candle, which is popular in the Catholic faith, etc. If you'd like your ceremony to reflect your cultural heritage, you have many options: You might borrow components from your background, like a hand-fasting ritual, which comes from Celtic history, for example.

Or, you may want to put your own unique spin on old traditions to create a more modern ceremony. Instead of a unity candle, some couples pour different colored sand into a jar. If you're Jewish, you can rewrite the traditional seven wedding blessings to reflect your own intentions. Another fun idea is writing letters to each other, putting them into a box with a bottle of wine, and nailing the box shut mid-ceremony. Then, you can open the box on your one-year anniversary.

It all comes down to personal preference and what really speaks to you. You might want to incorporate religious, cultural, and modern components, and you may feel strongly about going in one direction or another. Whatever you choose will be meaningful and beautiful, as long as it's from you two and reflects your love and commitment.

Ceremony Programs

To guide your guests through your ceremony and help them understand the various components, you might consider making or having a company print up programs for you.

Programs are not always necessary; however, for some weddings they are essential. For instance, if your ceremony will be in another language, you should have a program to explain what's being said and done throughout the proceedings. If you're planning on incorporating a number of meaningful rituals, but don't have a ton of time to explain them in the moment, use the program as a way to inform your guests as to what's going on and what the meaning behind each component is. Or, if you'd like your guests to participate in the ceremony—by singing or calling out responses—a program is a great way to tell them this and guide them along.

Another reason you might want to have programs is if you'd like to honor loved ones that can't be with you on your big day. Some couples would like to pay tribute to grandparents or others who have passed by calling them out and making guests aware of who they were.

Finally, you might want to use a program as a way to thank guests for their presence. A simple note of appreciation to loved ones can be a gracious way to kick off the ceremony.

INSIGHT ON INTERFAITH WEDDINGS

If you have different religious backgrounds, you may consider having an interfaith wedding that incorporates each of them.

Some couples do this by having two officiants—one representing each religion—to preside over different rituals or components of the ceremony. Others have one officiant representing one faith but ask a family member of the other religion to lead prayers, give readings, or orchestrate a ritual.

The first thing you need to do to make this happen is talk to your officiant about how they feel about incorporating the other religious component—would they be comfortable with sharing the stage with someone else, or would they prefer to weave in the other religion on their own?

Then, decide what elements from each religion you want to include: Perhaps you will do a prayer from each side, as well as a reading from each side, then traditional vows from one religion, and a ritual from the other. Keeping both sides "even" (so to speak) is typically a good idea to appease your families, if that is a potential concern.

To help make this process as easy as possible, bring up the idea of having an interfaith ceremony early in your engagement, both with your parents and with your officiant. While it's your wedding and it's your decision as to how you want your ceremony to unfold, you may need to bring others on board with your ideas. Your parents or grandparents may have strong feeling or expectations that should be discussed early on (to avoid surprises or backlash later), and your officiant needs to be aware of your interfaith vision before they are hired.

HOW TO DIY YOUR CEREMONY

Writing the ceremony yourselves is another way you might choose to personalize your wedding. Here's how to do it:

Determine your basic structure and style.

Talk with your partner to figure out what type of ceremony you want to have: how long you want it to be, how religious (or not) you want it to be, and how traditional (or not) you want it to be.

From there, you can start fleshing out your structure. Typically, a marriage ceremony has the following components: an opening address, the expression of intent (your "I dos"), your vows, the exchange of rings, the pronouncement, and, finally, the kiss.

Start personalizing.

Within the structure above, you may want to include readings or rituals that are meaningful to you. There are no rules about when or how they might happen, so the way your ceremony unfolds is up to you, but typically readings would come before your "I dos" and any rituals might make sense after you've exchanged rings.

It may also help to have an overarching theme or tone for your ceremony that the readings, address, and even your vows might touch on, just to keep everything cohesive, but this certainly isn't required.

Decide on vows.	We'll talk more about vows on page 210, but you'll want to decide if you'd like to write your own or if you'd like to use pre-written words. A quick online search will give you a ton of ideas.
Be sure you comply with city requirements.	Before you write the ceremony, check with your wedding city to see if there are any requirements you need to be sure you include to make sure the marriage is official.

wedding vows

Your marriage ceremony is the most important part of the wedding, and your vows are the most important part of the ceremony. Vows range from the traditional "to have and to hold" script to self-written promises you'll make to each other. Whether you borrow words that thousands have said before you or pen new ones unique to your relationship, the thing that really matters is that those vows resonate with you.

Top Planning Tips

1. If you want to go traditional, look for different variances of the tried-and-true vows, then pick and choose from those versions to find the ones that best fit your relationship and ceremony.

2. If you're writing your own vows, make them personal, but beware of including too many inside jokes and references—you don't want guests going "Huh?" the whole time you're saying them.

3. When writing your own, be sure to read out loud multiple times while editing: What you say may be slightly different than what you wrote. While eloquent writing is all well and good, you want to make sure your vows are as easy to *say* as possible.

4. Talk with your officiant about doing "response" vows—where they say a line first and you repeat it—or if you want to read on your own.

5. Even if you plan to memorize your vows, be sure the officiant has a copy just in case your mind goes blank in the moment.

Before You Begin

Decide if you're going to choose the DIY route or go with the pre-written route—or a combo of the two. One of you may feel strongly about one or the other (meaning you need to compromise) or you might be totally on the same page. If you're not sure, go online to read sample vows: A simple Google search will yield a number of options to help you decide what you'd like to do for your own ceremony.

TREND ALERT Couples have increasingly started borrowing vows from their favorite books, movies, and TV shows, lending a pop-cultural flair to their "I dos."

to-dos

- Research vows and decide if you're going to use existing vows or write your own.
- Choose or write your vows.
- Practice saying your vows (to yourself or to each other).
- Edit vows as needed.
- Figure out how you want to say them at the ceremony.
- Make sure your officiant has a copy of the vows so you can read from them if needed.
- Say your vows!

wedding day schedule

If you've hired a wedding planner or day-of coordinator, that professional should devise a schedule for your celebration on their own, then go over it with you. However, you may have some special requests or strong ideas about what happens when, in which case you may decide to try your hand at a loose schedule yourself. And, if you're going into your big day without a day-of vendor, but a friend who will manage the schedule, you will have to create your own timeline of events, of course. This section will guide you through, no matter what your situation is.

Top Planning Tips

1. Ask your coordinator to show you some sample timelines so you can get an idea of the order other couples lay out for their big day and how long certain components take. This will help you get a sense of how your wedding might play out.

2. Budget extra time: You may expect your ceremony to last only 30 minutes, but in case someone is running late or you don't start on time, it's best to add a buffer of 10 minutes on either side.

3. If you decide that you want to take pictures during cocktail hour, know that you really will have only an hour: Longer than that and your guests will start to get antsy.

4. Review your timeline with your caterer, photographer, hair/makeup pros, and entertainment to make sure everyone is on the same page about arrivals, departures, and major moments. Edit and hone the timeline as needed.

5. Be sure everyone who is on your final timeline gets a copy, from your parents to your vendors. That way everyone knows where to be and when.

Before You Begin

Decide on the big moments that will anchor your timeline, such as a first look (more on that on page 214), photos in advance, a first dance, an official send-off, and so on. Once you've settled on those moments, put them in order and work on filling out the times that are already set, like when the ceremony will start, what time dinner will be served (ask your caterer about this), and when you need to clear out the reception venue.

♥ **PLAN AHEAD** Budget an hour for cleanup in your timeline—within the constraints of your venue's hours. If your "hard out" is at 11 p.m., plan to have the music shut off at 10 p.m. (More on cleanup in the next chapter.)

to-dos

- Talk to your planner or coordinator about if/when they will create a timeline.

- Determine your must-have moments.

- Work with your planner or coordinator to hone and edit your timeline.

- Talk to key vendors about the timeline, and edit as needed.

- Share the final timeline with everyone involved.

find out more on lover.ly
For helpful day-of timelines, head over to lover.ly/tools/wedding-checklists.

First Look

It used to be considered bad luck for the couple to see each other before the ceremony. But a recent trend has more and more couples eschewing tradition by having what's called a "first look."

A first look is a staged moment when you both see each other, all dressed up in your wedding finest. While the moment is usually private, you will likely want your photographer there to capture your reactions to seeing each other for the first time on your big day.

The reason having a first look has become so popular is twofold: First, a first look alleviates those pre-ceremony jitters because you get to see, kiss, and hug your partner and otherwise get excited for the wedding to officially start. Second, a first look eases your wedding timeline because it allows you to take photos (with each other and your families) before the ceremony, which in turn enables you to enjoy your cocktail hour with your guests.

Aside from doing a first look with your partner, you may also consider doing first looks with each of your parents. Typically, a bride's mother will help her get dressed (so no first look needed!) but a bride may want to do a first look with her father, grandparents, brother—anyone who won't be getting ready with her. Similarly, a groom may want to have the photographer capture first look moments with his mother (and father, if Dad got ready separately), his sister, grandparents, or anyone else special to him. These moments not only make for great photos, they allow you to have special time with those who mean the most to you before the frenzy of your wedding day begins.

REAL COUPLES SPEAK "It's so easy for the whole day to become a complete blur, so try to pause and take mental pictures—or real ones. Weddings are normally seen through the eyes of observers, so it's cool to get the perspective of the couple. Adèle still cherishes the memory of her father's hand holding hers as he walked her down the aisle and seeing how strong he looked as he held her up and smiled. Those mental pictures are how you remember one of the biggest days of your life, so it's worth taking your time to treasure them."
—Adèle and Brett

More Meaningful Moments

There are a number of traditional wedding moments you may want to build into your timeline, take out altogether, or revise to fit your wants and needs. Here's a handy guide so you can figure out what's best for your celebration.

Post-ceremony alone time: Traditional in Jewish weddings—called the *yichud*—this wedding component has been widely adopted by non-Jewish couples. This is basically a private post-ceremony moment (10 to 15 minutes) for the happy couple, during which you can celebrate (and eat appetizers!) alone before joining your guests.

Grand entrance: Becoming more popular, a grand entrance is where the couple enter their reception after guests are seated, during which they're officially introduced as married.

First dance: To kick off the dancing, the couple dance alone to a song of their choice. (If this seems scary, or you don't want to dance alone, dance solo for the first 30 seconds, then ask the DJ or band to invite everyone else to the dance floor.)

Parent dances: Usually, a bride will have a special dance with her dad, and a groom will have special dance with his mom. However, depending on your particular wants and needs, you might choose to dance with other family members instead, or do these dances more informally while others are dancing, too.

Bouquet and garter toss: A bride will toss her bouquet to the single ladies at the wedding, while a groom will remove the bride's garter and toss it to the single men. (Tip: If you're planning to toss a bouquet, you might want to ask your florist to make a smaller, lighter version of the one you held down the aisle so no one gets hurt and you can keep your own.) And of course, if neither of you feel comfortable with these old customs, or if they don't apply to your particular lifestyle or outfits, make up a new tradition or forgo the toss completely.

Last dance: To signal the end of the night, you may ask your DJ to announce and play a certain song of your choosing to get everyone out on the dance floor together one last time.

seating chart

Deciding who will sit where at your wedding can be a puzzle indeed—and it's one part of wedding planning you often hear that couples dread. But this task certainly doesn't have to be a total headache. Bust out your RSVP spreadsheet, budget a few hours, and work together to figure out who's sitting where. (Adult beverages optional, but highly recommended.)

Top Planning Tips

1. Write confirmed guests' names on yellow sticky notes, then use them to create a mock seating chart. As you work on this task, you can easily move and shift people as needed. There are also sites—like WeddingWire and Wedding Mapper—that allow you to create online seating charts.

2. Talk with your families about anyone who can't or shouldn't sit together, just to alleviate any potential drama.

3. Depending on how many people you end up hosting, you might decide to switch table sizes, if you're renting and are able to do make a change to your order. For example, some round tables fit 8 to 10, while others can seat 10 to 12. As you fill in your seating chart, it may help to get a mix of tables to accommodate different size groups. Not every table has to have the same number of people.

4. Plan to have escort and/or place cards to tell your guests what tables they are at and/or which seats are theirs.

5. Revisit the seating chart a week before the wedding in case anyone declined last-minute and changes need to be made. Give the final list to the caterer and wedding planner/coordinator.

Before You Begin

Make sure you have the majority of your RSVPs back before you start figuring out the seating chart, otherwise you'll likely need to do multiple revisions as you receive more replies. Also, decide where you'd like to sit first: with your attendants, with your parents, by yourselves, etc. (See page 218 for more on common seating arrangements.)

♥ **INSIDER INSIGHT** Creating a seating chart can be exhausting, so you may be tempted to forgo it. Don't! Telling guests where to sit (at least the table) prevents the chaos that will ensue if you have open seating for more than 20 guests.

to-dos

- Decide on your seating arrangement.

- Create a mock seating chart, and start playing around with who goes where.

- Finalize the chart once you've received all of your replies.

- Make a final chart in a Word or Google doc, or sketch out and give to caterer and planner/coordinator.

- Create or buy escort cards and/or place cards, and put guests' names and table numbers on them.

- Determine setup and distribution of escort/place cards, as well as who is taking them to the venue and when (coordinate this with planner/coordinator).

- Tweak the final seating chart if needed, and send changes to caterer and planner/coordinator.

Common Seating Arrangements

When figuring out who will sit where, sometimes your venue does the work for you if it provides you with tables: You'll have a set number of them, they'll be a set size or shape, and you'll need to arrange your guests accordingly. When you rent your own tables, you have more flexibility: You may opt for round tables, or longer rectangular ones. (And you could even put those rectangles together to create super long banquet tables, if you wish). However, there is one choice that you'll need to make no matter what: where *you* will sit.

Your first option is to create a head table at which you two, your wedding party, and your parents will sit. This table is usually a focal point of the reception and situated in the middle, with other tables fanning out from it, or on one end of the room, with the other tables placed facing it, across the dance floor.

Your second option is to have a sweetheart table, where the two of you will sit alone. This allows your wedding party to sit with spouses, partners, and friends, and your parents to sit with other family. Like the head table, the sweetheart table is a focal point and would be positioned as such.

Finally, you could seat yourselves with other guests without any kind of specialty table. In this case, you might sit with your parents or some members of your wedding party.

There's no better or right way to do it: Just imagine who you want to sit with, or not, and what would make you two the happiest on your big day!

COMMON SEATING FAQS

Should we have a kids' table?

If you have a group of 10 or so kids who are old enough to eat on their own without supervision or discipline, this can be a great idea. Kids can enjoy each other's company and their parents can enjoy some adult time. If you're not sure where to seat a child, ask the parents.

How do we seat divorced parents?

You could ask them what they'd prefer. If your parents have a good relationship, they might all feel it makes sense to seat everyone together (so that one set isn't put with your in-laws while the other set is left out). If they'd rather sit separately, put parents with your siblings, their siblings, or grandparents and have multiple family tables.

What do I do if I'm feeling pressure to sit with certain friends or family members?

In this case, go for a sweetheart table. That way, you aren't forced to choose between parents or friends.

Where's the best place to seat grandparents and older folks?

Away from the band, DJ, and speakers. That way, they aren't getting overwhelmed with noise and can comfortably sit if needed. Put younger people near the music. But remember, your grandparents might have a thing or two to teach you about cutting a rug, so make sure they feel included and ready to dance themselves.

wedding toasts

Having people speak at your wedding is one of the most memorable parts of your celebration. From funny stories to sweet anecdotes to meaningful advice, the words your toast-givers say will stick with you for years to come. Having toasts allows everyone at your wedding to share (and learn) additional insight into who you both are, from hearing about your adventures as kids to your journey together in your relationship. While giving a little direction may be necessary (these are toasts, not roasts!), you'll undoubtedly be pleased and honored with the speeches your loved ones give.

Top Planning Tips

1. Share any parameters or information your speakers should know. For example, it's great to give a time limit (two minutes is usually enough), tell everyone the order in which they're speaking, and share any topics that are off-limits.

2. If you plan to speak at your wedding, don't just wing it or write your remarks the night before unless you're a seasoned speaker. You'll be more nervous and stressed if you're not prepared.

3. Unless you're having a small wedding, you don't plan on having dancing, or your reception has no hard-and-fast end time, don't do open mic toasts where everyone is invited to speak.

4. If you have your toasts during the meal—which is a great way to keep your timeline moving right along—ask the first person who speaks to invite everyone to keep eating as they toast you. That way, the food won't get cold as people attempt to be polite.

Before You Begin

Determine who you want to speak. While at many weddings the best man, maid of honor, and father of the bride give toasts at the reception, there are no rules about who needs to speak. Your best man may be very shy, or you may want to give an important role to another key person in your life who isn't part of the wedding party. You may even decide to break up the "traditional" speeches between the rehearsal/welcome dinner and the wedding, depending on how long your reception will be and what kind of meal you're serving (buffet or plated).

ETIQUETTE ADVICE It's often the custom for the best man to toast first, followed by the maid of honor, then you and your new spouse, if you wish to speak, then the father of the bride (or all of your parents—the bride's, then the groom's). But again, these are simply examples, and modern couples shouldn't feel obligated to stick to this plan. Anything goes, and do what feels right for you.

to-dos

- Talk to everyone who will be speaking about expectations and parameters.
- Answer questions as needed from your speakers.
- Figure out where speeches will fall into your wedding timeline.
- Tell speakers when they will be speaking and in what order.
- Coordinate with your DJ or bandleader to let them know where speakers are sitting during the reception and give them the order as well.
- Talk to the DJ or bandleader about audio: Is there a wireless mic that your speakers can use?
- Share any additional logistical info with speakers as needed.
- Write your own speeches, if needed.
- Enjoy your toasts!

to sum up . . .

Use this table to record the wedding elements described in this chapter as you tackle (and complete) them.

Item Requiring Attention	Your Decisions Thus Far
WEDDING VOWS	*Writing ourselves*
WEDDING VOWS	
CEREMONY	
WEDDING DAY SCHEDULE	
SEATING CHART	
WEDDING TOASTS	

Notes and Reminders

Start brainstorming ideas A S A P!

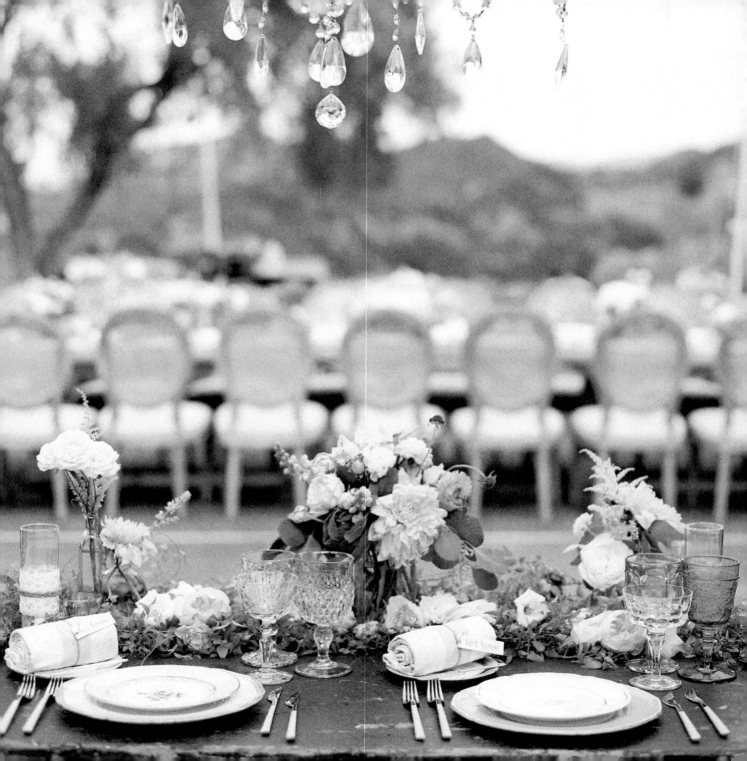

chapter ten
tying up
loose ends

1 WEEK OUT

*I*t's really happening—you are getting married this week! After months and months of planning, the fact that the big day is almost here may feel completely surreal to you. Stay grounded and stress-free by focusing on those last-minute tasks and let any loose-end details or DIYs fall by the wayside at this point. This week is for relaxing and gearing up for one of the most important days of your life—you don't want to be worrying about anything or running around all over town with a lengthy to-do list.

wedding week beauty prep

There are a few appointments you may want to make this week, depending on your typical beauty routine or needs. While getting married doesn't mean you need to completely change your look or go out of your way to primp, you and your partner may want to do some maintenance to get yourselves perfectly polished for the big day! Having beauty treatments is also a great way to force yourself to relax and have some "you time," so take advantage of it.

Top Planning Tips

1. If you're getting a manicure, consider paying a little extra for gel nails. This chip-free process lasts around two weeks, meaning you can get it done a couple of days ahead of time and it will stay perfect for the honeymoon.

2. A few days before the wedding, get what's called a "dusting" on your hair. Your stylist will just take a tiny bit off the ends, lopping off any damage and cleaning up your style.

3. Guys, consider getting a professional shave or beard trim to keep your facial hair (or lack of) in check—and so you don't accidentally cut yourself the morning of the wedding. In fact, if you can afford it, consider hiring a private barber to take care of all of your groomsmen.

4. The week before your wedding is not the time for your first facial or brow waxing. In fact, even if you've had these services before, schedule them at least two weeks ahead just in case you get a weird reaction.

5. You'll also want to *feel* your best on your wedding day. Take a yoga class, get a massage, or otherwise engage in some self-care so you'll glow from the inside out.

Before You Begin

Book your appointments at least a month in advance. Most beauty establishments require some lead time and you don't want to have to call 10 nail salons until you find one that can squeeze you in the day before the wedding. The best time to go to your appointments is mid-morning or midday a day or two before your wedding day—salons will be less crowded and you won't have to worry about getting rushed service. After all, a relaxed beauty pro means a more relaxed you, too.

INSIDER INSIGHT Some people opt to get spray tans for their weddings . . . but beware that the (often orange) solution can come off on your white clothing if you sweat. It is better to be pale than to ruin that gorgeous gown or crisp white shirt.

to-dos

- Decide what beauty services you'll need before your wedding.

- Call salons to make appointments at least a month in advance to secure time slots.

- Shoot for one or two appointments per day a day or two before your wedding.

- Go get your nails done, hair cut, beard trimmed, etc.

- Admire how good you look!

day-of emergency kit

On your wedding day, it's safe to say that you should expect the unexpected, which is why it's important to be prepared for things like wardrobe malfunctions, forgotten items, and general mishaps. Glitches may not happen, but if they do, you'll be thankful that you had the foresight to prepare by creating a day-of emergency kit. Here's what you'll need.

Top Planning Tips

1. For getting ready, have the following: Spot remover, static-cling spray, tiny scissors, a sewing kit, spare buttons for suits and dresses (you never know!), deodorant, pain reliever, bandages, dental floss, cologne, eye drops, toothbrush, hairspray, antacid, and clear nail polish.

2. For the actual wedding, be sure that you designate someone to carry your emergency kit—this could be a parent or one of your honor attendants. Make sure they have your cell phones, breath mints, a bottle of water, tissues, any needed touch-up makeup, an extra razor, and a brush.

3. If you're wearing makeup, don't forget straws! You'll want to stay hydrated while getting ready, and drinking from a glass can ruin your lipstick and even the makeup around your mouth—especially if you're doing airbrush foundation.

4. Drugstores and Bed Bath & Beyond carry travel sizes of many items you need so you don't need to pack the big ones.

Before You Begin

Talk with your parents or honor attendants about this to-do. Then go over together what you need and leave it in their hands. You'll have enough on your mind without worrying about putting together the kit and making sure it gets to the wedding.

💛 **TREND ALERT** Check out a company like Pinch Provisions for all-in-one emergency kits, which come pre-stocked with mini versions of things you need. The company offers special kits for all members of the wedding party.

to-dos

- Decide who is making and/or holding your kit on the big day.

- Determine what items you need and purchase.

- Put items into a small bag or pouch.

- Give the pouch to a parent or honor attendant.

the rehearsal

The day before your wedding, you and anyone who is part of your ceremony will do a quick run-through (usually no more than an hour) of the logistics to ensure everything runs smoothly for the big moment. Your wedding planner or coordinator, as well as your officiant, will handle this to-do for the most part, so all you need to do is show up. (And make sure everyone else does, too!)

Top Planning Tips

1. While this task won't happen until the week of your wedding, let your wedding party, parents, and readers or other ceremony participants know where and when the rehearsal will take place at least a couple of weeks in advance—then remind them again the week of the wedding.

2. Note how wide the aisle needs to be: If both of your parents are walking you down, for example, you'll want to fit comfortably. When you practice, ask your planner/coordinator to mark (or mentally remember) the width you need for clearance.

3. Your planner/coordinator will likely match your attendants by height so there's a clean line of people flanking you at the altar. Let them know, however, if there are certain people you definitely do (or don't!) want paired up.

4. If you expect your flower girl or ring bearer will be antsy during the rehearsal, bring new coloring books and crayons to keep them occupied.

5. Practice walking slowly (couples always rush down the aisle!) and, for brides, practice holding your bouquet at your navel so guests can see your dress (and face!).

Before You Begin

Check venue stipulations on when and where you can rehearse before sending any information out to your planner/coordinator, officiant, and the wedding party. Your venue may have only a certain window of time available, or it may allow you only to practice outside (even if your ceremony is inside). Be super clear about these rules in advance to prevent confusion the week of your wedding. (And be sure there won't be another wedding during the time you want to rehearse!)

💙 **ETIQUETTE ADVICE** At your shower, your maid of honor may have made you a fake bouquet out of your gifts' ribbons and bows—such a fun tradition!—so don't forget to bring it to your rehearsal.

to-dos

- Coordinate a rehearsal time with your venue.

- Spread the word about when the rehearsal will take place with your VIPs.

- Bring your fake bouquet—and your wedding shoes—to rehearse with.

- Let your planning/coordinator and officiant take the lead during the rehearsal.

- Run through the ceremony one or two times (until people are comfortable and clear on what they're doing, the order, etc.).

- Talk to your planner/coordinator about any logistics or questions that came up during rehearsal.

post-wedding logistics

At this point, you're probably very clear on how everything—food, décor, flowers, rentals—is getting to the wedding, but you may not have determined how everything brought in will leave the venue once the celebrations concludes. For the most part, your vendors will take care of everything they brought in, but there are still some logistical and cleanup-related tasks you'll want to sort out. Here are some important points to consider and how to make the wedding break down as easy as the setup.

Top Planning Tips

1. Even if you're providing wedding transportation, ask someone (perhaps a parent or trusted friend) if they can drive to the wedding. That way, anything you want to take home can be stored (and schlepped) in their car.

2. If you provided DIYs or any décor, give instructions to your planner or coordinator as to which items are yours, and make sure to leave empty boxes for them so they can be carefully set aside during cleanup.

3. If you want to keep your flowers after the wedding (and you didn't provide your own vases), talk with your florist about what might be needed from you in order for you to take flowers home, like plastic containers to place the arrangements in.

4. Bring some large cardboard boxes to your venue in which your planner/coordinator can put your wedding gifts/cards.

5. Find out if rentals (like tables) need to be broken down and stored in a designated place for pickup, as well as who would be in charge of doing that.

Before You Begin

Revisit your venue contract, or talk with the person in charge, about when your rental company (and other vendors through which you're renting items, like linens) can pick up their stuff. Some venues require everything to be out the night of your wedding, while some are open to the following day, or even the Monday after the wedding. Then, check these rules against when your rental company requires everything to be turned in. If the two match up, great. If not, work with your vendors to figure out when exactly the pickup can occur and if there are any additional costs you need to pay to make that happen.

PLAN AHEAD If you've arranged with the caterer to keep the top tier of your wedding cake, designate someone to take it back to your home or your hotel room so you can either enjoy it the next day or freeze it for your one-year anniversary.

to-dos

- Find out the venue and vendor stipulations on rental pickup.
- Determine who's breaking down what.
- Ask the coordinator/planner about how your personal items will be cleaned up and stored.
- Talk to your florist about taking home centerpieces.
- Ask the venue about any cleaning fees or rules about breaking down.
- Enlist extra help from family and friends for cleanup, if needed.

Cleanup Crew

The last thing you want to think about before your wedding is how the heck your celebration is going to get cleaned up afterward. Luckily, if you're holding your reception at a hotel or other all-inclusive venue, you don't have to worry about much—you just need to get your gifts, cake, and maybe your flowers home at the end of the night.

However, if you're hosting your fete at a place for which you rented a number of items or brought in a bunch of your own décor, you're going to need to figure out how everything will be removed from the space.

For your rentals, usually your caterer and staff will break down your tables, chairs, and linens and put them in a designated place for the rental companies to pick up—just as they have done dozens of times. It's always a good idea to check in with your caterer, however, to make sure.

For DIY and décor items, talk with your planner or coordinator about striking those: Typically, your vendor will be contracted to stay an hour later than your event's end time, meaning they will devote that hour to cleanup. Whatever you need done during that time, they will do.

If you're hosting your wedding at a private home, brought in all of your own items (no rentals), and/or don't have a wedding planner/coordinator, you'll have to do a bit more legwork. In this case, you'll want to designate a cleanup crew (or hire one) to come in and do the job. You two don't want to be stacking chairs and taking down twinkle lights on your wedding right, right?

REAL COUPLES SPEAK

"Remember to get an exact time for leaving the party and give jobs to other people, or else you'll end up running around trying to finish things yourself on your wedding day."
—Adèle and Brett

Vendor Payments and Tips

The other component of post-wedding logistics has to do with paying your professionals and tipping them. Even though most wedding vendors are paid a premium for their services and most are self-employed, tipping is still customary and, typically, tips are to be given on the night of the wedding.

However, since many vendors now require payment in full before the celebration takes place—and because bringing a bunch of cash to your wedding is just one more thing to plan—you may consider a different approach: Pay your vendors on their due dates, as stated in your contracts. Then, after the wedding, write your vendors thank-you notes and include the tip in the envelope.

The reason for this? Because you don't really know how much to tip someone until they've actually performed their service. Usually, tips are between 10 and 20 percent, but the amount you tip will vary by state (and country), so it's best to ask around to find out what's customary for superb service.

Speaking of service: At this point in the game, you may find that you're really happy with certain vendors and not so much with others. If you have a hard-to-work-with, or even total nightmare, vendor, there are a few things you can do. First, speak with them frankly about your concerns—you are the paying customer, after all. If your relationship is at the point where you don't feel comfortable having this person as part of your big day, you might want to break your contract (and lose your deposit) to try to secure a new vendor. But beware, it may be very difficult to find another pro as you get closer to your wedding date.

If you decide to just grin and bear it, or your candid discussion didn't yield results, give your feedback after the wedding and opt not to tip the person.

TIPPING CHART

This is a general guide on how much to tip your various vendors. Of course, how much you give is entirely up to you!

Wedding planner/day-of coordinator: 15% or personal gift

Photographer and videographer: $100 or personal gift

Officiant: $50 to $100 or personal gift

Musicians: $20 to $50 each

DJ or bandleader: $50 to $100

Catering manager: $200 or personal gift

Chef: $100 to $200 (depending on scope and scale of food)

Waiters: $20 to $30 apiece

Bartenders: $20/hour apiece or 10% of total liquor bill (if you didn't supply your own alcohol)

Transportation: 15%

Hair and makeup: 15%

Coat check and valet attendants: $1 to $2 per guest

Restroom attendants: $1 per guest

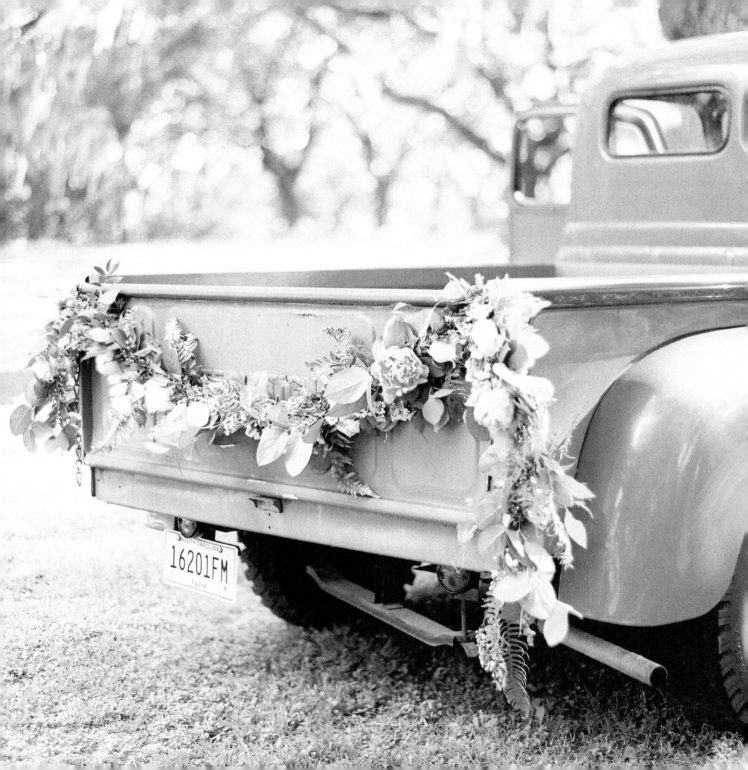

to sum up . . .

Use this table to record the wedding elements described in this chapter as you tackle
(and complete) them.

Item Requiring Attention	Your Decisions Thus Far
DAY-OF EMERGENCY KIT (YOU)	*Mom putting together*
DAY-OF EMERGENCY KIT (YOUR PARTNER)	
WEDDING WEEK BEAUTY	
THE REHEARSAL	
POST-WEDDING LOGISTICS	

Notes and Reminders

Send her some ideas

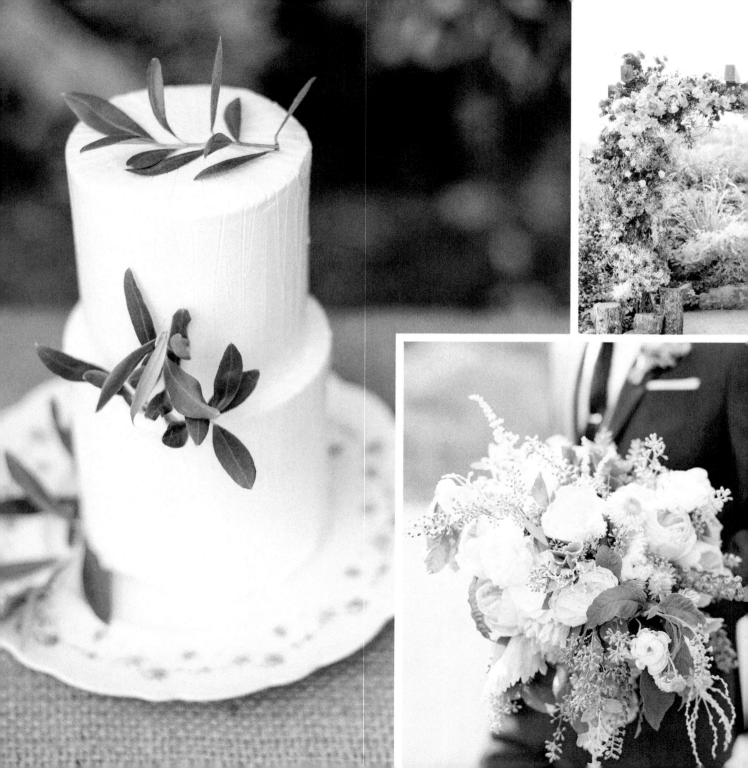

The Big Day and Beyond

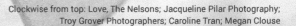
Clockwise from top: Love, The Nelsons; Jacqueline Pilar Photography; Troy Grover Photographers; Caroline Tran; Megan Clouse

chapter eleven

tying
the knot

The day is finally here—you two are getting married! Time probably sped up just a little bit as the days ticked down to *the* day and your to-do list got shorter and shorter until . . . woo hoo, no more to-do list! You may have some jitters, but rest assured—no matter what happens—you're about to have one of the most fun, memorable, and meaningful days of your life. This chapter is all about guiding you through your wedding weekend so you have some idea of what to expect, as well as some insight on how to get the most out of your day.

the night before

You've completed the rehearsal and now it's time for your rehearsal dinner or welcome party, at which you'll get to see some of your closest family members and friends—all in the same place at the same time! The feelings of gratitude and excitement may be overwhelming. Everyone is here to celebrate *you*, after all!

Guests will likely be in a festive mood, but you'll want to try your best to keep alcohol consumption to a minimum and get to bed early. Yes, this might be very hard to do with *all* of your nearest and dearest around you. If you can, follow the Cinderella rule and shoot for being back at your home (or hotel) by the time the clock strikes midnight.

If you two are staying together as a couple, the night before is a great time to exchange gifts (or cards) and just talk a little bit about what you're looking forward to the next day. If not, and you're staying with siblings, parents, or friends, maybe watch a quick sitcom to help keep you from getting nervous. Also, do a quick double check that you have your wedding attire, accessories, emergency kit, and your vows, to set your mind at ease.

Then, take a hot shower or bath and set yourself up for a good night's sleep . . . if you can.

Many couples have trouble sleeping the night before the wedding whether or not they are sharing a bed that night, which is perfectly understandable. However, this isn't a good night to try a sleep aid for the first time! Instead, drink some chamomile tea or do some deep breathing to relax and quiet your mind. Don't beat yourself up for not being able to catch some Zs—it's normal and you'll still have a great wedding day even if you wake up tired.

REAL COUPLES SPEAK "Keep a journal to record thoughts and experiences from your wedding weekend. We started ours on our long drive down to the venue and jotted notes at the end of each day, all the way through our honeymoon. We review it every year on our anniversary and laugh (or cry) as we remember the big and small things that made impressions on us." —Stacy and Stephanie

the big day

The morning of your wedding, you'll probably be in disbelief that the day you've spent countless hours thinking about and planning for is actually here. To stay grounded, try to go about your morning routine as normally as possible: Have your cup of coffee, eat breakfast, brush your teeth, shower—doing these everyday things will settle any nerves you might still have.

For brides: Before your makeup and hair persons arrive, wash your face and put on something comfortable that you can easily take off without messing up your 'do (like a robe). Throw on some tunes or a TV show or movie you like to set the mood, and then start getting ready with your girls.

For grooms: You have it a little easier—all you need to do is brush your hair and put on a suit or tux, along with any other kind of preening you like to do. If you can, sleep in, go for a run, take advantage of the hotel pool (don't forget sunscreen!), watch something on TV, or just spend time with your groomsmen. Then take a long, hot shower, clean yourself up, and make sure you don't

PRE-WEDDING JITTERS

Call them nerves, cold feet, or whatever you want—just don't freak out if you're, well, kind of freaking out the night before your wedding. You have all of your family and friends in one place and you're taking a huge life step. It's only natural that you'd be a bit worried about this high-pressure situation. More than likely, you're marrying your partner for the right reasons and you're beyond sure that you two should get hitched. But, at the last minute, you may still feel some doubt creeping in.

To combat your jitters, talk to a trusted friend about your feelings, meditate for 20 minutes, or do a quick workout. Any of these activities will help clear your mind and refocus on the positive. Plus, once the morning of your wedding arrives, your nerves will turn into excitement.

cut yourself shaving! Ultimately, though, do everything you can to relax before the big day officially starts.

As you go about preparing for the big day, make sure to breathe, drink some water, and keep the mood as low-key and stress-free as possible. If you need to take a break or get some space (which is only natural if you're in a hotel room with a bunch of people trying to get ready at the same time!), duck out into the hallway or bathroom to center yourself. Or, better yet, tell your honor attendants that you're feeling a bit overwhelmed and would like them to clear out the room for you for a bit. Doing this will ensure that you'll stay cool and collected.

What to Expect at Your Own Wedding

Don't be alarmed if your wedding seems to go by in an awesome, happy blur. Many couples report that they don't remember many visual details from their weddings, but more of a feeling of love from their big days.

One thing you can definitely count on is feeling amazed—in the best way possible—by having everyone you love the most in one place. As you walk down the aisle, and mingle with guests during the cocktail hour and reception, you'll see your childhood best friend sitting next to your partner's younger brother, and your college roommate chatting with your cousin. Talk about surreal!

Of course, you'll want to catch up with and talk to every one of these people since you care deeply for all of them—but don't beat yourself up if you can't have a meaningful chat with every one (or even any!) of your guests. You can have a receiving line after the ceremony, or try to make an effort to visit each table during the reception. Of course, people will be coming up and congratulating you, or asking for a photo, or even offering you a glass of champagne. You may feel a bit pulled in different directions—all of them great ones!—but it could be hard to really get a conversation going with anyone before you're sweetly interrupted by another dear friend or family member.

5 THINGS TO REMEMBER

1. **EAT!** Even if your dress is really tight. Even if you're not hungry. Just do it. You spent all that time putting together the perfect wedding menu—enjoy it!

2. **Don't stress if you run late.** While you don't want to be hours behind, it's normal for your timeline to run a bit late on the big day (which is why you built all those buffers in). Take your time getting ready and don't rush—your wedding day will happen only once. Savor it, even when the clock is ticking.

3. **Keep your cool.** Inevitably, something will not go as planned. Maybe you'll hate your hair or your bouquet won't have the right flowers or one of your guests will miss a flight. Breathe slow, calming breaths, gently steer your attention back to the present moment, and remind yourself that it will all be okay. Yes, even if you hate your hair.

4. **Watch where you're going.** When you're walking down the aisle, you may start fretting that you'll somehow trip on your gown, if you're wearing a dress. And, as a result, you might feel the urge to look down at your feet. Instead, look at your partner: Not only will this be ideal for pictures, but you're far less likely to take a wrong step if your gaze is ahead of you.

5. **Get some alone time with your partner.** Sneak at least one private moment together after the ceremony, whether it's right after you recess (the venue may have a quiet place you can go) or before your grand entrance into your reception. You'll be surrounded by people the whole day/night so it's nice to take a little time for just you two. Have some champagne. Have your caterer bring you some cocktail bites. Most of all: Have fun celebrating the fact that you're married!

If you're not used to being the center of attention—and even if you are, nothing can prepare you for your wedding—you might feel a sense of incredulity that you and your partner are indeed the ones in the spotlight. After attending a number of weddings yourself, it can be hard to believe that it's your turn, happening right this second. It's all totally, totally normal!

Meaningful Moments at the Ceremony

Your ceremony will be incredibly meaningful as a whole, but there are certain moments in which you'll want to take pause and truly savor, no matter what kind of ceremony you have.

First, walking down the aisle toward your partner, watching your partner walk toward you, or walking together: It's likely a moment you've pictured in your head thousands of times and now it's actually happening. Look at each other, smile, cry, have an internal dance party.

At some point, your officiant may prompt you to look out on the crowd, but if not, sneak a glance during the ceremony if you can. Sitting before you is everyone you love and the significance of this cannot be emphasized enough. This group of people will literally never be assembled again—ever. (Unless, of course, you have a very intimate wedding.) Gaze out on everyone's faces and let yourself feel the emotion of knowing that they're all here for you.

Saying your vows is another special moment you'll want to cherish. Really listen to the words you're saying to each other and take your time speaking those words yourselves. Your vows are in fact more than words; they're solemn promises you're making that will last the rest of your lives.

Finally, the kiss: You and your partner have certainly smooched before, but this lip lock is different than all others—it's your first kiss as a married couple! Hearing your officiant say "By the power vested in me . . ." or some variation of that classic line is another instance where you'll feel a wave of "Wow, this is really happening!" And when your officiant prompts you to kiss each other, your guests will cheer and clap, creating a dreamlike moment that feels completely surreal.

Reception Memories to Treasure

The party component of your wedding will also be filled with a number of memorable moments. Here are just a few that many couples will experience, no matter what kind of shindig they've decided to throw.

Your grand entrance is the moment you're first announced as a married couple. While you've already seen all your guests cheer for you, for some reason this moment may feel different than the conclusion of your ceremony. There's just a different vibe: While ceremonies are usually a bit more reserved, the reception is for partying. Your guests may whoop and holler for you, making you feel like total rock stars.

You'll soon forget that all eyes are on you during your first dance as the two of you share a romantic moment swaying (and maybe even twirling) to a song that's meaningful to you. Even if you have two left feet, you won't remember your moves (or lack of, as it were). You'll cherish the way this first dance together felt.

If you chose to have parent (or grandparent) dances, these will be very special as well. When's the last time you actually danced with your parents, after all? Plus, since your wedding is a rush of people and excitement, getting just a few minutes to spend with just your parents is really special. As you whirl around the dance floor, you'll likely talk a little, reminisce a little, and just enjoy each other's company.

During your reception toasts, you'll laugh—and maybe even cry—as people close to you share stories, memories, and heartfelt words to honor both of you and your relationship with each other.

Finally, hitting the dance floor with everyone you love will be a surreal experience. You'll be grooving with your best friends, your cousins, aunts and uncles, and your family friends all at the same time. Nothing in the world compares to being surrounded by all of these people at once.

Post-Reception Parties

Depending on your (and your guests') stamina, you may opt to celebrate well into the night with your loved ones. Some couples plan a formal after-party (especially if their reception venue closes up fairly early), taking the soiree to another location. This after-party can be hosted by the couple, or it could be an every-person-for-themselves sort of affair, whatever your budget allows. Either way, your night-owl guests will love the chance to spend more time honoring you.

After-party ideas can range from late-night bites and beverages at the wedding accommodations hotel bar to karaoke at a local dive spot to a dance club. You can have your wedding transportation take guests either to the hotel or to the after-party, if the locations are different, giving your loved ones a choice of continuing the fun or getting some needed rest.

Some couples choose not to have huge after-parties, but instead invite the wedding party and other close family and friends to hang out in the wedding suite after the official celebration is over. However, this certainly doesn't appeal to everyone.

Others decide to have a quieter after-party just for two by ordering room service, walking down to the beach (if your hotel is near the ocean), or getting a nightcap at a favorite bar.

If you're not sure about an after-party while planning your wedding, that's okay! Sometimes, these post-nuptial celebrations are completely spontaneous. There's certainly no harm in just seeing where the night takes you.

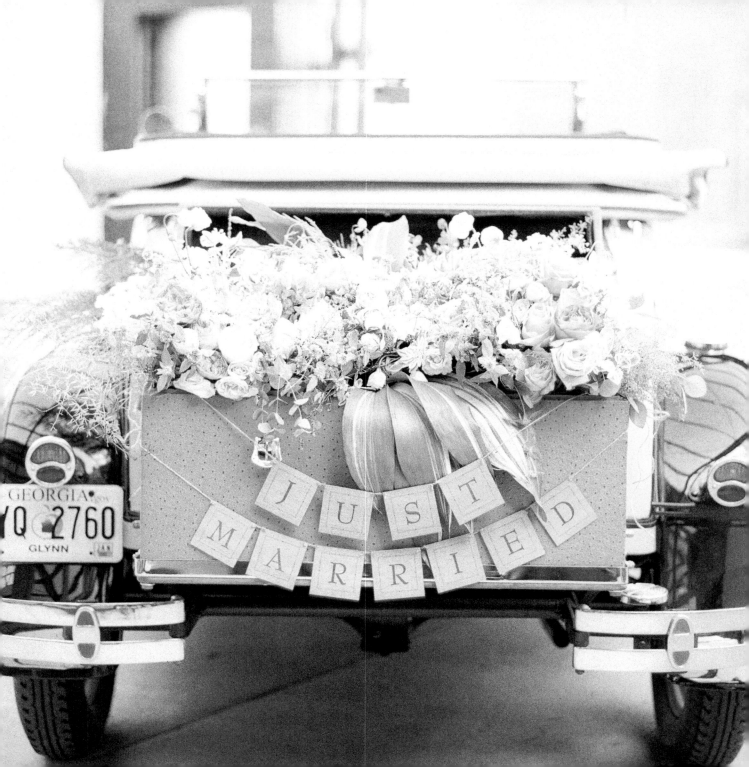

chapter twelve

happily
ever after

Can you believe it's over? All that planning and dreaming for one amazing day—and now you have incredible memories to cherish for the rest of your life. At this point, you may have already enjoyed your honeymoon (or will soon) and you may have even received your wedding photographs and video, allowing you to see a different perspective of your big day than just your own. But you not only have memories to enjoy . . . you also have special keepsakes and gifts! This means there are just a couple more to-dos to complete post-wedding.

post-wedding blues

For some, wedding planning couldn't be over soon enough. For others, they wish they could plan another wedding because they enjoyed the process so much. Either way, it's more than natural to mourn the fact that your big day, which you may have dreamed about since childhood, is now over.

One reason for these blues is because the time you spent planning was so much longer than the actual wedding itself. You had months to prepare, wonder, and execute— and mere hours to enjoy the fruits of your labor. This disparity can make you feel like you didn't cherish each moment enough or you may beat yourself up for not remembering enough. Again, this is normal. Your wedding day was such a rush of excitement, anxiety, and emotion, there is just no way you could think and process every minute clearly. Even if you had the most low-key, easygoing wedding day, you still might not remember everything. That's just how the brain works! Do you remember everything you did last Tuesday or even yesterday? Probably not! Your wedding is no different, even though you think it should be.

You may also be bummed that you got to see everyone you love in life—oh so briefly—and now most of them have gone back home. If many friends and family members are far away, plan some Skype dates or figure out when you might be able to visit them to quell these feelings of sadness.

If you truly have the blues about no longer being able to plan a fun celebration, channel your energy into other fun activities: Plan your spouse's birthday, or an upcoming holiday, for example. Decorate your new place, frame wedding photos, or host friends and family who live close by and put those party-planner skills (as well as all of those new registry items) to use.

albums and keepsakes

To preserve your wedding memories, you probably want to make a wedding album of your favorite photos. There are two ways to go about this: through your photographer or by creating an album yourself. The latter

is more affordable and will allow you to choose the shots you like the best, which is why many couples decide on this route.

You'll also want to have some photos printed so you can frame and display them in your home. Going through your photographer directly is an option; however, there are a number of companies that do professional-quality printing and enlargements that might be more budget-friendly. Snapfish is good resource for photo prints, while Framebridge is known for providing services that allow you to print photos on canvas.

Another way to create a keepsake is by making a shadowbox of key items from your day: your invitation, a favor, a menu, a program, some confetti, a dried flower from your bouquet, and so on. You could even just frame your invitation as a way of remembering your day.

Finally, you'll probably want to save the cards you received from your wedding guests, as well as RSVP cards or any other card you asked guests to write on (advice cards, Mad Libs, etc.). Put all of these keepsakes into a labeled box so you can revisit

them on your anniversaries, or, if you plan to have children, to show them how their parents celebrated their special day.

gratitude and appreciation

While you may have heard that you have a year to send thank-you notes for your guests, some etiquette experts say that you have only two months after your wedding to mail your notes of appreciation. Send thank-you notes along the way as you receive gifts. Aim to complete thank-yous within three months after the wedding, but keep cranking them out even if you miss that deadline. It's better to send a late thank-you card than to give no thank-you at all.

To help make this process easy and painless, use the spreadsheet you created to track your RSVPs to log your gifts and thank-you notes, too. Add a column so you can input what you got from each person, and then add another column that you can check off after you've sent your thank-you card. This way, no sentiment of appreciation will fall through the cracks.

STORAGE TIPS

Preserving a gown: Getting your wedding dress preserved is a long-time tradition that's supposed to prevent your gown from yellowing or getting damaged. At the very least, get your dress professionally cleaned soon after your wedding to prevent any stains from setting in. (For example, if you happened to get frosting on your gown, the enzymes in sugar can actually turn your dress brown over time.) Research options in your area, which can range from local full-service gown preservation companies to national companies to which you can mail your dress for cleaning.

Preserving the cake: Many couples choose to freeze the top layer of their wedding cake and eat it on their first anniversary. To ensure your cake stays as palatable as possible, set it on a foil-wrapped or plastic cake board, then put it in the freezer for 30 minutes. Once the frosting has set, take it out and cover the entire cake with two layers of foil, then freeze. Transfer to your refrigerator 24 hours before your anniversary so it can defrost, then let it sit out an hour before you want to eat it. An alternative (and very old-school) choice for preservation is to have a traditional fruitcake as the cake-topper, and instead of freezing it, preserve it in rum, like any holiday fruitcake. It's up to you!

Saving the bouquet: Some brides opt to preserve their entire bouquets, either by drying them or having them dipped. While wanting to save your flowers is common, know that they'll never look the same as they did on the big day. Instead of drying the bouquet intact, you may want to pull blooms out and press them, which can help the flowers retain their color and shape. Then, you can frame and display them with pride.

When writing your thank-you notes, split up your guest list by "side" to expedite the process, and keep your letters short, sweet, and specific. Thank each person for coming to your wedding, for the gift they got you, and then say something unique about how you might use the gift or a memory you have of them from your wedding—something that shows the person how much you care.

Vendor tips were mentioned in chapter 10, but it's worth noting that thank-you notes for your wedding pros—and well as any tips you'd like to give—should also be sent out soon after your wedding, too. You should also write reviews for your vendors on WeddingWire as well—it's an important way for vendors to get business.

newlyweds and names

To change or not to change, that is the question. And only *you* can answer it. While there are all sorts of reasons why someone might want to change their last name to match their spouse's, it's really a matter of personal preference.

Here are some reasons why many choose to change their names:

- Because they'd like to identify themselves as a family unit with their spouses.

- Because having the same name can make it easier for teachers or doctors to identify them as their child's mother, if their children have their spouse's last name.

- Because they believe in keeping with tradition.

- Because it's something that's important to them or their spouses.

- Because they don't feel attached to their given names.

And here are some reasons why people choose to keep their names:

- Because they love their original last names.

- Because it's too much of a hassle to change it.

CHANGING YOUR NAME

Switching to a new last name can be a lengthy, paperwork-ridden process. Here's the order you need to go in:

1. Get your marriage license (at least two copies so you have one to keep).

2. Change your Social Security card using your marriage license.

3. Change your driver's license. (You'll need your new Social Security card and marriage license.)

4. Change your bank accounts. (Bring your new driver's license and marriage license.)

5. Change your passport. (You'll need to mail in your current passport and a certified copy of your marriage license.)

6. Change your name everywhere else—with your employer, the post office, your doctor, your voter registration, your insurance companies, and your credit cards. (You will need one of your new IDs to do this in many cases.)

- Because they're established in their professions and don't want to cause confusion with a new name.

- Because they don't agree with the tradition.

- Because they or their spouses don't feel strongly about it either way.

However, there's more to this decision than just changing your name: You might decide you'd like to hyphenate both of your last names, change your middle name to your previous last name and take your new spouse's last name as your surname, or your spouse may even opt to take your last name. Some couples choose completely new last names and/or combine portions of their given surnames; for instance, Rinski and Werner could become Rinner. One thing you need to be sure of is that whatever you decide to do matches what your marriage license says. In some states, you're actually required to make your name change decision *before* you get married, or else you have to go through some extra hoops after the fact.

celebrating your first year of marriage

While you may already be in the habit of celebrating your dating anniversary, marking your years of marriage is even more special! There are certain traditional gifts associated with each wedding anniversary, with the first year being paper and the second cotton, as well as their modern-day equivalents (first year is clocks and the second is china), which is a fun way to mark the years.

Whether or not you want to follow these gift-giving guidelines is up to you. Some couples choose to take a vacation every year on their anniversaries, others watch their wedding videos, renew their vows, or write heartfelt love letters reaffirming their commitment.

Your first wedding anniversary not only sets the tone for all others, but it also has some unique aspects that your subsequent anniversaries won't. First, you might have a sweet treat from your wedding awaiting you in the freezer. (Flip back to page 256 for directions on thawing that wedding cake out!) Second, you may have something from your wedding—like a memory box, time capsule, or the like—that you vowed to open on your one-year anniversary.

Whatever you do, take time to celebrate your partnership and the amazing foundation of love, respect, and commitment you've built together. The first year of marriage can be a wild ride of officially beginning your life together, assuming your new spousal roles, and meeting each other's expectations—plus, you may have even started a family, adopted a pet, moved cities, or bought a house! Commemorate the occasion with pride, and take this time to revel in your relationship—and each other.

You may have heard people say that your wedding is the best day of your life—and it's true that getting hitched is one of the most memorable and amazing experiences you'll ever have. But don't think that the best is past, because your wedding is certainly not the culmination of your relationship—it's only the beginning! A lifetime of memory-making, adventures, and love awaits you. Have an absolute *blast*!

acknowledgments

When my parents planned their cross-cultural wedding back in the 1980s, my American mother and Lebanese father didn't have the resources to guide them through the weaving together of different traditions. So, when the first of my four siblings got engaged many years later, our family was especially determined to make the day as personal as it was memorable. At that time, our mom was very sick, so our emotions were even more heightened while we planned. But it all came together as we found special ways to celebrate the joining of two families, while also honoring our mom.

During this process we were reminded that weddings can be full of happiness, and also challenges. With this book, I hope to make the planning part easier, so you can really focus on what matters most to you—this joyful union.

My gratitude for the people who helped to put this book in the hands of busy couples knows no end. Thank you to my father,

Charles, my late mother, Kaaren, and my stepmom, Maggie, for instilling their dedication, passion, and vibrant entrepreneurial spirit in me. To my siblings and their other halves—Leila, Tony, Jacque, KarriAnn, Monika, Jirard, Rick, Tanya, and Tony—for their unwavering support, and to my niece and nephews for their unconditional love. Thank you also to Elliot Tomaeno, Mike Zusel, Jaime Davern, and Kristen Dennis, for being my friends and forever

cheerleaders, and to Robyn Costanzo, for truly helping me find my voice.

I'd like to thank Peggy Fry, for being a wonderful mentor and partner, and Meredith Howard, for helping me build a powerful brand we're all so proud of. Thank you to Natasha Burton and Jessica Laird for helping to fill these pages with the best advice; to Alexia Conley, Sharon McMullen, and Jaclyn Kerschner for the gorgeous imagery and inspiration; and to Danielle Morrone for getting this guide to couples in need of a helping hand. And a huge heartfelt thanks to the entire Loverly family for their hard work and endless enthusiasm. Look at what we built!

Thank you to the dedicated wedding vendors and bloggers, whose talents have helped to bring Loverly and this book to life. And to all of the photographers whose stunning work is showcased here. I'd also like to thank the inspiring tech communities on both coasts, for welcoming me, challenging me, and cheering me on. And, an enormous thank you to my inspirational boss ladies, Anu Duggal, Joanne Wilson, Jenny Lefcourt, and all of the female entrepreneurs who have helped to pave the way for strong women in business.

Finally, thank you to the team at Callisto for helping make my dream of publishing a beautiful wedding book for modern couples an even more beautiful reality.

xo, Kellee

sample timelines (checklists)

These same timelines and checklists are also available for free on our website at lover.ly/tools/wedding-checklists. Use these to manage all of your important details so that your wedding day becomes the best day of your life thus far.

18-month timeline

12 to 18 months out

- ☐ Brainstorm your wedding vision, style, or theme
- ☐ Take engagement photos, if desired
- ☐ Set your date
- ☐ Start creating your guest list to get a sense of scope
- ☐ Confirm that potential venues are available on the date you'd like
- ☐ Share your date with your nearest and dearest as an informal pre-save-the-date
- ☐ Create a budget
- ☐ Hire a wedding planner or day-of coordinator
- ☐ Book your venue
- ☐ Attend tastings and book your caterer

9 to 11 months out

- ☐ Set your guest list, and order save-the-date cards
- ☐ Contact guests to ask for their addresses, and save them in a spreadsheet
- ☐ Create your wedding website
- ☐ Research invitation styles (especially if you want them to match your save-the-date cards), and order invites
- ☐ Plan your engagement party, if you're having one
- ☐ Send out save-the-dates (at least 6 months before, longer if you're hosting a destination wedding)

- ☐ Decide who you want to be in your wedding party, and ask them
- ☐ Set up your gift registry, and add the info to your wedding website
- ☐ Research guest accommodations, and book hotel room blocks if needed
- ☐ Book an officiant
- ☐ Book your photographer
- ☐ Book your florist
- ☐ If applicable, shop for your wedding dress (remember that designer gowns can take 6 months to create)
- ☐ If applicable, shop for your tux (or research rental options)

6 to 8 months out

- ☐ Book a videographer (if needed)
- ☐ Book your entertainment
- ☐ If applicable, do hair/makeup trials, and choose your beauty vendors
- ☐ Decide on your menu, and schedule an additional tasting with your caterer if necessary
- ☐ Book a baker or dessert vendor for your wedding cake (or other confection you plan to serve)
- ☐ Determine your transportation needs, and book cars/limos/shuttles
- ☐ Shop for and order your wedding rings
- ☐ Choose wedding party attire

4 to 5 months out

- ☐ Ask the venue for a room layout so you can plan the venue setup and determine what rentals you'll need
- ☐ Put rental orders in
- ☐ Choose additional games and entertainment
- ☐ Make honeymoon travel arrangements
- ☐ Make sure your passports are updated and valid for the time of your honeymoon (if applicable)
- ☐ Submit vacation time for any days you'd like to take off from work for your wedding well in advance
- ☐ Choose your own wedding accommodations
- ☐ Plan the rehearsal dinner or welcome party (venue, guest list, invitations, etc.)
- ☐ Plan the post-wedding brunch (location, invitations, etc.)
- ☐ Research marriage license requirements
- ☐ Attend premarital counseling if your officiant requires it
- ☐ Finalize floral choices, including attendant and personal flowers
- ☐ Choose shower date, and give guest list (plus addresses) to your shower host
- ☐ Start beauty regimes (skin care, eyebrow shaping, personal training, etc.)
- ☐ Hire a calligrapher, if needed

2 to 3 months out

- ☐ Purchase gifts for attendants, parents, each other, and those who are hosting your shower(s)

- ☐ Visit your venue(s) with your planner or day-of coordinator to go over logistics (your caterer or florist might want to come with you as well)

- ☐ Assemble invites, determine postage, and send at least 6 weeks before your wedding day

- ☐ Attend celebrations in your honor, such as showers or bachelor(ette) parties, then write and send thank-you notes

- ☐ Plan bridesmaid luncheon (if applicable)

- ☐ Choose and order/make your wedding favors, escort cards, place cards, menus, and ceremony programs

- ☐ Plan and create welcome baskets (if applicable)

- ☐ Pick up rings

- ☐ Attend suit/tux and/or wedding gown fitting

- ☐ Finalize décor and details—and finish all DIYs—by your 2-months-out mark

- ☐ If providing your own alcohol, put in your delivery order or buy outright from store

- ☐ Get your marriage license (at least 30 days before your wedding)

- ☐ Buy wedding accessories, including shoes, headpiece, tie, etc.

- ☐ Purchase any extra items like a cake knife, guest book, ring pillow, etc.

- ☐ Meet with photographer and videographer to go over expectations and logistics

1 month out

- ☐ Talk to your officiant about your ceremony structure and content

- ☐ Choose (or write) your vows

- ☐ Create and finalize wedding-day schedule, and share with vendors

- ☐ Create your seating chart, and share with planner/coordinator, DJ/bandleader, and caterer

- ☐ Talk to family/friends who you want to speak (ceremony readers and people giving toasts)

- ☐ Decide on your music for key moments: processional, recessional, first dance, any other special dances, cake-cutting, last dance

- ☐ Put together must-play and do-not-play lists for DJ/bandleader

- ☐ If you still have outstanding replies after your RSVP date, contact those guests to find out if they are coming or not

- Give final guest count to planner, caterer, rentals company, and other vendors who request it by their deadlines
- Pick up your wedding outfits
- Confirm with all vendors
- Make beauty appointments for the week of your wedding
- Figure out how décor items you own (and DIYs) will get to and from your wedding

1 week out

- Attend beauty appointments: manicure, shave, haircut, etc.
- Pack for honeymoon (if applicable)
- Pay outstanding vendor balances by due dates
- Assemble day-of emergency kits
- Determine post-wedding logistics (cleanup and vendor tips)
- Attend your bridesmaid luncheon (if applicable)

Day before

- Do something relaxing (yoga, meditation, light workout)
- Attend rehearsal
- Attend welcome party/rehearsal dinner
- Give attendants, parents, and each other your gifts

Day of

- Eat breakfast
- Drink plenty of water
- Get ready
- Get married!

six-month timeline

6 months before (ASAP!)

- Brainstorm your wedding vision, style, or theme
- Take engagement photos, if desired
- Set your date
- Start creating your guest list to get a sense of scope
- Confirm that potential venues are available on the date you'd like to choose
- Share your date with your nearest and dearest as an informal pre-save-the-date
- Create a budget
- Hire a wedding planner or day-of coordinator
- Book your venue
- Attend tastings and book your caterer
- Research guest accommodations, and book hotel room blocks if needed

- Set your guest list and order save-the-date cards
- Contact guests to ask for their addresses, and save them in a spreadsheet
- Create your wedding website
- Send out save-the-dates
- Start researching invitation styles (especially if you want them to match your save-the-date)
- Decide who you want to be in your wedding party and ask them
- If applicable, shop for your wedding dress (remember that designer gowns can take 6 months to create) and/or suit/tux
- Determine your transportation needs, and book cars/limos/shuttles
- Shop for and order your wedding rings
- Choose wedding party attire
- Order invitations
- Set up your gift registry, and add the info to your wedding website
- Shop for your tux (or research rental options)
- Book a baker or dessert vendor for your wedding cake (or other confection you plan to serve)
- Do hair/makeup trials, and choose your beauty vendors

- Ask the venue for a room layout so you can plan the venue setup and determine what rentals you'll need
- Put rental orders in

4 to 5 months out

- Ask the venue for a room layout so you can plan the venue setup and determine what rentals you'll need
- Put rental orders in
- Choose additional games and entertainment
- Make honeymoon travel arrangements
- Make sure your passports are updated and valid for the time of your honeymoon (if applicable)
- Submit vacation time for any days you'd like to take off from work for your wedding well in advance
- Attend premarital counseling if your officiant requires it
- Choose your own wedding accommodations
- Plan the rehearsal dinner or welcome party (venue, guest list, invitations, etc.)
- Plan the post-wedding brunch (location, invitations, etc.)
- Research marriage license requirements
- Choose additional games and entertainment

- Finalize floral choices, including attendant and personal flowers
- Choose shower date, and give guest list (plus addresses) to your shower host
- Start beauty regimes (skin care, eyebrow shaping, personal training, etc.)
- Hire a calligrapher, if needed

2 to 3 months out

- Purchase gifts for attendants, parents, each other, and those who are hosting your shower(s)
- Visit your venue(s) with your planner or day-of coordinator to go over logistics (your caterer or florist might want to come with you as well)
- Assemble invites, determine postage, and send at least 6 weeks before your wedding day
- Attend celebrations in your honor (showers, bachelor/bachelorette parties), then write and send thank-you notes
- Plan bridesmaid luncheon (if applicable)
- Choose and order/make your wedding favors, escort cards, place cards, menus, and ceremony programs
- Plan and create welcome baskets (if applicable)
- Pick up rings
- Attend wedding attire fitting

- Finalize décor and details—and finish all DIYs—by your 2-months-out mark
- If providing your own alcohol, put in your delivery order or buy outright from store
- Get your marriage license (at least 30 days before your wedding)
- Buy wedding accessories, including shoes, headpiece, tie, etc.
- Purchase any extra items like a cake knife, guest book, ring pillow, etc.
- Meet with photographer and videographer to go over expectations and logistics

1 month out

- Talk to your officiant about your ceremony structure and content
- Choose (or write) your vows
- Create and finalize wedding-day schedule, and share with vendors
- Create your seating chart, and share with planner/coordinator, DJ/bandleader, and caterer
- Talk to family/friends who you want to speak (ceremony readers and people giving toasts)
- Decide on your music for key moments: processional, recessional, first dance, any other special dances, cake-cutting, last dance

- Put together must-play and do-not-play lists for DJ/bandleader
- If you still have outstanding replies after your RSVP date, contact those guests personally to find out if they are coming or not
- Give final guest count to planner, caterer, rentals company, and other vendors who request it by their deadlines
- Pick up your gown and suit/tux
- Confirm with all vendors
- Make beauty appointments for the week of your wedding
- Figure out how décor items you own (and DIYs) will get to and from your wedding

1 week out

- Attend beauty appointments: manicure, shave, haircut, etc.
- Pack for honeymoon (if applicable)
- Pay outstanding vendor balances by due dates
- Assemble day-of emergency kit
- Determine post-wedding logistics (cleanup and vendor tips)
- Attend your bridesmaid luncheon (if applicable)

Day before

- Do something relaxing (yoga, meditation, light workout)
- Attend rehearsal
- Attend welcome party/rehearsal dinner
- Give attendants, parents, and each other your gifts

Day of

- Eat breakfast
- Drink plenty of water
- Get ready
- Get married!

contracts and negotiation

negotiation tips

As you meet with and hire vendors, you may find someone whose work you really love, but is out of your price range. Here are some strategies for negotiating so you can work with the pros you'd like to hire.

1. Set your budget first: You can't negotiate if you don't know how much you have to spend.

2. If you find a vendor your want to work with but can't afford, ask if they have an associate or assistant who can handle whatever component of your wedding they specialize in with the vendor's supervision.

3. Be realistic and respectful: If you can spend only $1,000 on photography, but are contacting photographers who charge $8,000, you can't expect these pros to meet your budget.

4. Know what other vendors cost: Do your homework to get some comparative pricing and talk with the vendor you want to hire about what other pros charge. Explain that you'd like to go with them, but you're curious as to why their fee is higher. Either you'll get a solid explanation about what added value they offer, or they will offer a discounted rate to secure your business.

5. Inquire about abbreviated service options: You may save by asking your coordinator or photographer to work for fewer hours at a discounted rate.

6. Always, always ask for price breaks: You might feel self-conscious about

negotiating, but if you don't ask, you won't get a discount.

7. Meet in the middle: If your budget for videography is $1,500 and the pro you want costs $2,000, ask if you can find a happy medium with $1,750.

8. See what your planner or coordinator can do for you: Some vendors work together to provide clients with kickbacks for hiring their pals— your planner may offer a trusted photographer they love working with for a discounted price.

9. Be nice: Vendors are often more than willing to go the extra mile for clients who are kind and easy to work with.

10. Inquire about freebies: If you're dropping serious dough with your caterer, ask if you can have coffee service free of charge, or see if their company can print up menus for you. When you spend a lot with one vendor, they might be willing to throw some extras in for free.

how to deal with contracts

Each of your vendors will give you a contract (and if they don't, request one) that will lay out the terms of their services for hire. Here are some tips for making this process a smooth one:

1. Read each contract carefully.

2. Ask your partner or a parent to read each contract carefully so you have another set of eyes scanning each document.

3. Circle any mistakes (if they wrote the wrong wedding date or there's a misspelled name), as well as any points you don't understand.

4. Request changes and ask questions: Be sure you're clear on every point.

5. Reread the edited contract.

6. If there are still points on which you're unsure, ask a lawyer or someone familiar with contracts to make sure you're not signing anything unlawful or that might be questionable.

7. Before you sign, make sure the contract clearly spells out how much the service costs and exactly what you are paying for to ensure there won't be any surprise charges or fees.

8. Be sure that your contract includes contingency clauses of what might happen in case of emergency. (Will your venue provide you with another space if it becomes unusable? Will your coordinator find you a replacement if the coordinator becomes ill?)

9. Sign your contract, then request copies once it's been signed by your vendor as well.

10. Keep copies in a secure place (and consider scanning them in so you have digital versions). If something comes up or you have a question, you'll want to be able to easily refer to these documents.

11. If anything changes—you request more services, for example—ask your vendor to draw up an addendum that you can both sign.

resources

books

The Big White Book of Weddings:
A How-to Guide for the Savvy, Stylish Bride
by David Tutera

Budget Weddings for Dummies
by Meg Elaine Schneider

Colin Cowie Wedding Chic: 1,001 Ideas for
Every Moment of Your Celebration
by Colin Cowie

Emily Post's Wedding Etiquette
by Peggy Post

The Engaged Groom: You're Getting
Married. Read this Book
by Doug Gordon

The Everything Weddings on a Budget
Book: Plan the Wedding of Your Dreams—
Without Going Bankrupt!
by Barbara Cameron

The Wedding Book: The Big Book
for Your Big Day
by Mindy Weiss

websites: planning and inspiration

- BLovedWeddings.com
- BaysideBride.com
- BridalGuide.com
- BridalMusings.com
- BrideandBreakfast.ph
- TheBridesCafe.com
- CamilleStyles.com
- DesireeHartsock.com
- DIYBride.com
- EngagedandInspired.com
- EquallyWed.com
- TheEveryLastDetail.com
- FabYouBliss.com
- Food52.com
- GlamourandGraceBlog.com
- GreenWeddingShoes.com
- GreyLikesWeddings.com
- HeartLoveAlways.com
- HowHeAsked.com

- HuffPostWeddings.com
- InspiredByThis.com
- LoveIncMag.com
- LoveMyDress.net
- TheLovelyFind.com
- Lover.ly
- MagnoliaRouge.com
- MaharaniWeddings.com
- MindyWeiss.com
- MunaluchiBridal.com
- Oh-Lovely-Day.com
- OnABicycleBuiltForTwo.com
- OnceWed.com
- PolkaDotBride.com
- SimplyPeachy.com
- Smitten-Mag.com/blog
- SnippetandInk.com
- SouthAsianBrideMagazine.com
- SouthernWeddings.com
- SocietyBride.com
- StyleMePretty.com
- TwoBirdsNest.com
- WeddingChicks.com
- WeddingSparrow.co.uk
- WeddingWire.com
- WellGroomedBlog.com

websites: diy, décor, and other resources

- Etsy.com
- Minted.com
- WeddingPaperDivas.com
- WeddingWire.com

software/apps

- Argus
- Amazon Universal Registry
- DropBox
- Evernote
- Google Docs
- Instagram
- Loseit
- Mint
- Pinterest
- Splash for Loverly
- Spotify
- Squarespace
- Trello
- Wanderable
- WedPics
- Zola Registry

organizations and experts

- American Association of Certified Wedding Planners
- Colin Cowie
- David Tutera
- Jacin Fitzgerald
- Mindy Weiss
- Renée Strauss
- Wedding Photographers Association

wedding gowns and designers

- Alfred Angelo
- Ann Barge
- BHLDN
- Carolina Herrera
- Donna Morgan
- Ines DiSanto
- Jenny Packham
- Jenny Yoo
- Jim Hjelm
- Kleinfeld Bridal
- Lazaro
- Marchesa
- Maggie Sottero
- Monique Lhuillier
- Naeem Khan
- Oscar de la Renta
- Reem Acra
- Stephen Khalil
- Vera Wang
- Watters
- Wtoo by Watters
- Zac Posen

credits

PAGE 2: Photographer: Caroline Tran, Wedding Planner: CCL Weddings & Events, Florist: Green Leaf Designs, Cake: Sweet and Saucy Shop, Rentals: Found Vintage Rentals

PAGE 6: Photographer: Caroline Tran, Wedding Planner: Daughter of Design, Florist: Saipua, Venue: Oheka Castle

PAGE 9: (Kellee and sister) Photographer: Jose Villa Photography, (Kellee alone) Photographer: Christina Lilly Photography

PAGE 10: Photographer: Rachel Solomon, Cake: Honey Moon Sweets, Flowers: Sarah's Garden

PAGE 12: (Blue Couch) Photographer: Troy Grover Photographers; (Bouquet and Blue Dress) Photographer: Caroline Tran, Wedding Planner: CCL Weddings & Events, Florist: Green Leaf Designs; (Just Married Sign) Photographer: Caroline Tran, Wedding Planner: Kelly Oshiro, Event Designer, Florist: Tricia Fountaine, Venue: Ranco Dos Pueblos; (Rings) Photographer: Braedon Photography, Wedding Planner: Cassandra Santor Events

PAGE 13: Photographer: Megan Clouse

PAGE 14: Photographer: Troy Grover Photographers, Florist: Floral Occasions

PAGE 28: Photographer: Theo Milo Photography, Florist: The Bloom Room, Wedding Planning & Design: Come + Together Events

PAGE 38: (Pickup Truck) Photographer: Landon Jacob; (Rehearsal Dinner) Photographer: Braedon Photography; Wedding Planner: Lady Liberty Events; (Chalkboard Sign) Photographer: Abby Jiu Photography, Planning and Design: Events in the City, Paper Goods: Fig.2 Design, (Stationery Suite) Photographer: Troy Grover Photographers, Stationery: Joni Joy Prints, Wedding Planner: Coastyle Events

PAGE 39: (Bouquet) Photographer: Braedon Photography; Wedding Planner: International Event Company; (Cake) Photographer: Rachel Solomon, Cake: Honey Moon Sweets, Flowers: Sarah's Garden

PAGE 40: Photographer: Braedon Photography; Event Coordinator: The Love Riot, Event Designer: Jesi Haack, Florist: JL Designs, Pies: Polly's Pies, Rentals: Archive Vintage Rentals & Signature Party Rentals

PAGE 75: Photographer: Braedon Photography, Wedding Planner: Lady Liberty Events

PAGE 78: Photographer: Troy Grover Photographers; Stationery: Joni Joy Prints, Wedding Planner: Coastyle Events

PAGE 100: Photographer: Braedon Photography; Wedding Planner: International Event Company

PAGE 105: Photographer: Abby Jiu Photography, Planning and Design: Events in the City, Paper Goods: Fig.2 Design

PAGE 134: Photographer: Caroline Tran; Wedding Planner: CCL Weddings & Events, Florist: Green Leaf Designs, Cake: Sweet and Saucy Shop, Rentals: Found Vintage Rentals

PAGE 157: Photographer: Caroline Tran, Florist: Twig and Twine, Planner: So Happi Together, Tableware: Casa de Perrin, Rentals: Found Rentals & Archive Rentals, Venue: Saddlerock Ranch

PAGE 160: Photographer: Braedon Photography; Wedding Planner: Sterling Social, Venue: Rancho Dos Pueblos, Rentals: Found Rentals, Florist: JL Designs

PAGE 180: Photographer: Valorie Darling, Florals and Design: Poppy + Blush, Rentals: Archive Rentals, Dishware: Dish Wish, Woven Table Runner: The Trim Shoppe, Calligraphy: Alley+Co

PAGE 200: Photographer: Rachel Solomon; Floral Design: Sarah's Garden, Rentals: Shabby Chic Weddings

PAGE 224: Photographer: Caroline Tran; Wedding Planner: So Happi Together, Florist: Twig and Twine, Tableware: Casa de Perrin, Rentals: Found Rentals & Archive Rentals, Venue: Saddlerock Ranch

PAGE 237: Photographer: Landon Jacob

PAGE 240: (Cake) Photographer: Megan Clouse, Cake: Crisp Bake Shop; (Arch) Photographer: Love, The Nelsons, Wedding Planner and Florals: Hey Gorgeous Events, Venue: Vista West Ranch; (Man Holding Bouquet) Photographer: Caroline Tran, Wedding Planner: So Happi Together, Florist: Twig and Twine

PAGE 241: (Champagne Glass) Photographer: Jacqueline Pilar Photography; (Keys) Photographer: Troy Grover Photographers

PAGE 242: Photographer: Braedon Photography; Wedding Planner: Alison Events

PAGE 251: Photographer: Troy Grover Photographers

PAGE 252: Photographer: Brklyn View Photography; Florals: Lindsay Rae Design, Styling: Michelle Edgemont, Just Married Sign: Modern Press, Venue: 501 Union

PAGE 260: Photographer: Jacqueline Pilar Photography; Bridal Luncheon for Samantha Hutchinson of Could I Have That, Glass and Napkin: Anthropologie

Index

CPSIA information can be obtained
at www.ICGtesting.com
Printed in the USA
BVOW11s1110280717
490503BV00006B/16/P